Put any picture you want on any state book cover. Makes a great gift. Go to www.america24-7.com/customcover

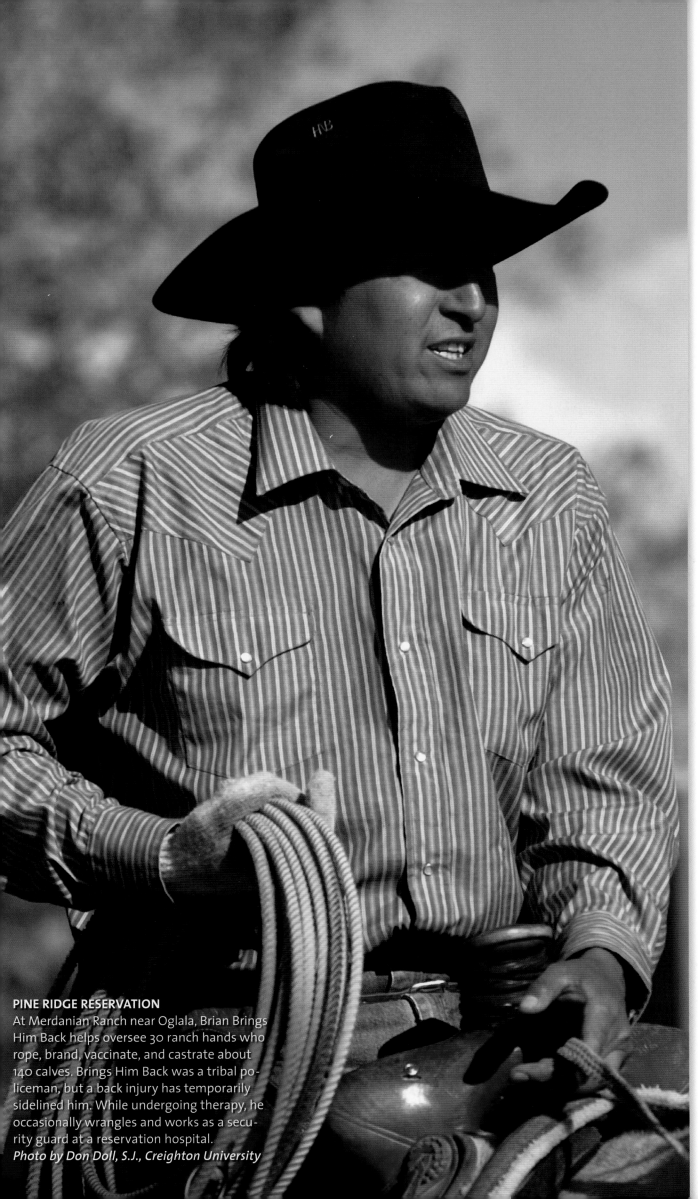

PINE RIDGE RESERVATION
At Merdanian Ranch near Oglala, Brian Brings Him Back helps oversee 30 ranch hands who rope, brand, vaccinate, and castrate about 140 calves. Brings Him Back was a tribal policeman, but a back injury has temporarily sidelined him. While undergoing therapy, he occasionally wrangles and works as a security guard at a reservation hospital.
Photo by Don Doll, S.J., Creighton University

South Dakota 24/7 is the sequel to *The New York Times* bestseller *America 24/7* shot by tens of thousands of digital photographers across America over the course of a single week. We would like to thank the following sponsors, the wonderful people of South Dakota, and the talented photojournalists who made this book possible.

LONDON, NEW YORK, MUNICH, MELBOURNE, and DELHI

Created by Rick Smolan and David Elliot Cohen

24/7 Media, LLC
PO Box 1189
Sausalito, CA 94966-1189
www.america24-7.com

First Edition, 2004
04 05 06 07 08 10 9 8 7 6 5 4 3 2 1

Published in the United States by
DK Publishing, Inc.
375 Hudson Street
New York, NY 10014

DK Publishing, Inc. offers special discounts for bulk purchases for sales promo-
tions or premiums. Specific, large-quantity needs can be met with special edi-
tions, personalized covers, excerpts of existing guides, and corporate imprints.
For more information, contact:

Special Markets Department
DK Publishing, Inc.
375 Hudson Street
New York, NY 10014
Fax: 212-689-5254

Cataloging-in-Publication data is available
from the Library of Congress
ISBN 0-7566-0082-0

Printed in the UK by Butler & Tanner Limited

First printing, October 2004

FAIRBURN
Female elk frame a ridge above Custer State
Park. In a few weeks, this maternal herd
will disperse to individual calving grounds,
where they will give birth to a new genera-
tion. South Dakota's population was nearly
extinct just a century ago—now the state
is home to a robust population of 5,500 ani-

SOUTH DAKOTA 24/7

24 Hours. 7 Days.
Extraordinary Images of
One Week in South Dakota.

Created by Rick Smolan and David Elliot Cohen

DK Publishing

About the America 24/7 Project

A hundred years hence, historians may pose questions such as: What was America like at the beginning of the third millennium? How did life change after 9/11 and the ensuing war on terrorism? How was America affected by its corporate scandals and the high-tech boom and bust? Could Americans still express themselves freely?

To address these questions, we created *America 24/7*, the largest collaborative photography event in history. We invited Americans to tell their stories with digital pictures. We asked them to shoot a visual memoir of their lives, families, and communities.

During one week in May 2003, more than 25,000 professionals and amateurs shot more than a million pictures. These images, sent to us via the Internet, compose a panoramic yet highly intimate view of Americans in celebration and sadness; in action and contemplation; at work, home, and school. The best of these photographs, more than 6,000, are collected in 51 volumes that make up the *America 24/7* series: the landmark national volume *America 24/7*, published to critical acclaim in 2003, and the 50 state books published in 2004.

Our decision to make *America 24/7* an all-digital project was prompted by the fact that in 2003 digital camera sales overtook film camera sales. This techno-logical evolution allowed us to extend the project to a huge pool of photographers. We were thrilled by the response to our challenge and moved by the insight offered into American life. Sometimes, the amateurs outshot the pros—even the Pulitzer Prize winners.

The exuberant democracy of images visible throughout these books is a revela-tion. The message that emerges is that now, more than ever, America is a supersized idea. A dreamspace, where individuals and families from around the world are free to govern themselves, worship, read, and speak as they wish. Within its wide margins, the polyglot American nation manages to encompass an inexplicably complex yet workable whole. The pictures in this book are dedicated to that idea.

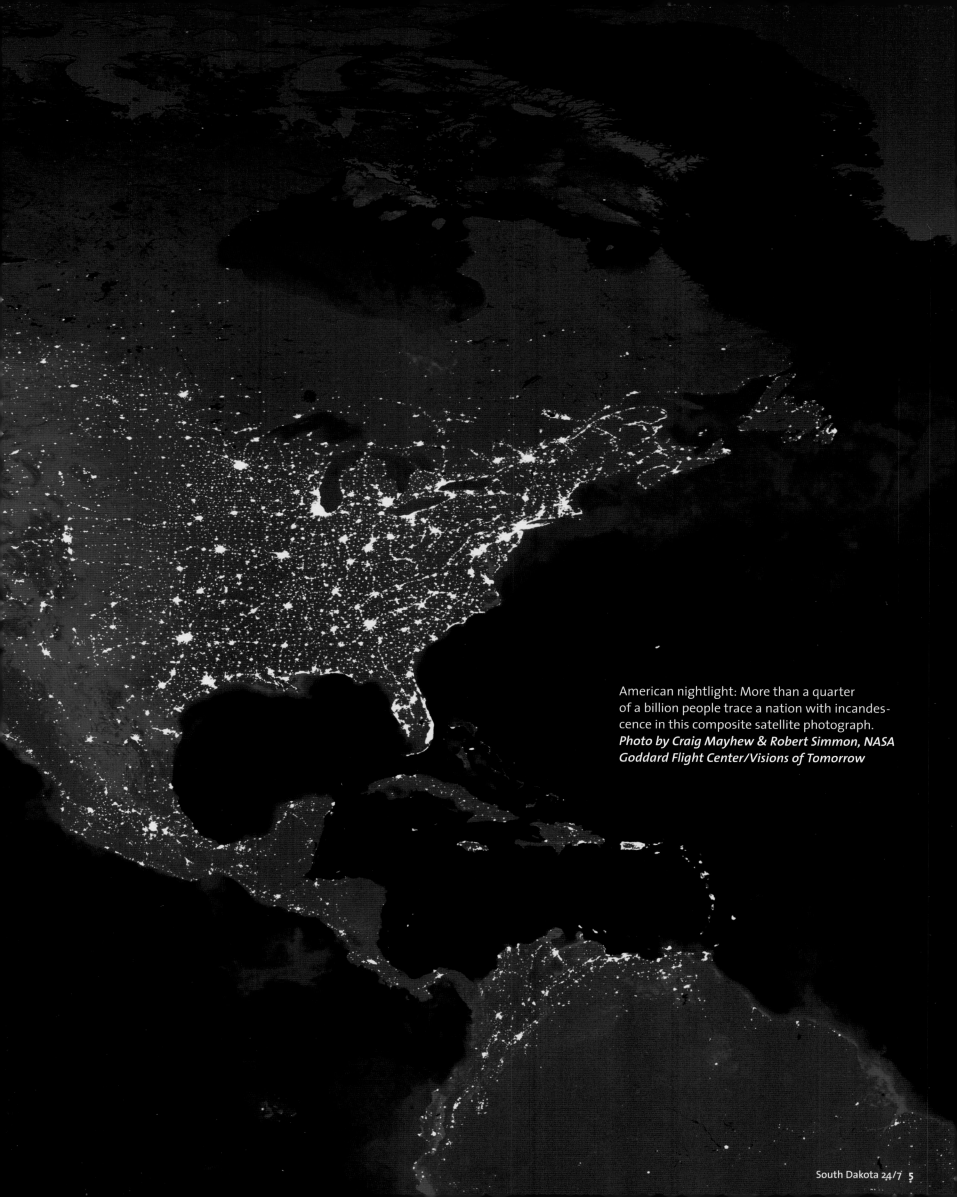

American nightlight: More than a quarter of a billion people trace a nation with incandescence in this composite satellite photograph.
Photo by Craig Mayhew & Robert Simmon, NASA Goddard Flight Center/Visions of Tomorrow

East River, West River

By Terry Woster

Among the slogans that promoters have tried out for South Dakota, one fits better than most: the Land of Infinite Variety. If you don't like the weather, the old joke goes, wait a minute and it'll change. In Spearfish, on January 22, 1943, the temperature rose 49 degrees in two minutes. The all-time high temperature is 120 degrees in Gann Valley in July of 1936; the bottom low is minus 58 degrees in McIntosh in February of the same year.

And the geography and people are just as up-and-down as the weather. With 75,956 square miles to fill, South Dakota crowds more than a quarter of its 764,000 citizens into two cities at opposite ends of the state: Sioux Falls to the east and Rapid City to the west. Rich, flat croplands blanket the east, while the pine-covered Black Hills anchor the west. In between are vast grassland and emptiness—all of it divided into two halves by the Missouri River.

The river divides the people, too: Compact grain farms, wing-tipped shoes, and Minnesota Vikings fans are commonplace in "east river," where Democrats carry weight. But cattle pastures, gun racks, and Denver Bronco partisans animate "west river," which tends to be a conservative, strongly Republican enclave.

It rained a lot in the 19th century, when Scandinavian, German, and Irish immigrants swarmed into the territory. They built houses and barns and planted and harvested whole crops before they figured out that in the Northern Plains, drought was as frequent a visitor as rain. Still, most of them stayed, too stubborn to admit they'd been duped.

Long before those hardy settlers arrived, of course, Lakota, Dakota, and Nakota hunters roamed the Black Hills. Their treaties with the U.S. government gave them everything west of the Missouri River—until gold was discovered at French Creek in 1874. Gold fever rendered the treaties meaningless. On a December day in 1890, a year after statehood, soldiers of the 7th Cavalry, suspecting an uprising, slaughtered 300 Lakota at Wounded Knee on the Pine Ridge Indian Reservation. Eighty-three years later, Native American militants occupied that same village for more than two months. Some say the scars of Wounded Knee will never disappear.

Now in its second century, the state of South Dakota struggles toward reconciliation. The state created an Office of Indian Education and has promised that economic development would not stop at reservation borders. Meanwhile, farms are larger and fewer. Survival means farmers joining together to build ethanol plants; ranchers banding together to process and market South Dakota beef; whole counties making deals with power companies for wind-energy facilities. The Homestake Mine closed in 2001, but leaders hope a physics research laboratory in the 8,000-foot-deep mine will stoke a new kind of gold rush. Or maybe tourism will fill the void. In 2003, Governor Michael Rounds set a goal to double visitor spending by 2010.

South Dakota's problems in its second century seem as variable as its geography or its weather. Solutions may depend, once again, on a people too stubborn to up and leave just because the work is hard.

TERRY WOSTER *was born and raised on a wheat and cattle farm in Reliance. He now lives with his wife in Pierre, where he is the capital bureau chief for the* Sioux Falls Argus Leader.

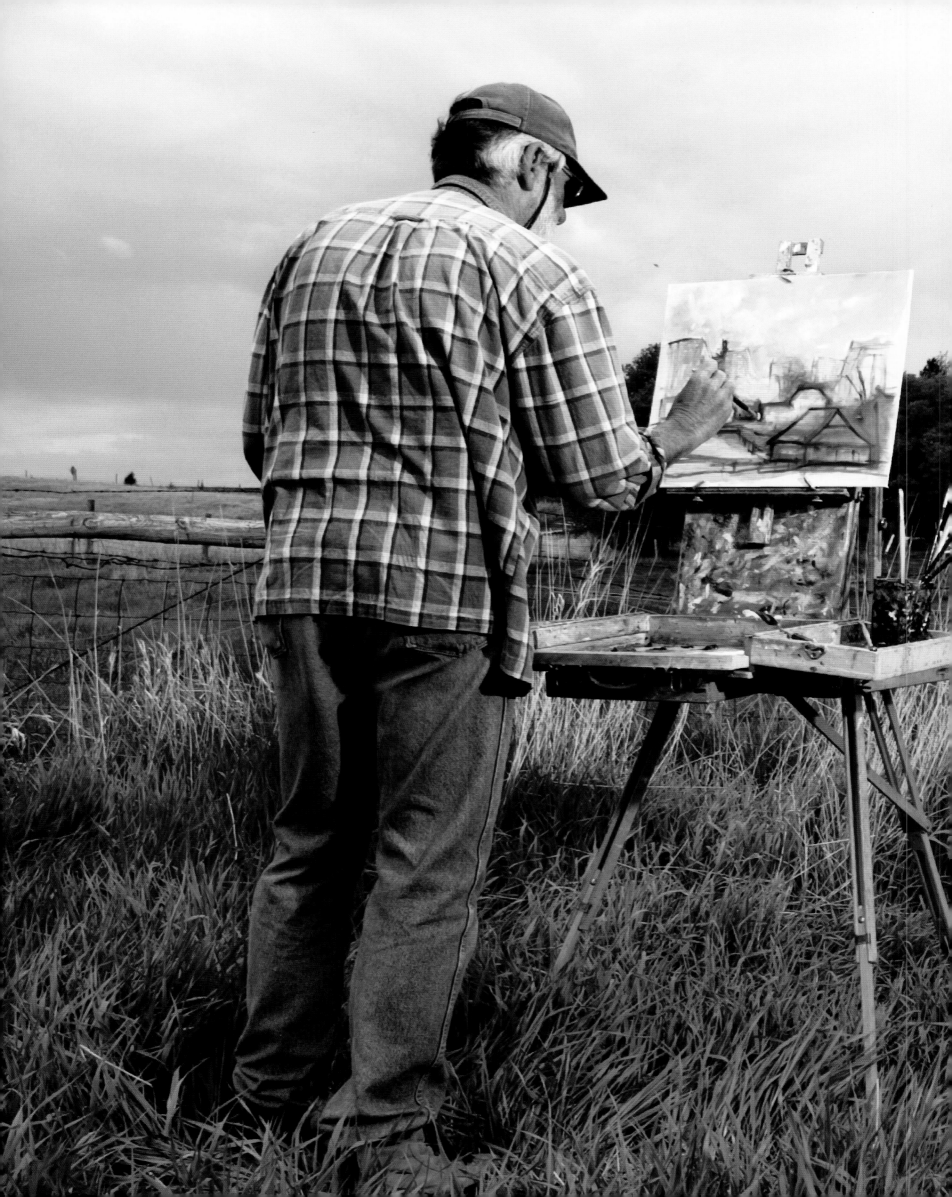

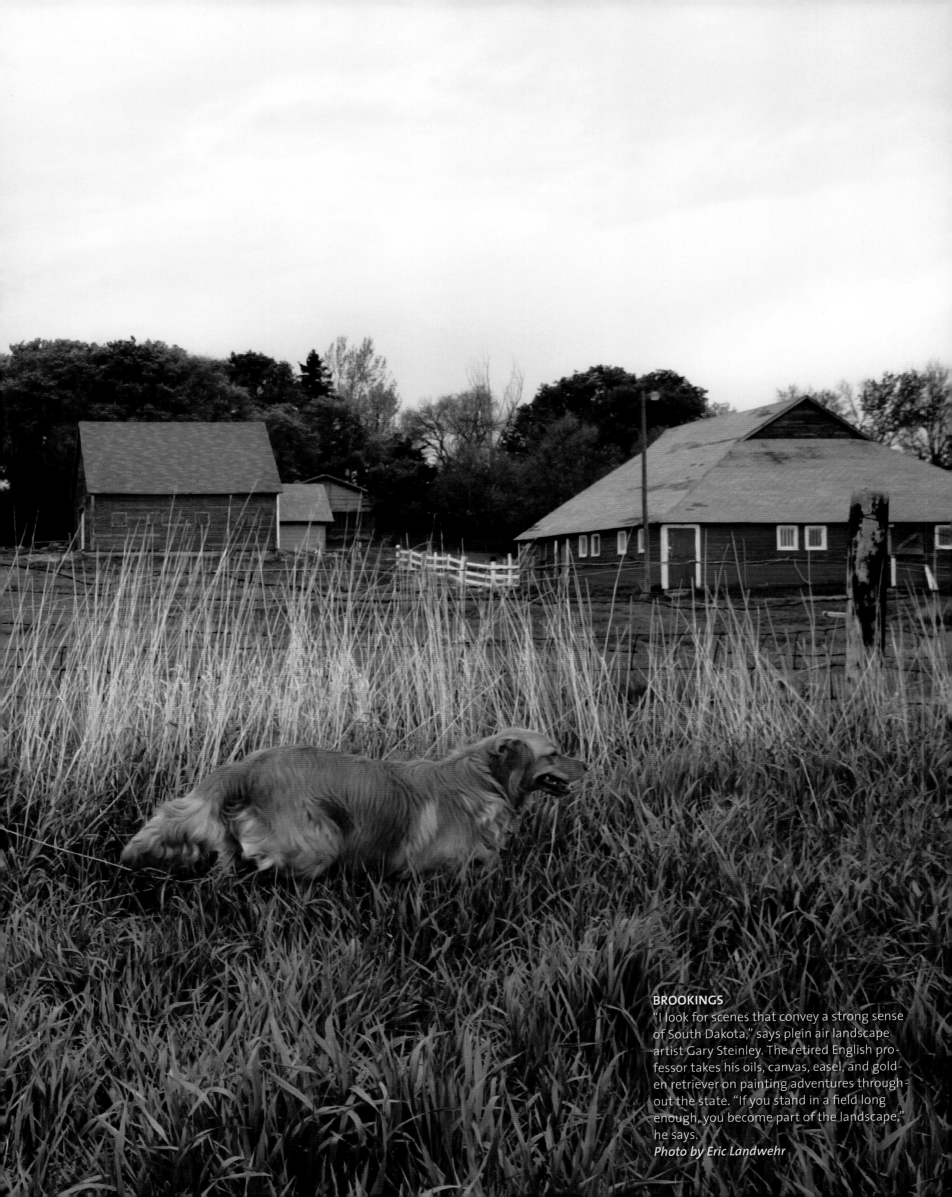

BROOKINGS
"I look for scenes that convey a strong sense of South Dakota," says plein air landscape artist Gary Steinley. The retired English professor takes his oils, canvas, easel, and golden retriever on painting adventures throughout the state. "If you stand in a field long enough, you become part of the landscape," he says.
Photo by Eric Landwehr

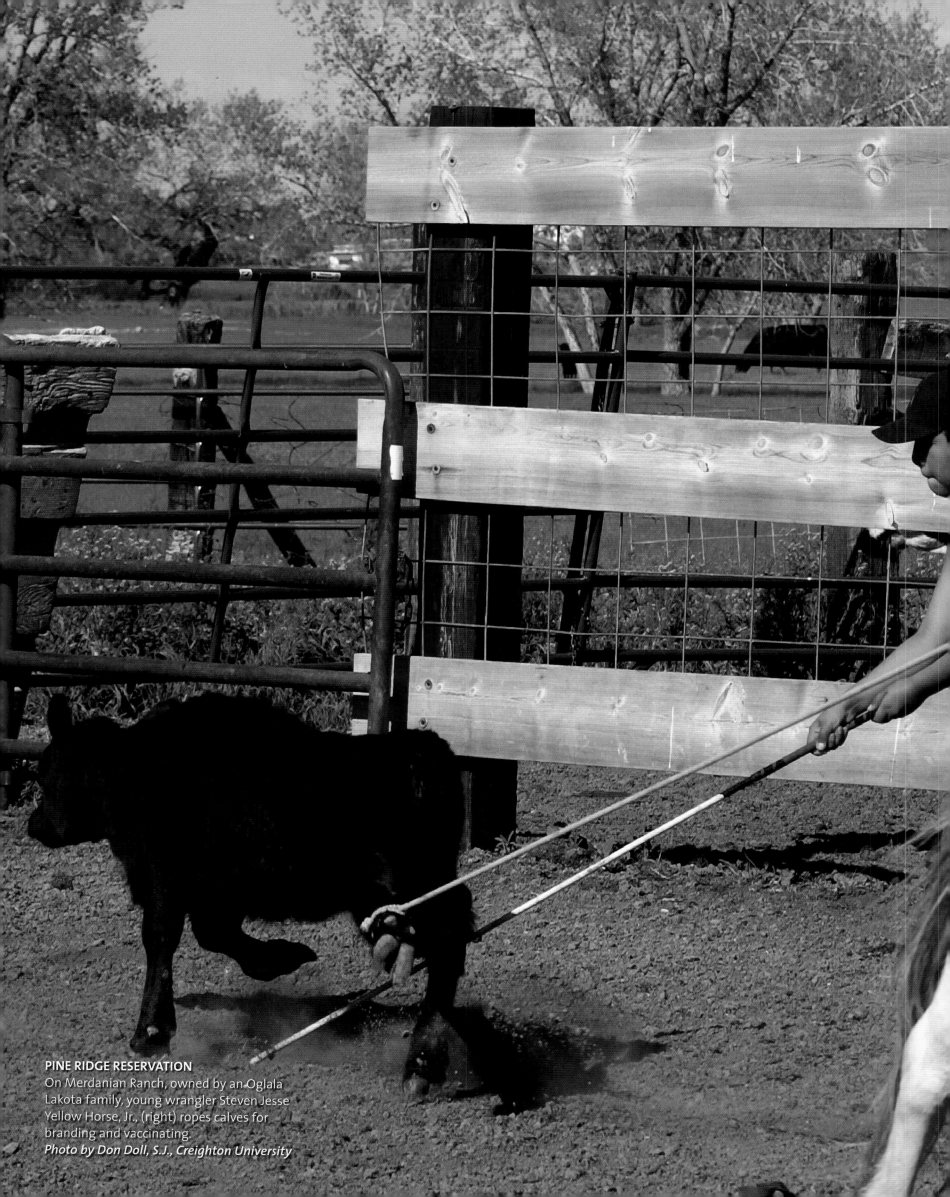

PINE RIDGE RESERVATION
On Merdanian Ranch, owned by an Oglala
Lakota family, young wrangler Steven Jesse
Yellow Horse, Jr., (right) ropes calves for
branding and vaccinating.
Photo by Don Doll, S.J., Creighton University

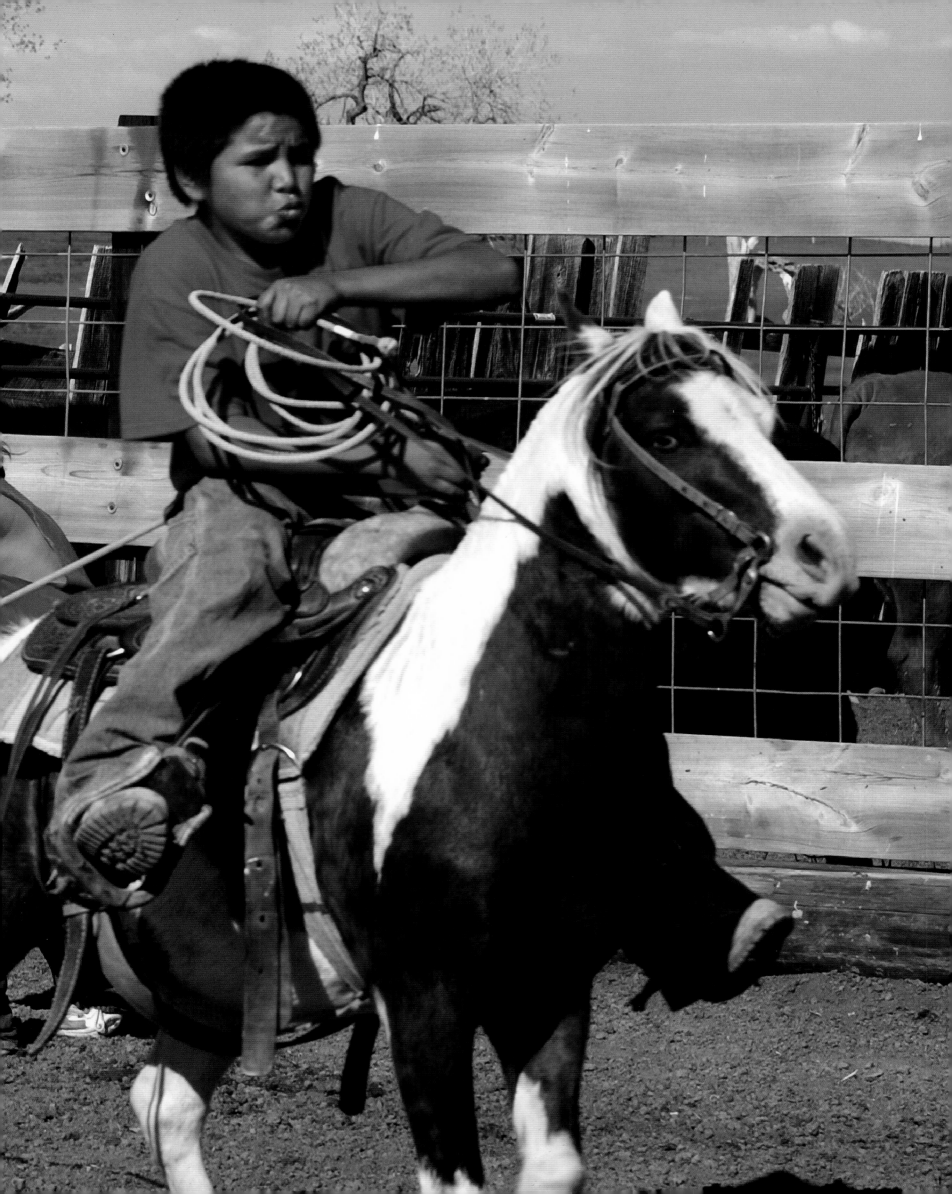

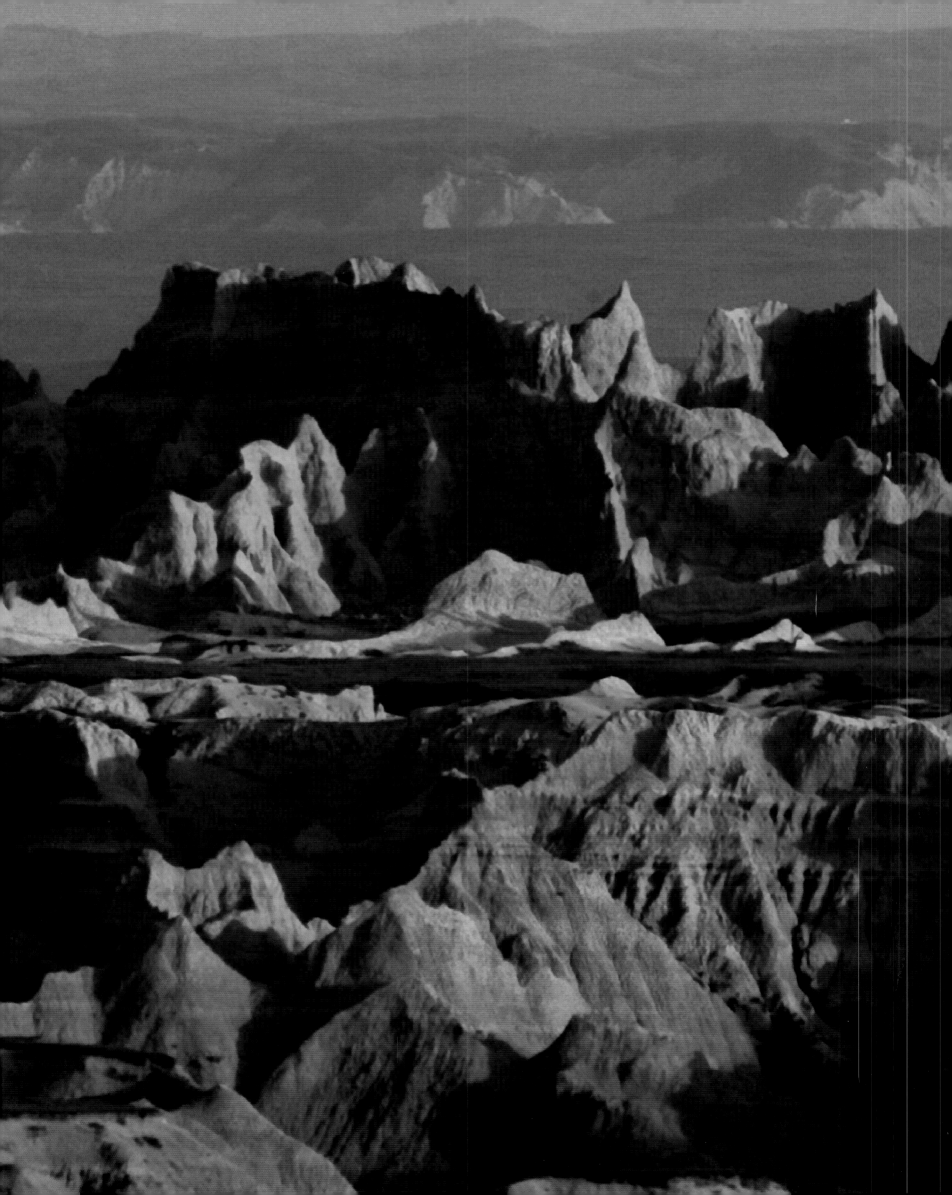

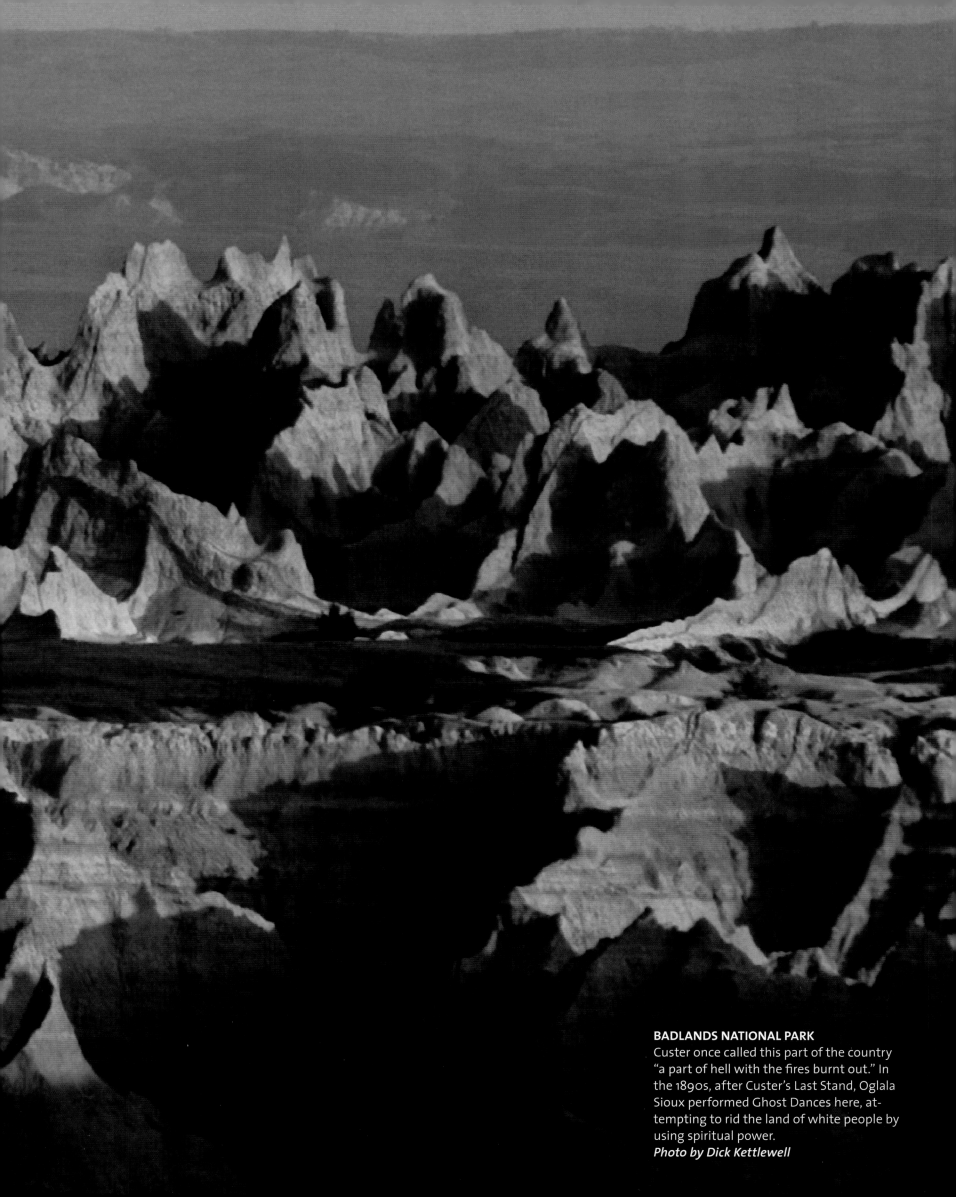

BADLANDS NATIONAL PARK
Custer once called this part of the country "a part of hell with the fires burnt out." In the 1890s, after Custer's Last Stand, Oglala Sioux performed Ghost Dances here, attempting to rid the land of white people by using spiritual power.
Photo by Dick Kettlewell

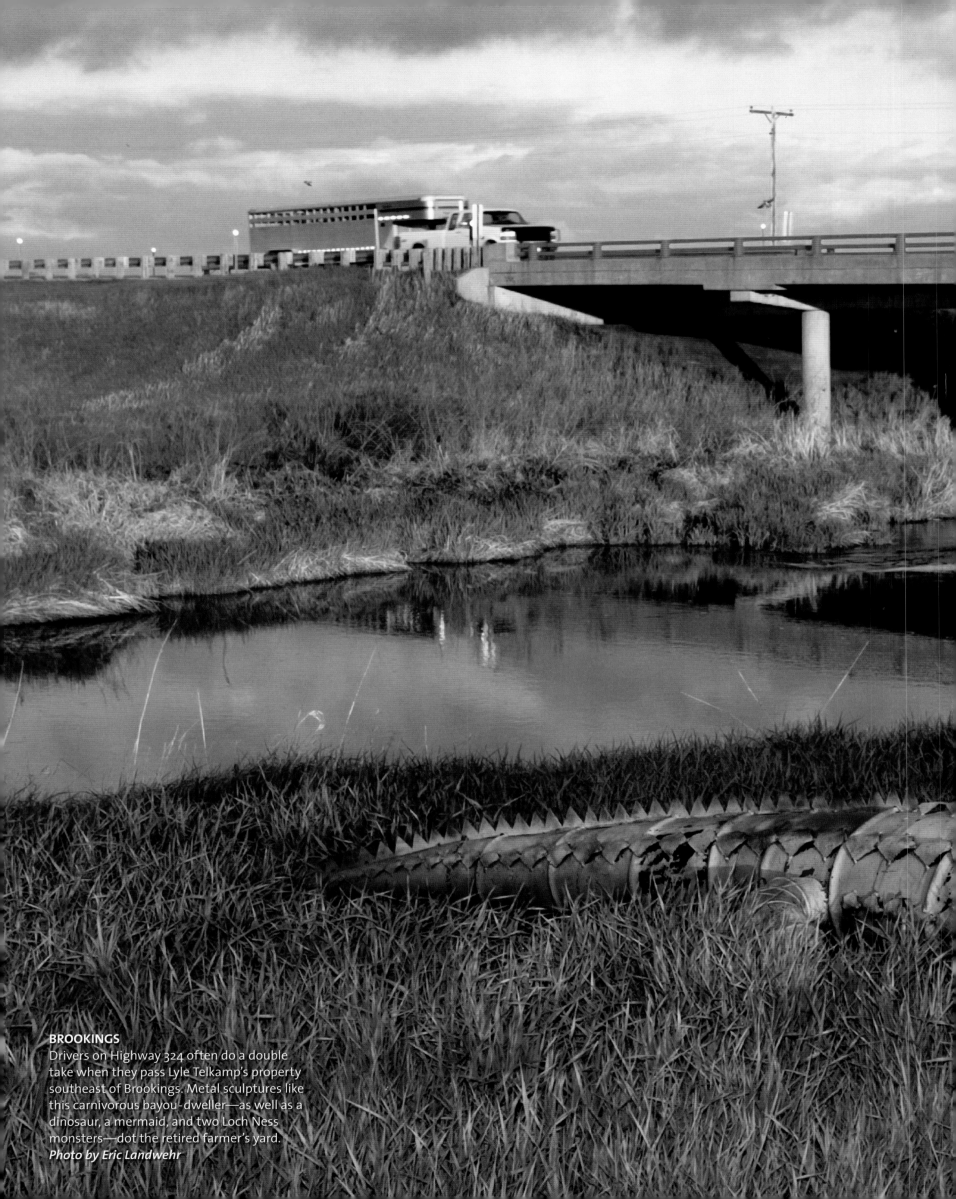

BROOKINGS

Drivers on Highway 324 often do a double take when they pass Lyle Telkamp's property southeast of Brookings. Metal sculptures like this carnivorous bayou-dweller—as well as a dinosaur, a mermaid, and two Loch Ness monsters—dot the retired farmer's yard.
Photo by Eric Landwehr

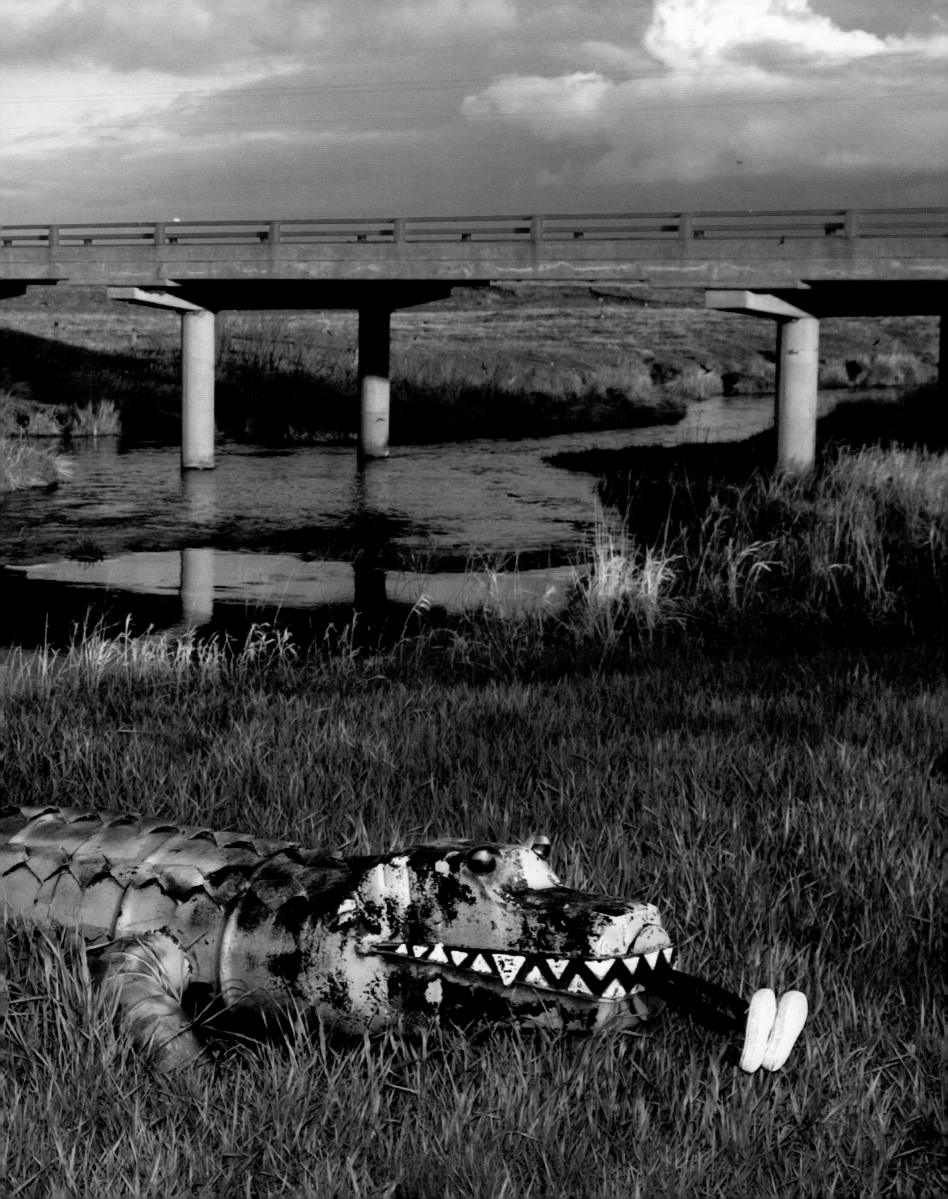

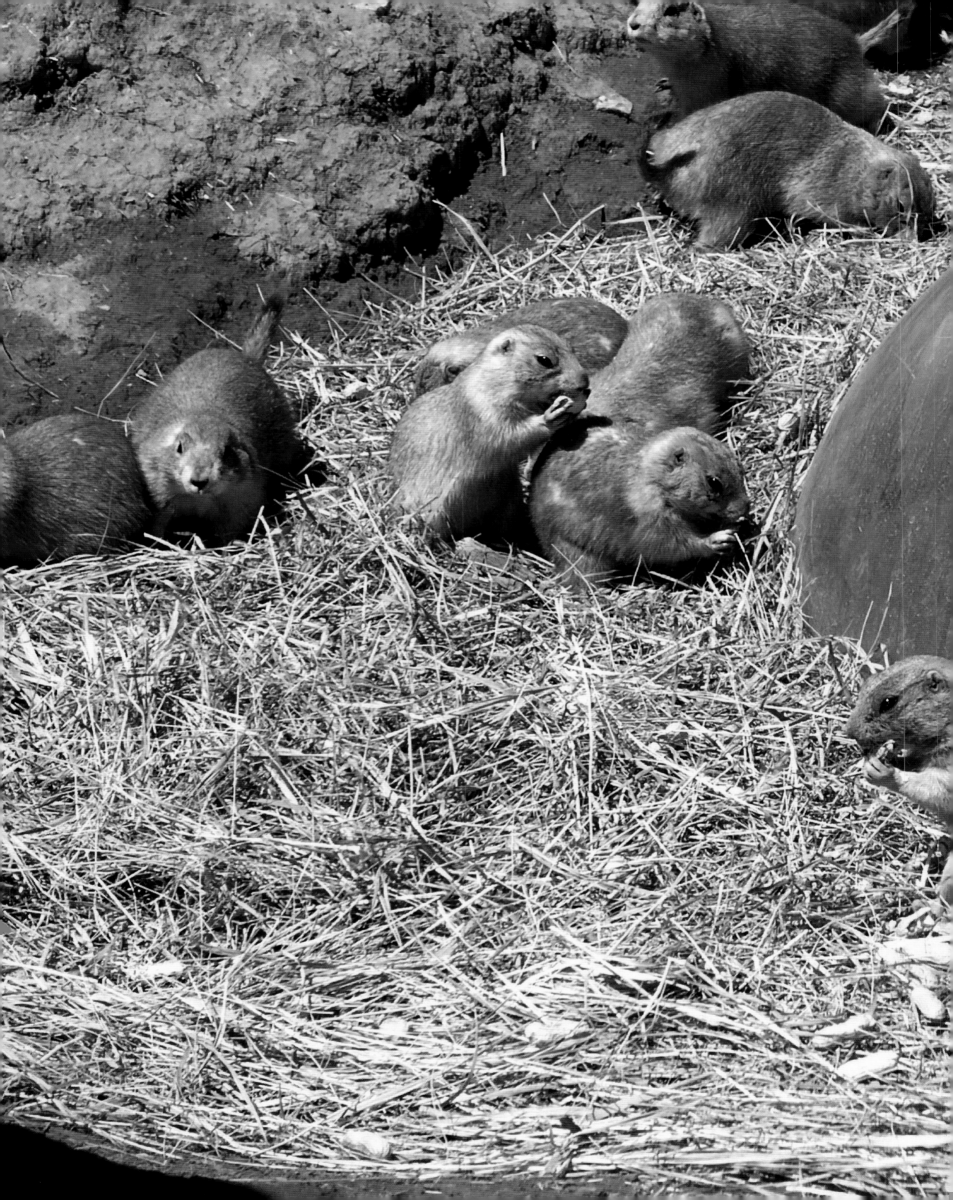

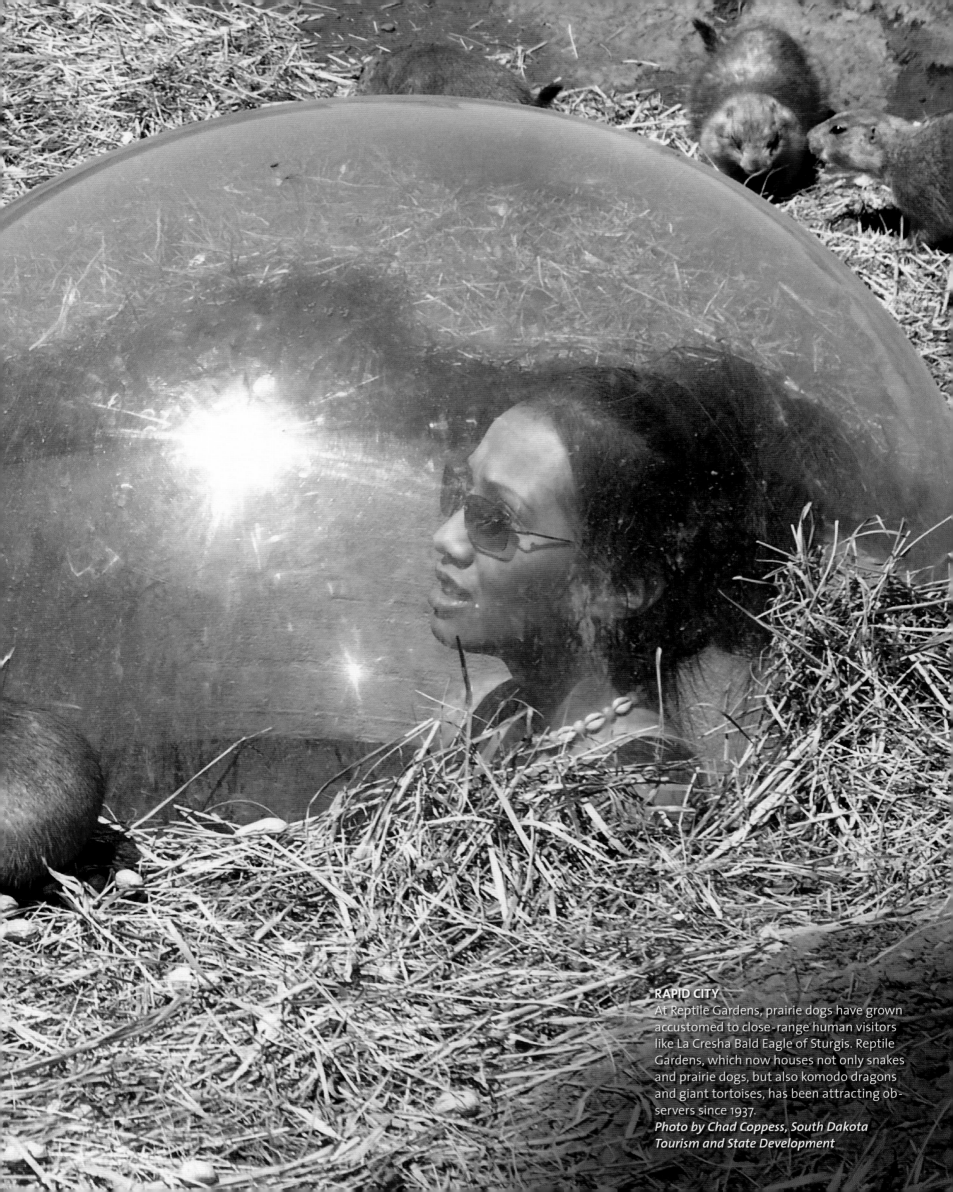

RAPID CITY

At Reptile Gardens, prairie dogs have grown accustomed to close-range human visitors like La Cresha Bald Eagle of Sturgis. Reptile Gardens, which now houses not only snakes and prairie dogs, but also komodo dragons and giant tortoises, has been attracting observers since 1937.
Photo by Chad Coppess, South Dakota Tourism and State Development

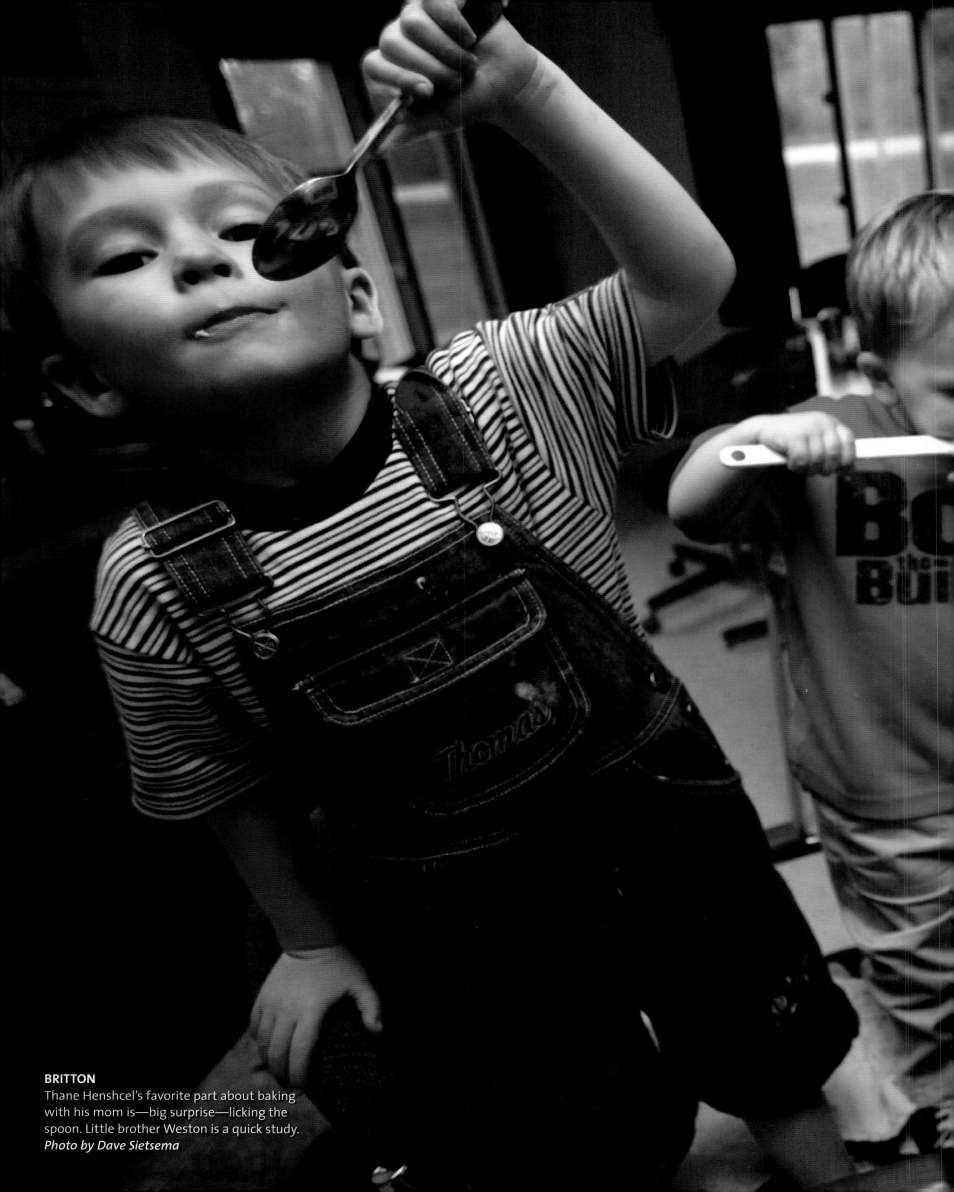

BRITTON
Thane Henshcel's favorite part about baking with his mom is—big surprise—licking the spoon. Little brother Weston is a quick study.
Photo by Dave Sietsema

Hearth & Home

FORT PIERRE

Anna Latza mothers her younger brother Luke, though she's apt to torment him as soon as she gets his socks on. The two awake from a nap on the bed that belonged to their great-grandfather.
Photos by Greg Latza, peoplescapes.com

FORT PIERRE

Stretched out, 6-month-old Jack Latza is about 20 inches. One day, he'll be big enough for the clawfoot tub at the old family farm.

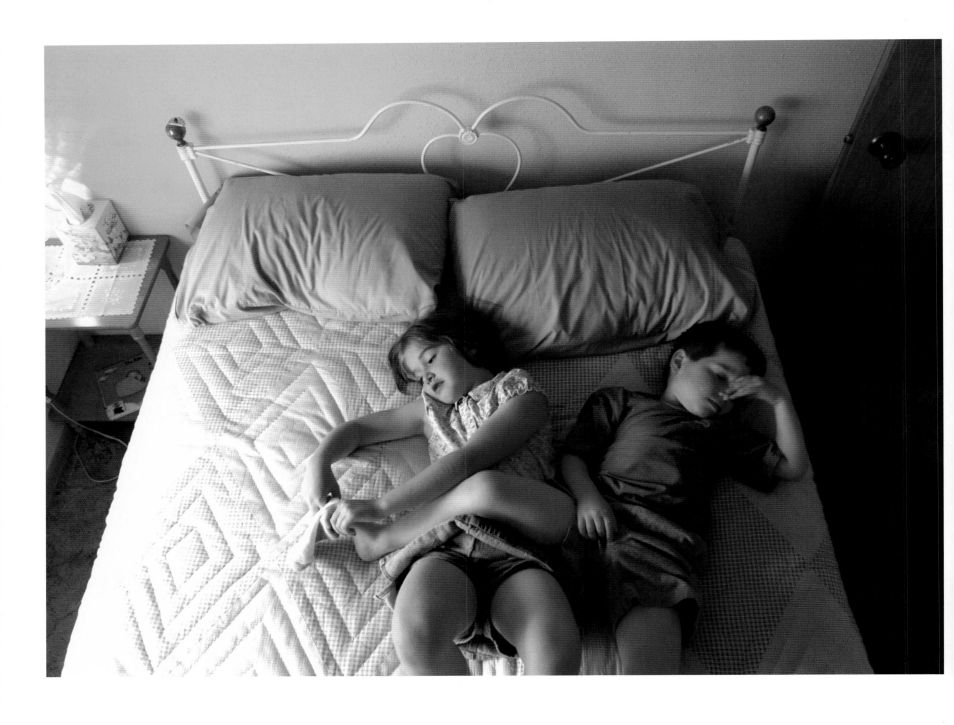

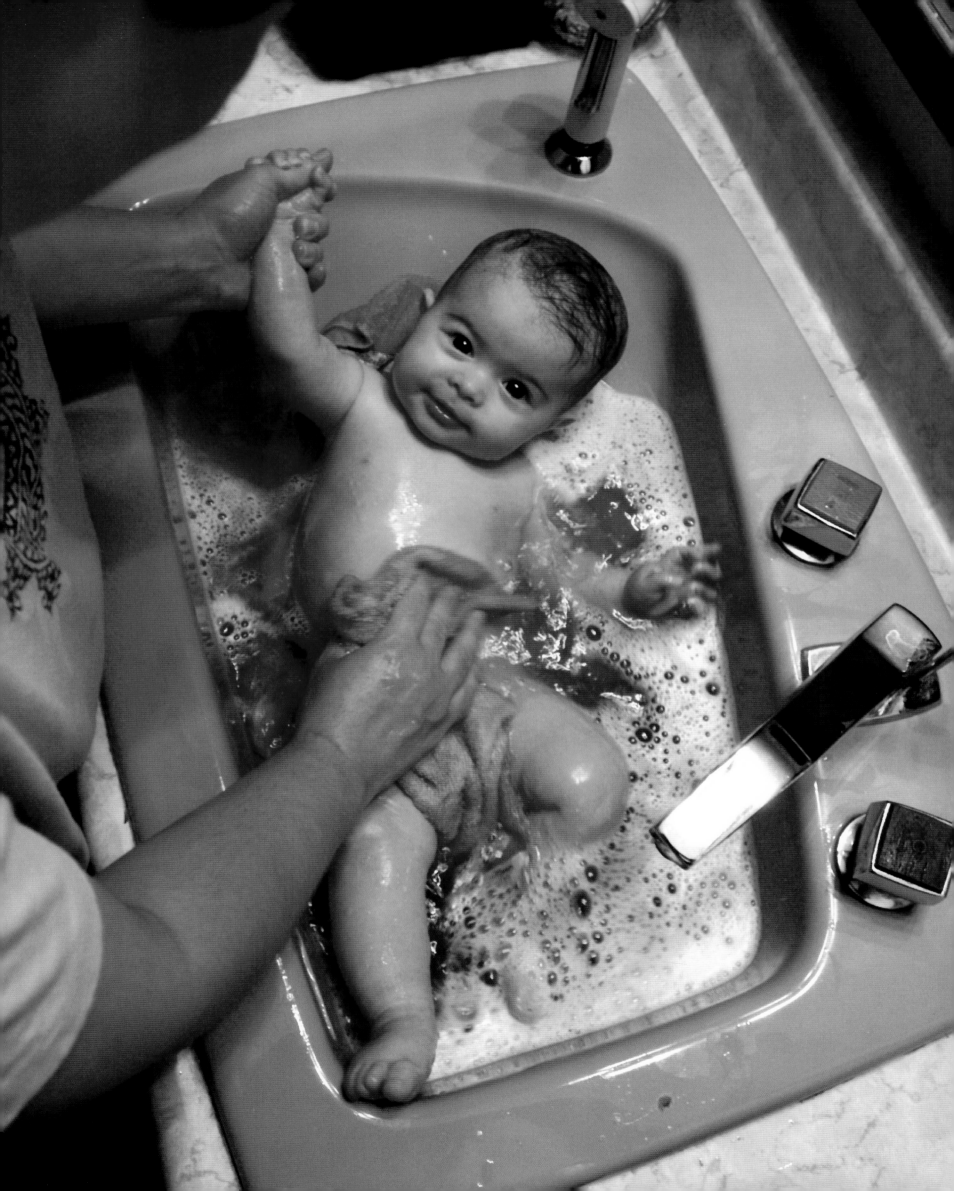

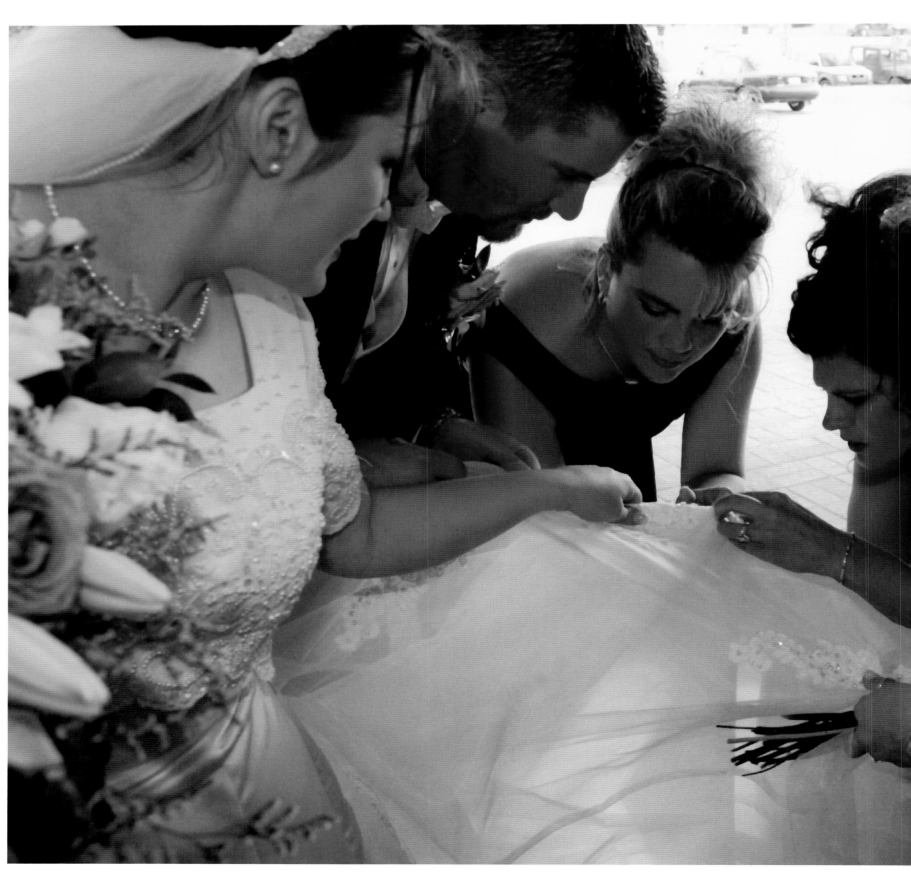

RAPID CITY
Katie Fisher needed three bridesmaids and her groom to attach the train to her gown. After a five-year courtship, Fisher tied the knot with Jason Rhoads at First Congregational Church. Once the gown was in order, they all headed to the reception at the Rushmore Plaza Holiday Inn.
Photos by Kevin Eilbeck

RAPID CITY

Katie Fisher was one of the last holdouts in her circle of friends. All of them, except Heather Lipp (center), have been married. To commemorate Fisher's inauguration into the "hitched" club, her bridesmaids flashed her a choreographed message: "Another one bites the dust."

RAPID CITY

Kason Rhoads gets a brush-up bowtie fastening lesson from dad Jason before the wedding reception. The 2-year-old gave an impeccable performance as the ceremony's ring bearer.

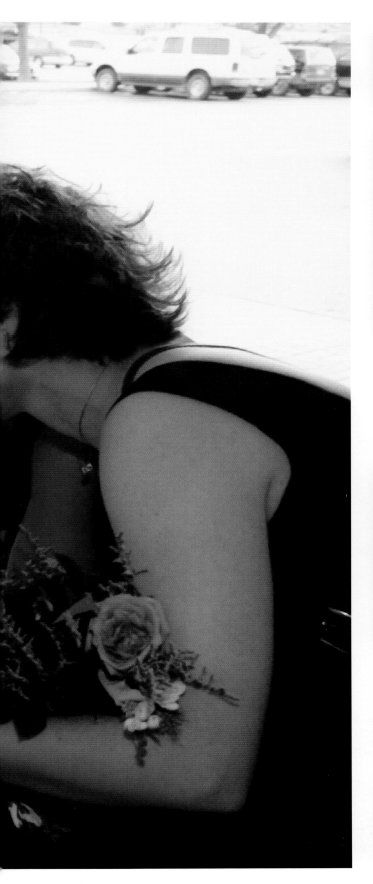

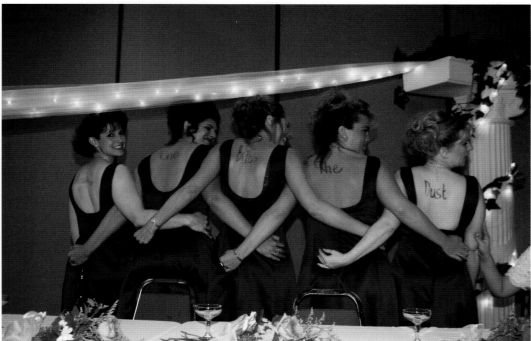

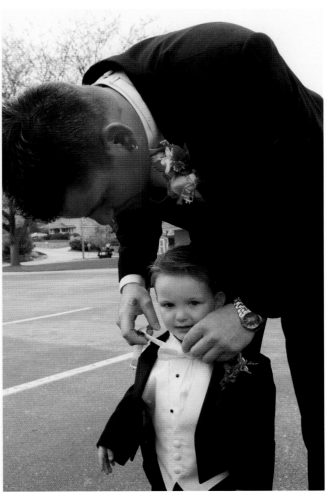

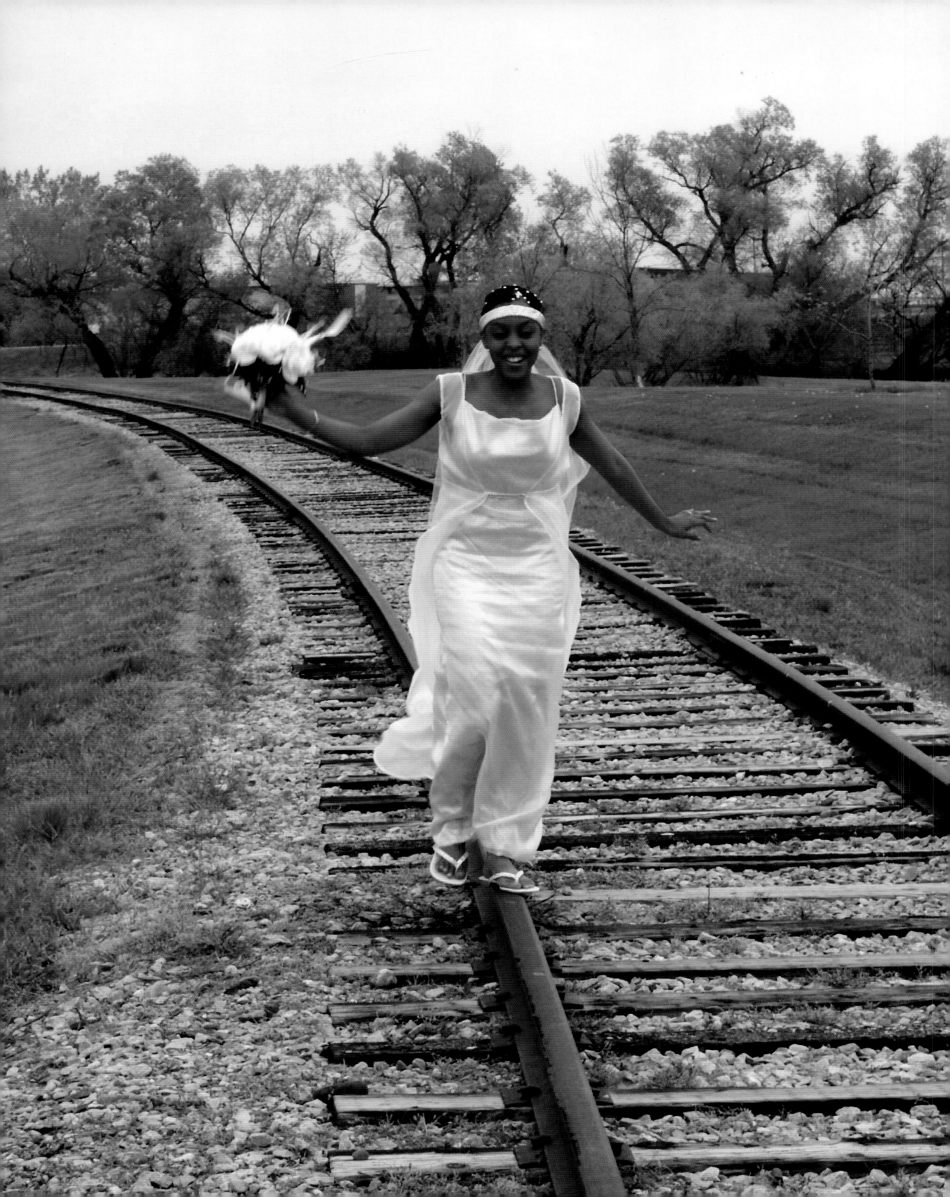

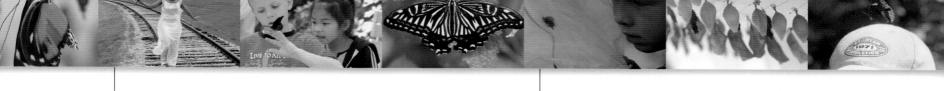

ELLSWORTH AIR FORCE BASE

As a child, Vita Oliver practiced her gymnastics balance beam routine on these railroad tracks just east of Rapid City. After her wedding to Joels Malama, a Zambian engineering student, the Iowa State University MBA candidate took a walk down memory lane.

Photo by Johnny Sundby,
Dakota Skies Photography

RAPID CITY

Colton Erk is into catching bugs. A homeschooled kid, Colton's natural curiosity about all things crawly is satisfied by science lessons with his mom, who says they take the classroom outdoors whenever possible. Today, he's caught a painted lady butterfly.

Photo by Markus Erk

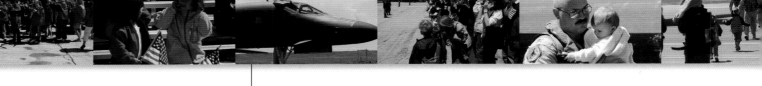

ELLSWORTH AIR FORCE BASE
A B-1B bomber returns home, taxiing to a stop on the tarmac at Ellsworth AFB, one of two air force bases in the country with B-1Bs. The squadron was the first contingent from the base to engage in tactical air strikes in Iraq.
Photos by Mike Wolforth

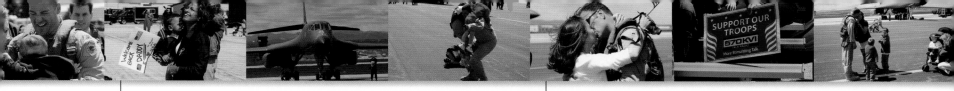

ELLSWORTH AIR FORCE BASE

The 650 airmen who returned to Ellsworth in May suffered no casualties on their mission. Relieved family members beamed even before their relatives reached their arms.

ELLSWORTH AIR FORCE BASE

After many months away from their loved ones, the crew are rewarded with heartfelt welcomes.

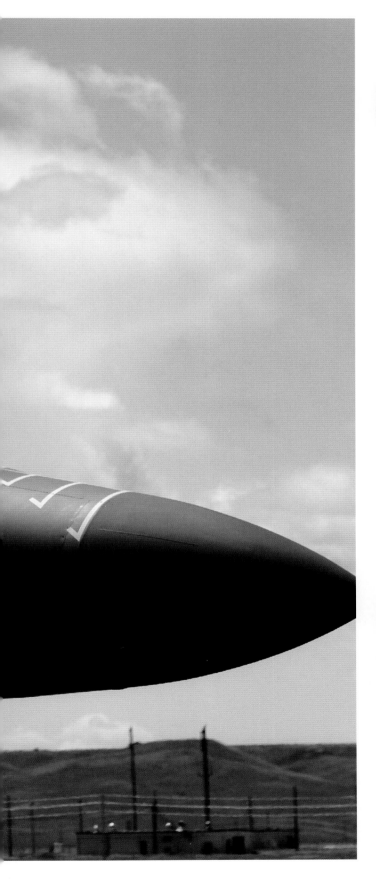

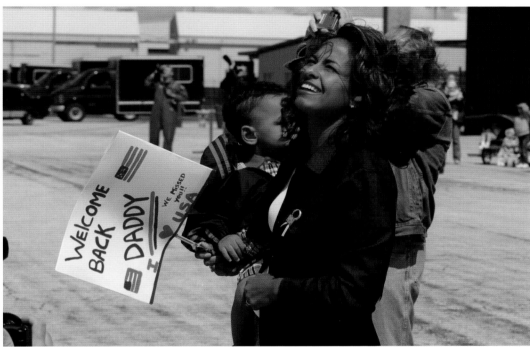

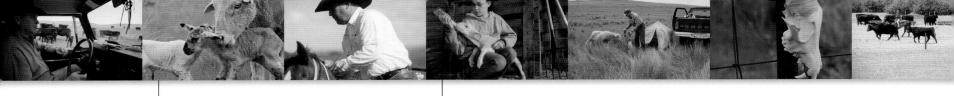

NEWELL

A Rambouillet ewe cleans up one of her newborn lambs on the Erk ranch. If the ewes are "flushed" —given good feed before they're put in with the rams—many of them will give birth to twins. A mature sheep produces 70-micron wool, and most of the lambs are sold to feed lots in Kansas and Iowa.

Photos by Markus Erk

NEWELL

"We sell our bums for school clothes," says Monica Deighton. Her older sisters have jobs away from the farm, so it's up to Monica to feed the "bums," lambs whose mothers do not have enough milk, have too many kids, or have died.

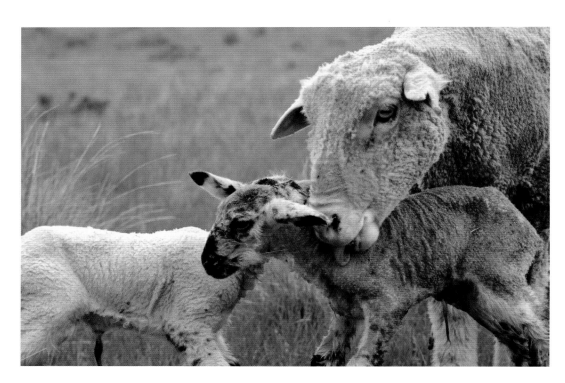

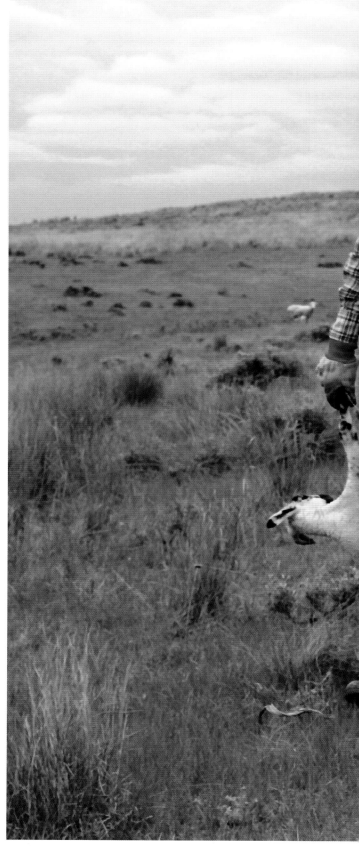

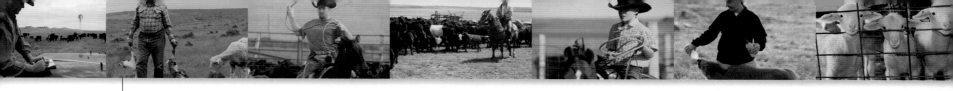

NEWELL

John Erk has been lambing sheep most of his life, and every May he helps his son lamb 700 ewes. "My mother took me out in a little goat cart before I could walk," says Erk. He carries just-born twins to a tepee shelter. "A newborn can chill down fast in a cold wind."

RAPID CITY
In Charlie's humble opinion, golden retriever Beesley is a hyperactive simpleton. The 11-year-old shih tzu just watches while his roommate starts in with the fetching and running in circles routine.
Photo by Kevin Eilbeck

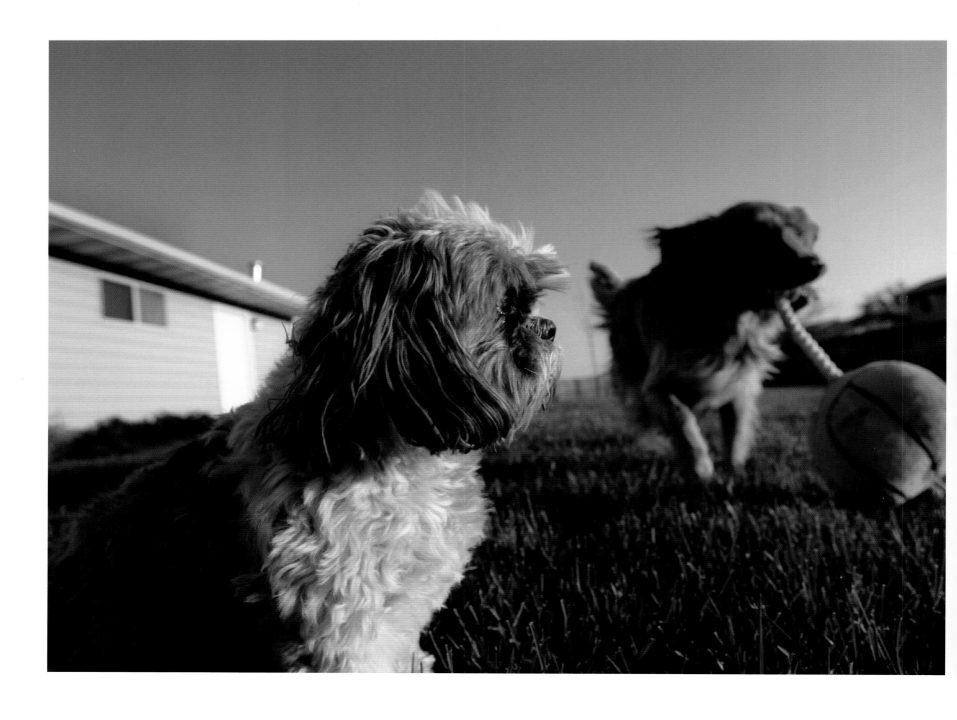

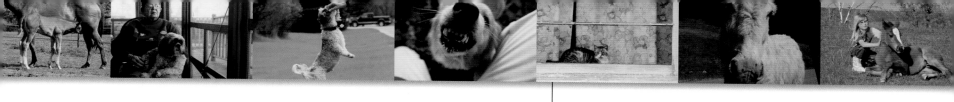

BUSHNELL
A domestic shorthair settles in for a nap on a south-facing windowsill, passing the time until the next meal is served.
Photo by Eric Landwehr

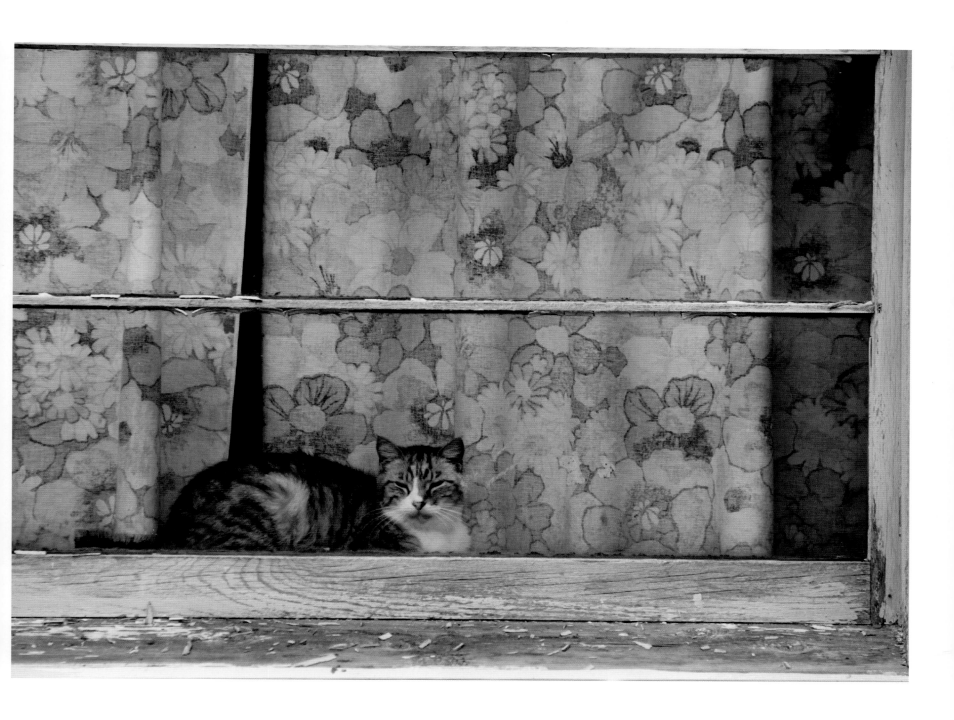

BUFFALO GAP

Anita "Shorty" Gallentine tends to 60 cattle and four buffalo on her 1,200-acre Black Hills ranch. The hale, independent 79-year-old spends her days mending fences and shoveling hay with occasional help from her Rapid City–based son. She's lived in Buffalo Gap her entire life—aside from a three-year stint in California during World War II when she worked in an aircraft factory.

Photo by Johnny Sundby,
Dakota Skies Photography

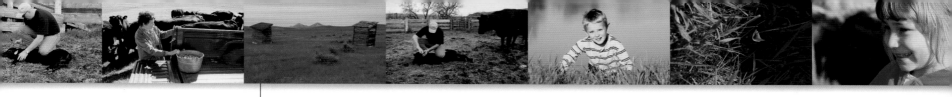

HOOVER

All that remains of the one-room Dakota Range school are two outhouses with a view of Deers Ears Buttes. Started in 1918, Dakota Range closed in 1971, when enrollment was down to just two students.

Photo by Markus Erk

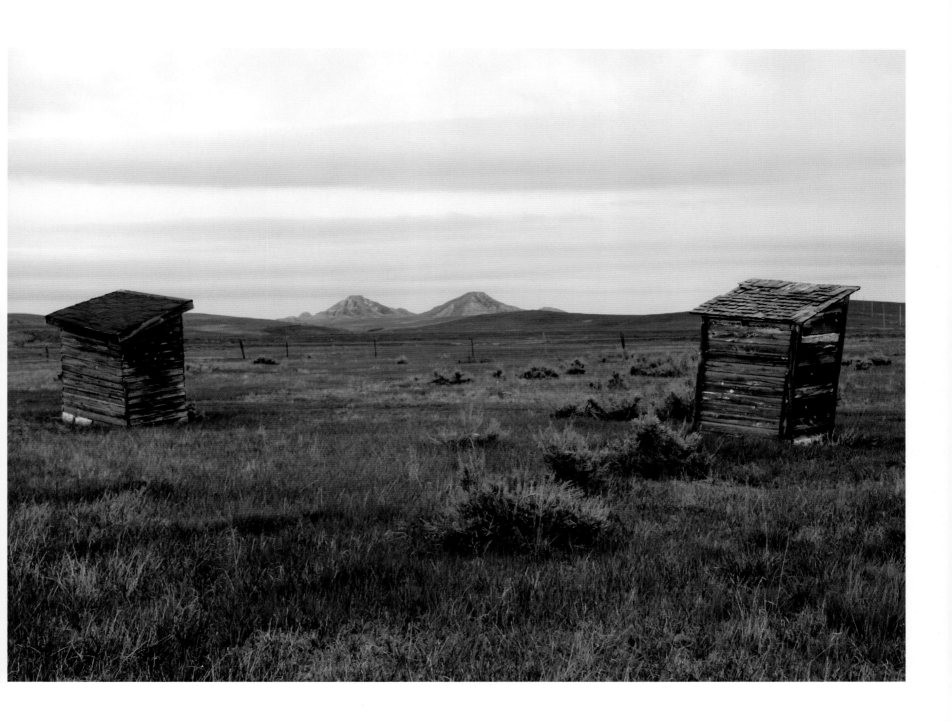

The year 2003 marked a turning point in the history of photography: It was the first year that digital cameras outsold film cameras. To celebrate this unprecedented sea change, the *America 24/7* project invited amateur photographers—along with students and professionals—to shoot and, via the Internet, submit digital images. Think of it as audience participation. Their visions of community are interspersed with the professional frames throughout this book. On the following four pages, however, we present a gallery produced exclusively by amateur photographers.

SIOUX FALLS Catch of the day: Jamie Spicer displays her first walleye of the year, caught from the family's new boat. At 5, Jamie considers herself a seasoned angler. *Photo by Chad Spicer*

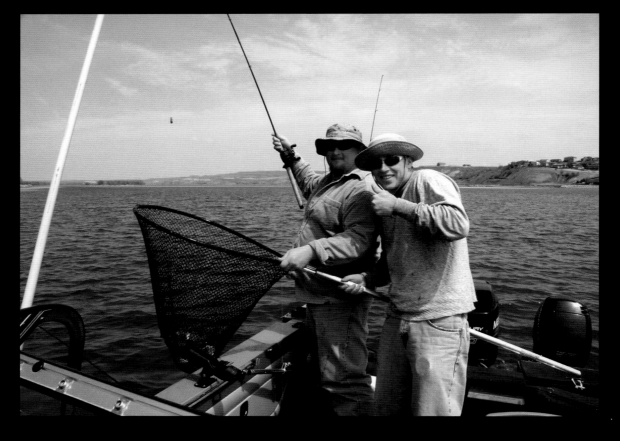

PIERRE Justin Mattson snags a walleye with a spincast reel on the Missouri River near the Oahe Dam. "Walleye are the best eatin' fish," says Mattson, who usually fly fishes in the Black Hills with pal Jeremy Barrett. *Photo by Dennes Barrett*

GETTYSBURG A joint birthday party at South Whitlock Resort gets a lot more fun when cake becomes ammunition in a food fight. Frosted birthday boy Dennes Barrett managed to land a shot on Tonya Burd.
Photo by Ted Williams

GETTYSBURG Tonya Burd gets peppered with cake as she lobs a piece back at Dennes Barrett. The Burd and Barrett families have been coming to their cabins at South Whitlock Resort for years. *Photo by Dennes Barrett*

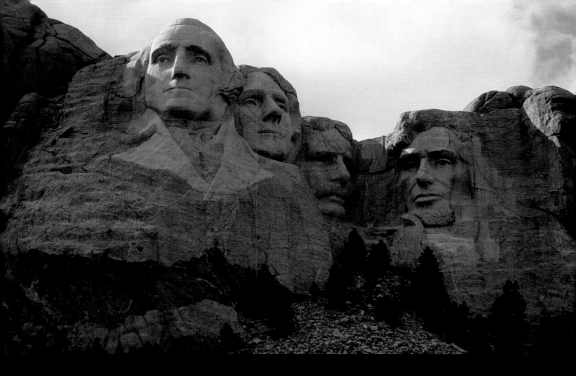

KEYSTONE Geologists estimate that Mount Rushmore's granite contours erode at a rate of one inch per year. At that pace, the visages of Washington, Jefferson, Roosevelt, and Lincoln should be discernable for another ;00,000 years. *Photo by Tom Russell*

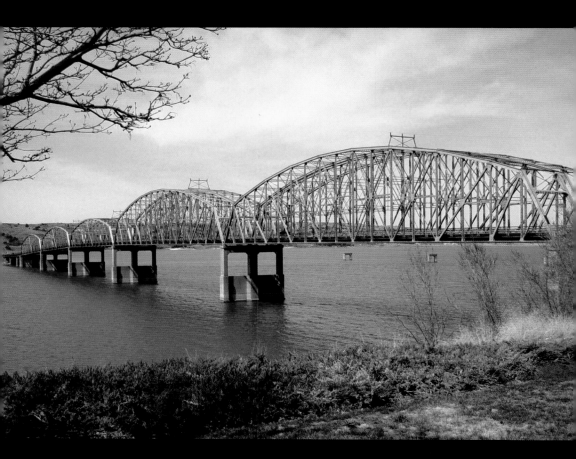

CHAMBERLAIN In the 1920s, five bridges were built in South Dakota to provide crossings for automobile traffic over the Missouri River. The Highway 16 Bridge, the last of the original spans still in use, connects Chamberlain

PIERRE Members of Destination ImagiNation, a problem-solving program for kids, chill out after their brain-teasing exercise in which they created a model of a roller coaster and then reconfigured it into a Ferris wheel.
Photo by Cody Coppess

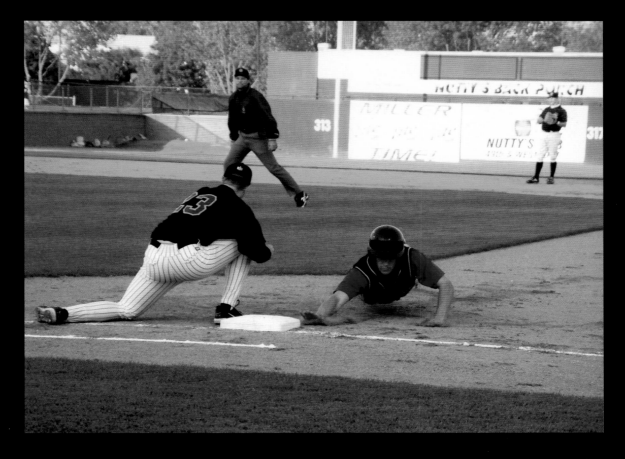

SIOUX FALLS A pick-off attempt comes too late in a Northern League exhibition game between the Sioux Falls Canaries and Kansas City T-Bones. The visitors won, 5 to 4. *Photo by Rob O'Keefe*

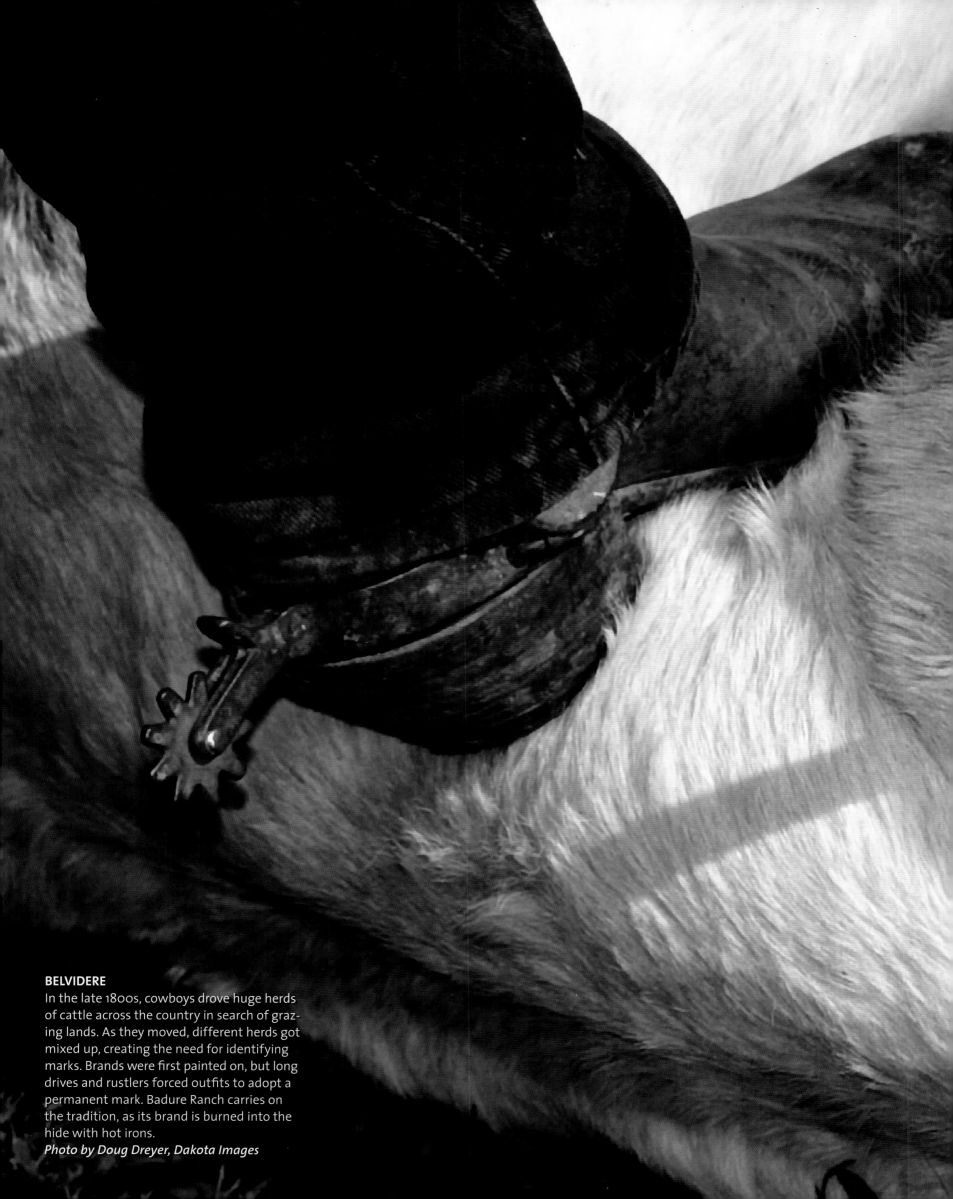

BELVIDERE

In the late 1800s, cowboys drove huge herds of cattle across the country in search of grazing lands. As they moved, different herds got mixed up, creating the need for identifying marks. Brands were first painted on, but long drives and rustlers forced outfits to adopt a permanent mark. Badure Ranch carries on the tradition, as its brand is burned into the hide with hot irons.
Photo by Doug Dreyer, Dakota Images

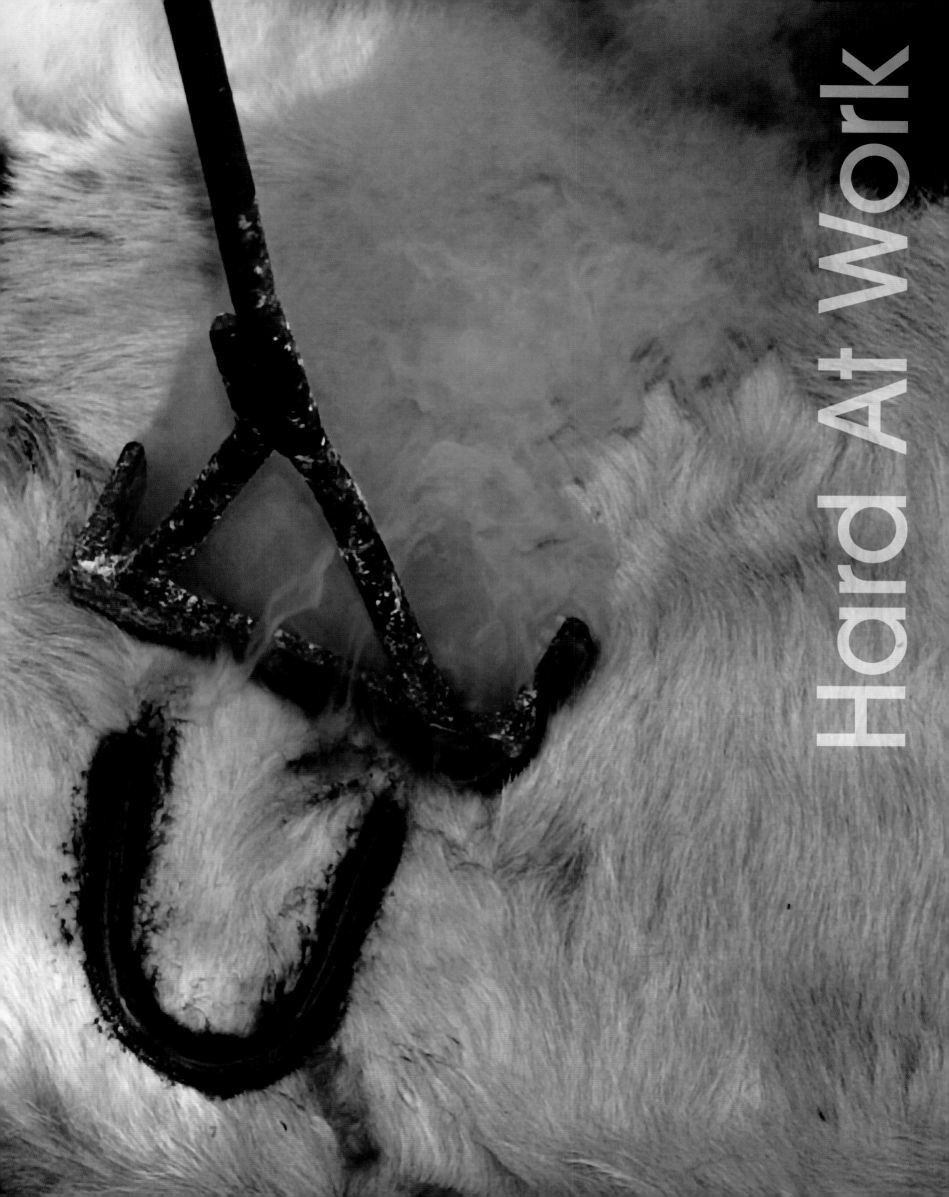

Hard At Work

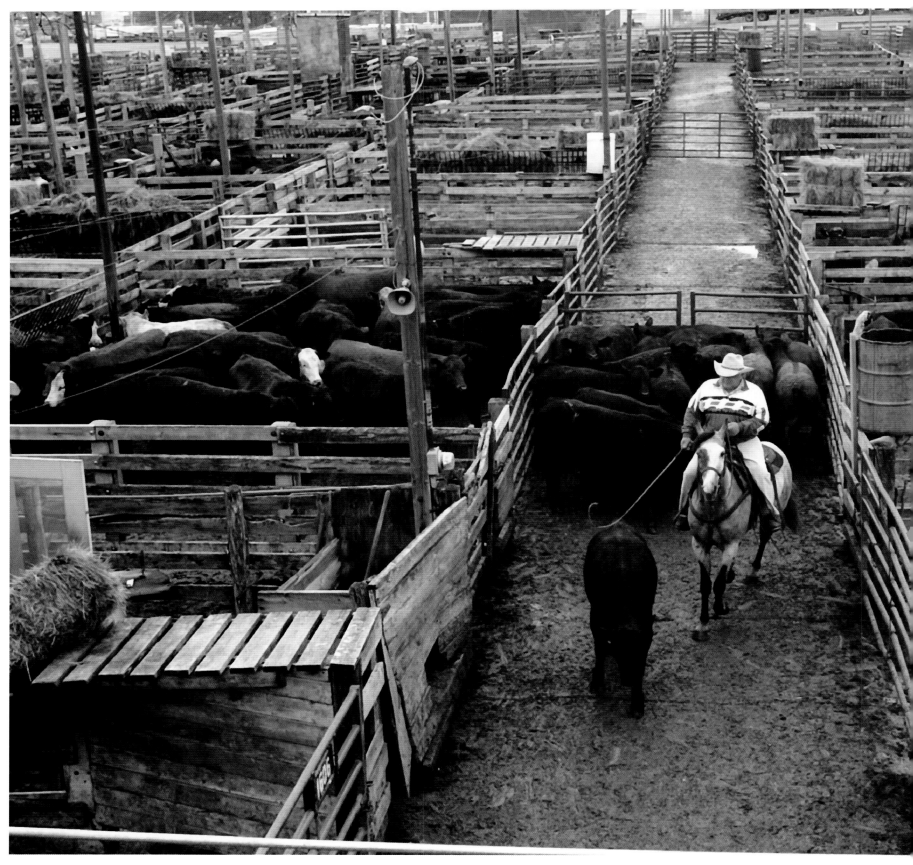

SIOUX FALLS

Sioux Falls Public Stockyards holds a livestock auction every Wednesday and Thursday. Ben Kringen begins those days by sorting cattle in pens—first by sex, then size, and finally weight. While everyone else sorts on foot, Kringen still does it the old-fashioned way, on horseback. "The cattle are easier to handle because horses calm them down," he says.

Photo by Lloyd B. Cunningham, The Argus Leader

BELVIDERE

After cowboys round up the cattle, they sort the cows from the calves. The calves are roped and brought to a team of two wrestlers, who hold down the calf while it gets a brand, vaccinations, and—in the case of bull calves—a castration. While the wrestlers release one calf, the roper catches another, and the process begins again.
Photo by Doug Dreyer, Dakota Images

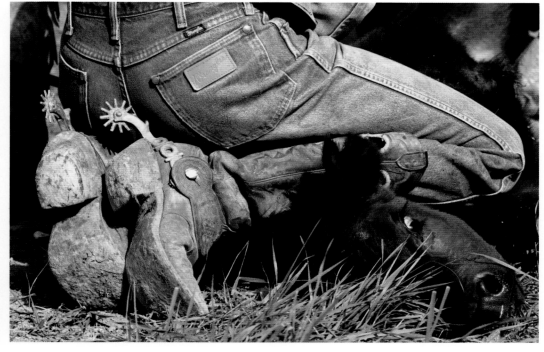

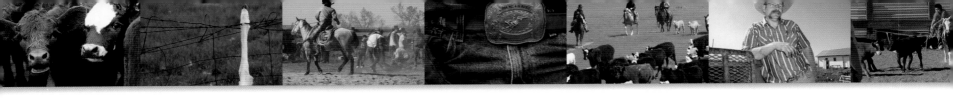

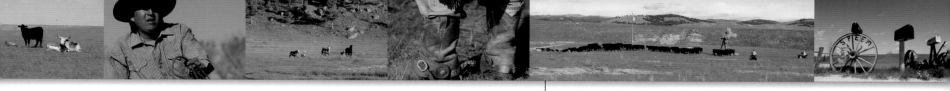

HERMOSA

Ranchers round up cattle on four-wheelers along an expanse of rolling prairie abutting the Black Hills. The all-terrain vehicle—rather than the quarter horse—is now the preferred mode of transport on Custer County's 476,498 acres of farm and ranch land.

Photo by Johnny Sundby,
Dakota Skies Photography

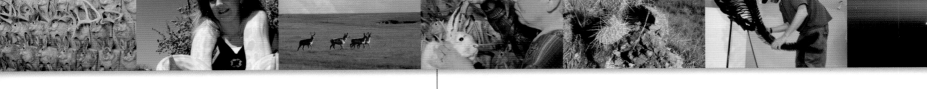

PIEDMONT

At the Jack-A-Lope Headquarters workshop, Brenda Pates installs white-tailed deer horns on stuffed jackrabbits. Pates and her husband Matt do a brisk business buying 5,500 jackrabbit skins a year, mounting them, and selling the critters for $75 a piece.
Photos by Markus Erk

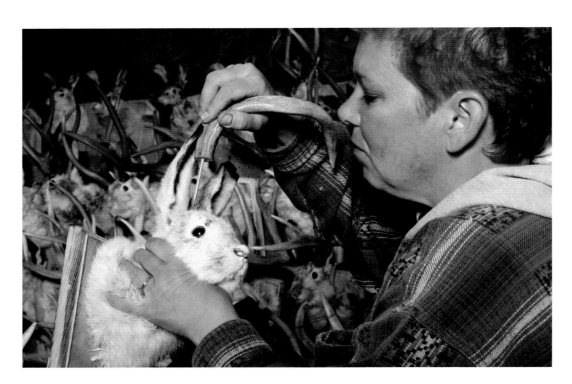

PIEDMONT

The myth of the horned hare predates the jack-alope legend of the Wild West by at least 500 years. Believers point to European and Asian depictions of the creatures, though sightings of diseased rabbits may be the source: In very wet years, rabbits sometimes develop a hornlike growth caused by the Shope papillomavirus.

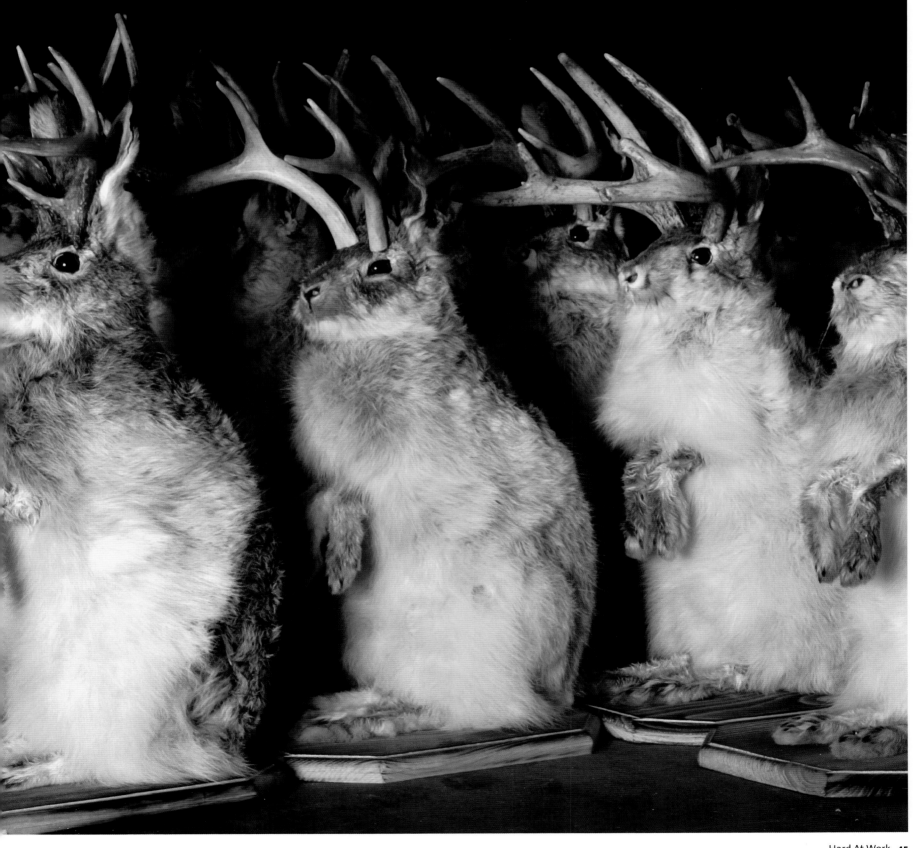

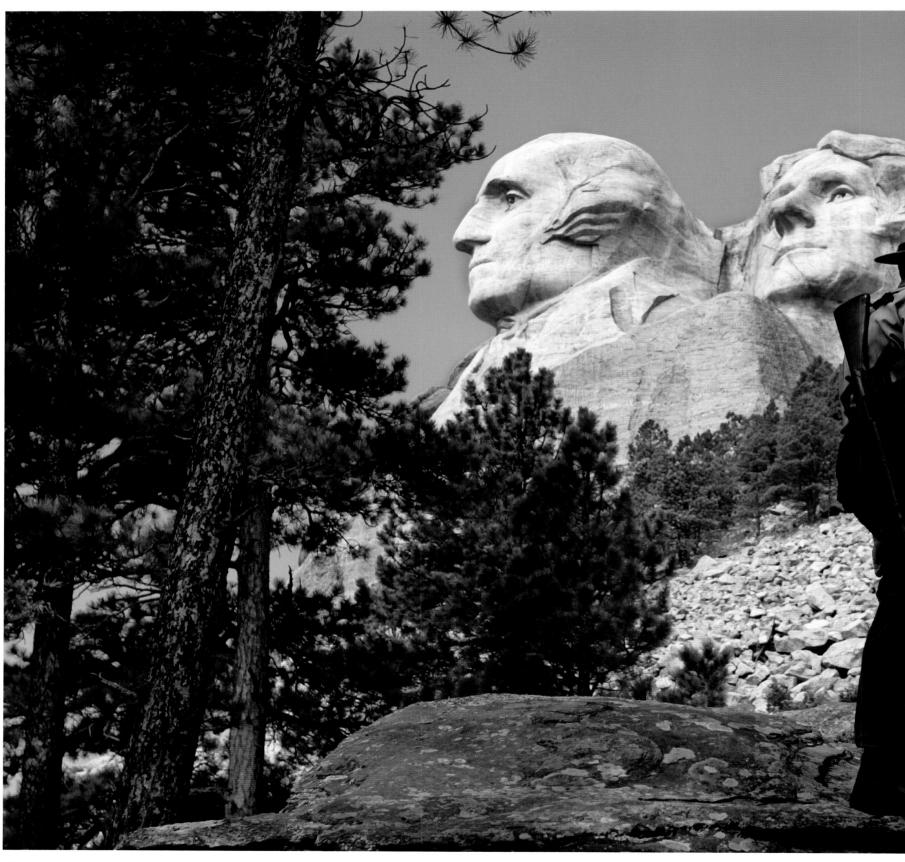

KEYSTONE

Mount Rushmore was conceived, in part, as a gimmick to lure tourists to an undervisited corner of the Great Plains. In 1923, state historian Doane Robinson noted that without a main attraction, "tourists soon get fed up with the scenery." Even today, few visitors stray from the viewing platform into the ponderosa pine and aspen forests of the surrounding Black Elk Wilderness.

Photos by Kevin Eilbeck

After 9/11, the Secretary of the Interior identified Mount Rushmore as one of five iconic monuments at especially high risk for terrorist attacks. In response, the National Park Service stepped up law enforcement training for its Mount Rushmore personnel. Ranger Eric Nelson practices a building sweep.

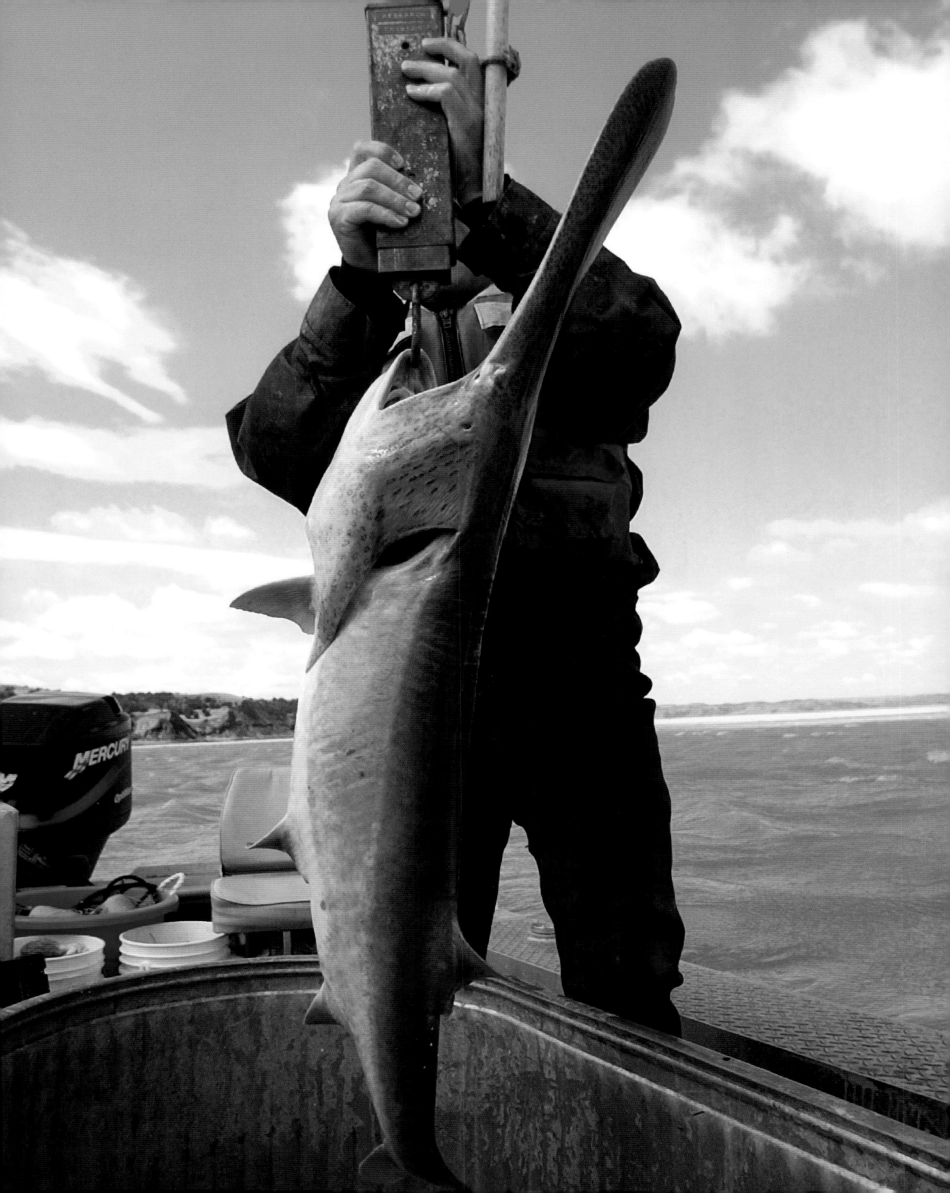

CHAMBERLAIN

After the Missouri River was dammed more than 50 years ago, sedimentation wreaked havoc on the breeding habitat of the prehistoric paddlefish. Since the mid-1980s, the South Dakota Department of Game, Fish and Parks has been catching them for artificial spawning programs. Collecting data, fisheries biologist Jason Sorensen weighs a fish with a spring scale.

Photos by Lloyd B. Cunningham, The Argus Leader

CHAMBERLAIN

Fisheries technician Jared Caba casts a gill net across the White River, a Missouri River tributary, to snare paddlefish. Each year, the Department of Game, Fish and Parks collects approximately six females and a dozen males for its paddlefish propagation efforts.

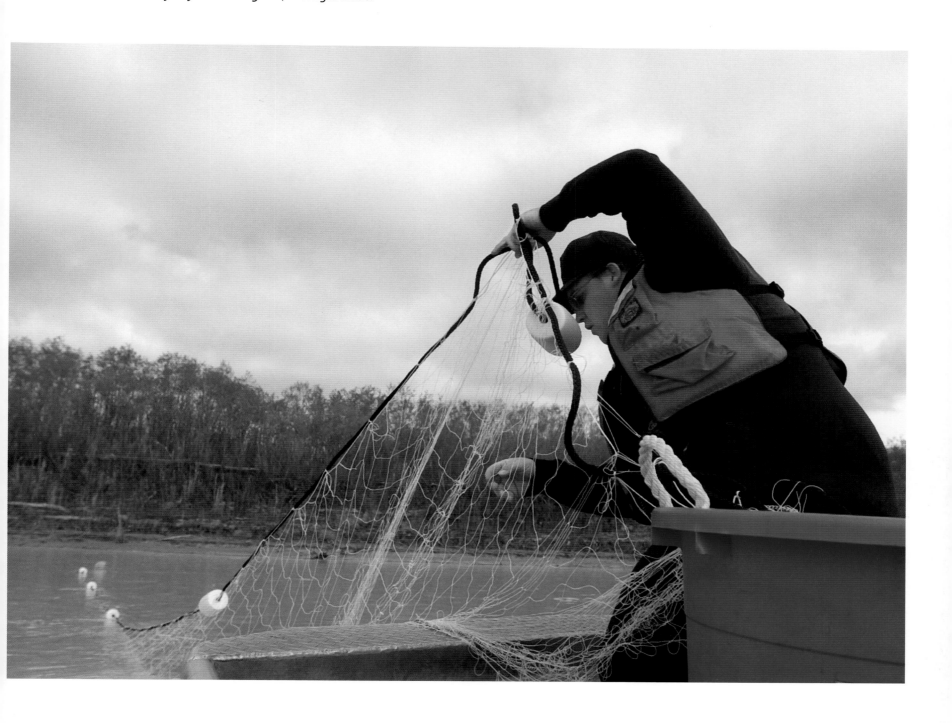

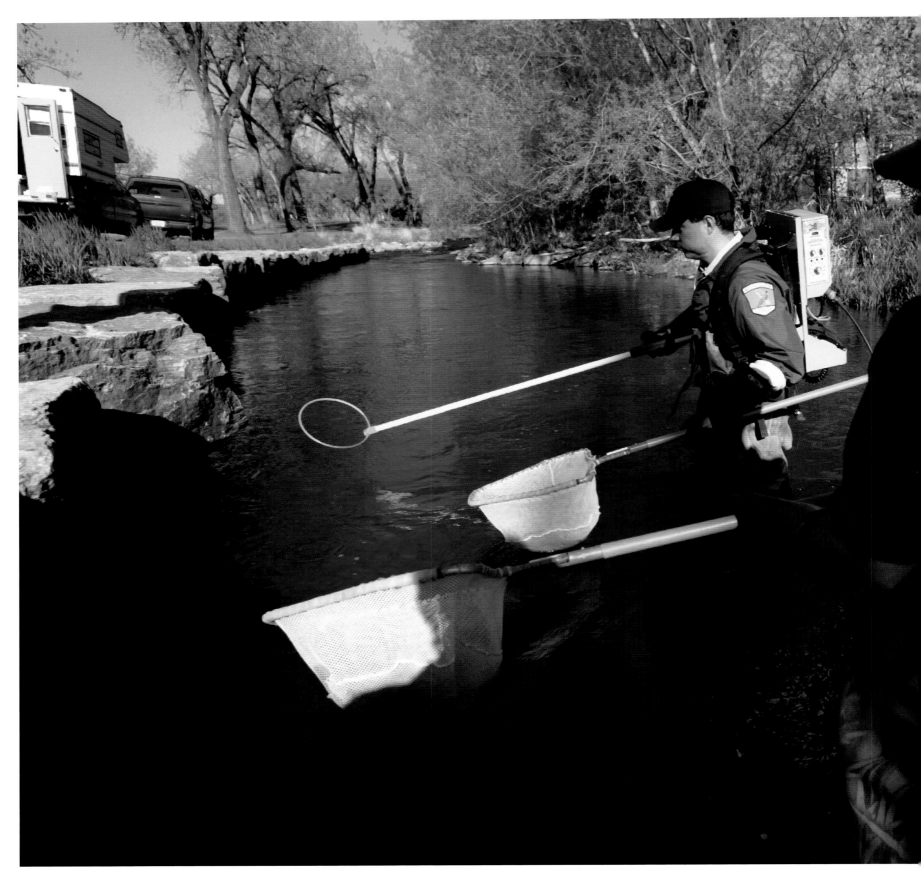

RAPID CITY

Rapid Creek descends from the Black Hills and wends its way through Rapid City's shopping malls, car dealerships, and subdivisions before continuing on to the Badlands. At this bend near downtown, Daniel James and John Laranger, researchers with the state's Department of Game, Fish and Parks, collect wild brown trout for a study on how urbanization has affected the creek's fisheries.

Photos by Kevin Eilbeck

RAPID CITY

Daniel James stuns brown trout, draws blood specimens, and then measures each fish's cortisol, or stress hormone, levels. The researchers hope the data will shed light on how brown trout have responded to storm runoff from Rapid City. "We're making sure we don't lose this fishery," says biologist Jack Erickson, director of the study.

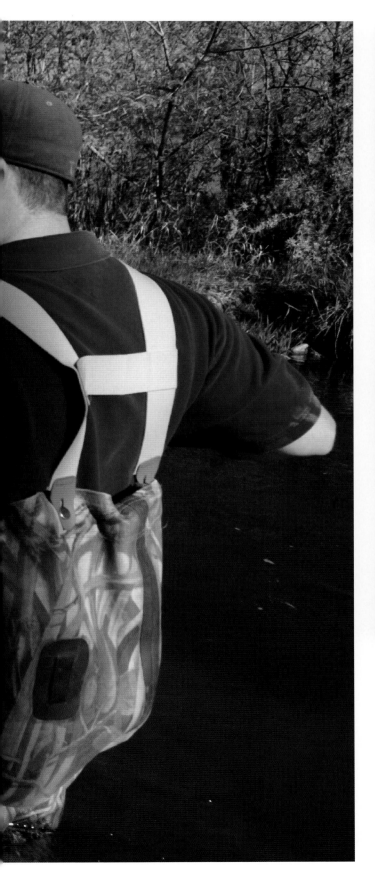

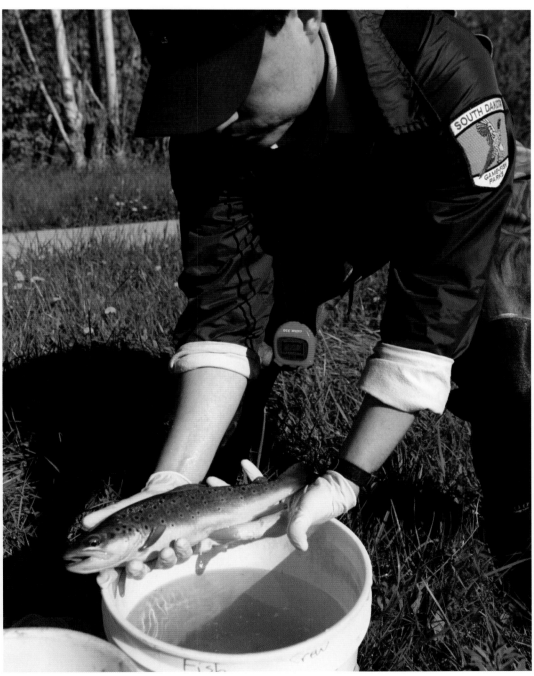

MEADE COUNTY

While much of the 1.2 million acres of forest in the Black Hills is protected for outdoor recreation, the timber industry is an important contributor to the local economy. It provides approximately 2,000 jobs and has an annual payroll of $40 million. The timber harvested by this feller buncher machine will eventually make its way to local mills for processing.
Photos by Steve Babbitt

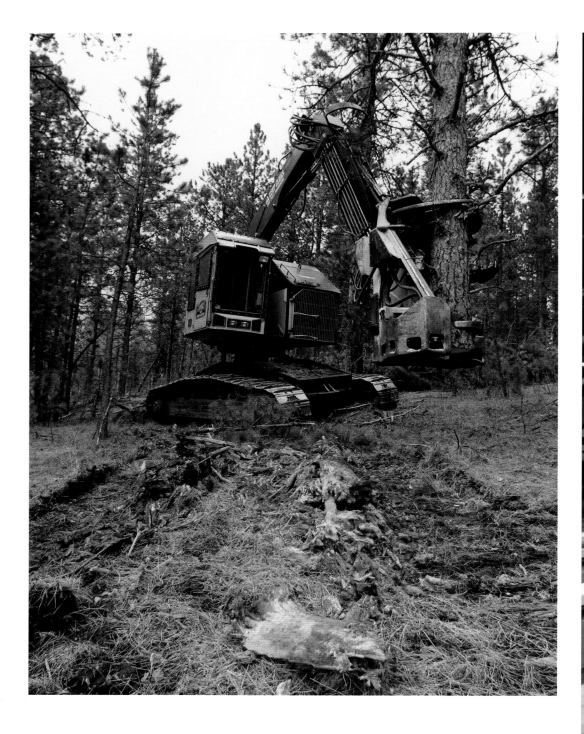

SPEARFISH

Lumber graders identify and mark boards of ponderosa pine as they emerge from the plane at Pope & Talbot. The 22-year-old sawmill processes timber harvested from the surrounding Black Hills of South Dakota and Wyoming, as well as parts of Montana and Nebraska.

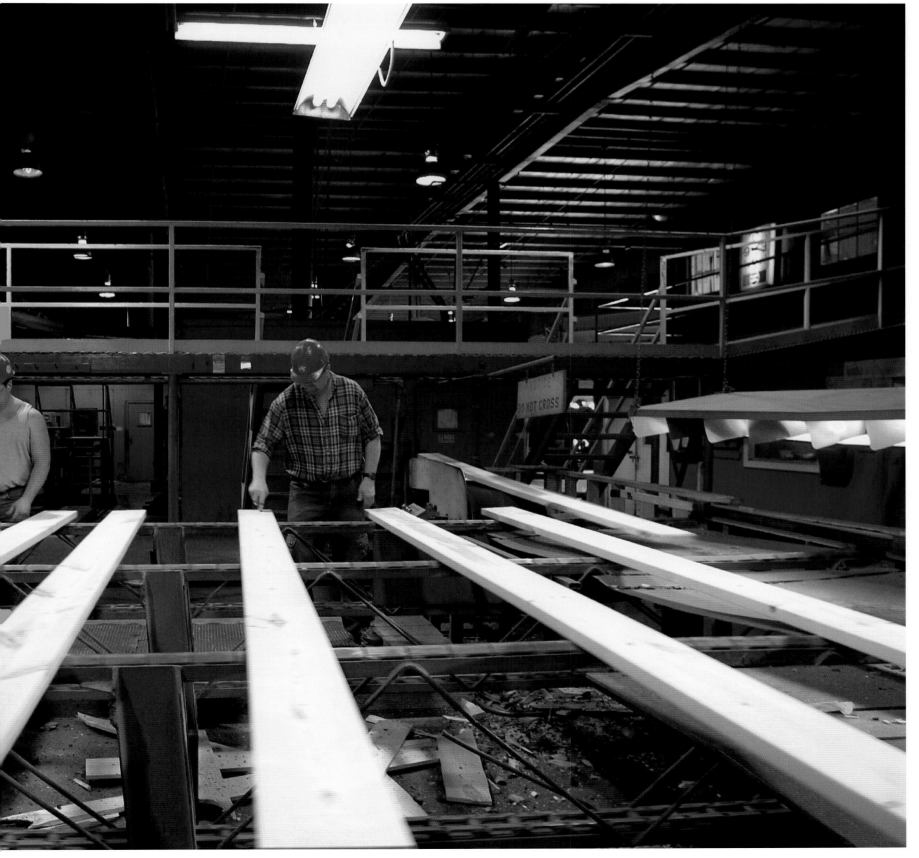

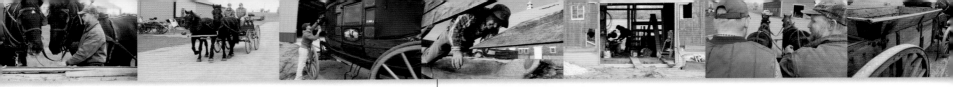

ARLINGTON
Ray Chamberlain straightens barns. At 77, he has
put more than 4,000 sagging barns back on square
and has others on his "a-kilter" list.
Photos by Greg Latza, peoplescapes.com

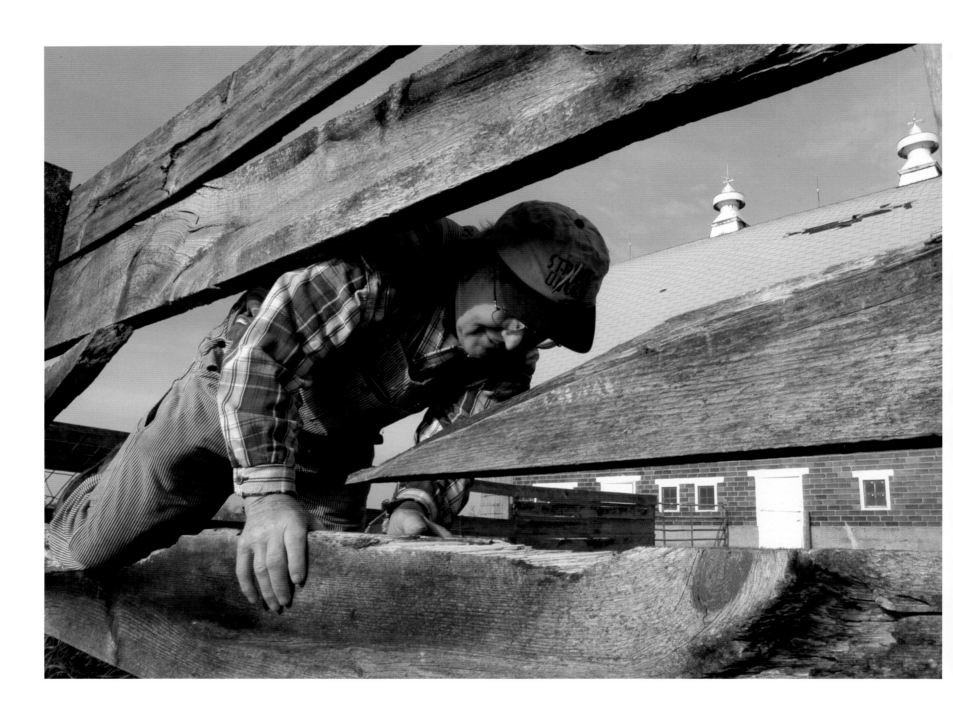

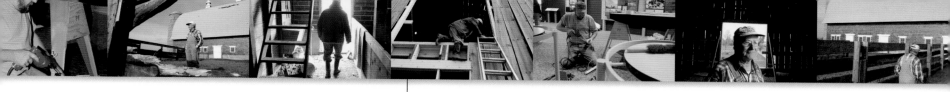

BROOKINGS

Using cables, pulleys, and levers, Chamberlain coaxes a leaning barn back to plumb, reinforcing it with carpentry. He's suffered eight broken ribs and two skull fractures when things didn't go as expected; recent injuries from a piece of falling concrete have him looking for an apprentice to take over.

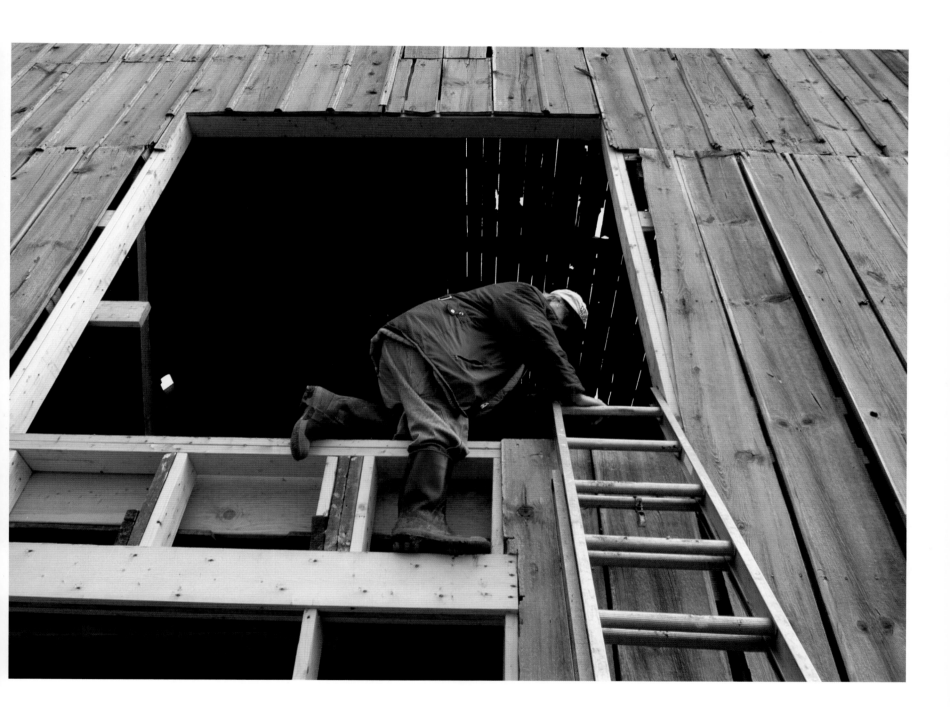

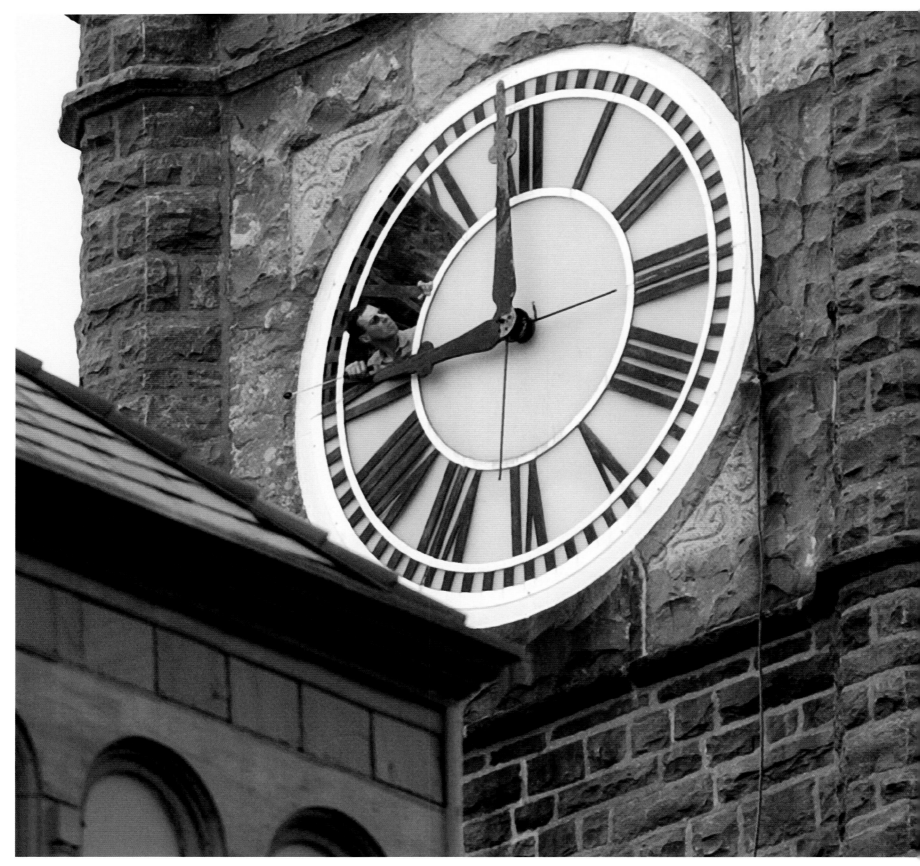

SIOUX FALLS

Face painting: One of the Old Courthouse Museum's four clocks just had its Roman numerals touched up. Richard Dodge, who was assisting the painter, catches his breath before replacing the panel. The clock tower was built in 1893, four years after construction of the original Minnehaha County Courthouse.

Photo by Lloyd B. Cunningham, The Argus Leader

SPEARFISH

During a two-week period, apprentice line workers Bryce Wright and Lee Myklebust must install 80 miles of new fiber-optic cable for Brink Electric of Rapid City. In order to accomplish that goal, the two will need to string cable to 11 of these towers each day.

Photo by Steve Babbitt

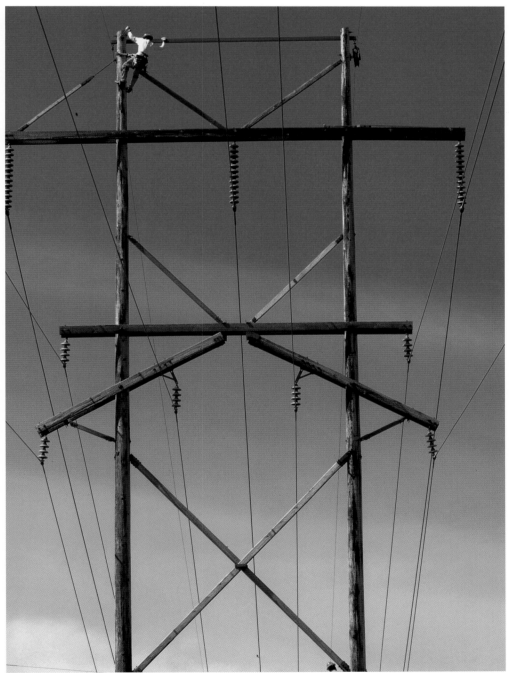

RAPID CITY
Volunteer Rochelle Marsland trains an abandoned white homing pigeon at the Wildlife Experiences bird rehabilitation center. The center rescues sick and injured birds, giving them a place to heal.
Photos by Markus Erk

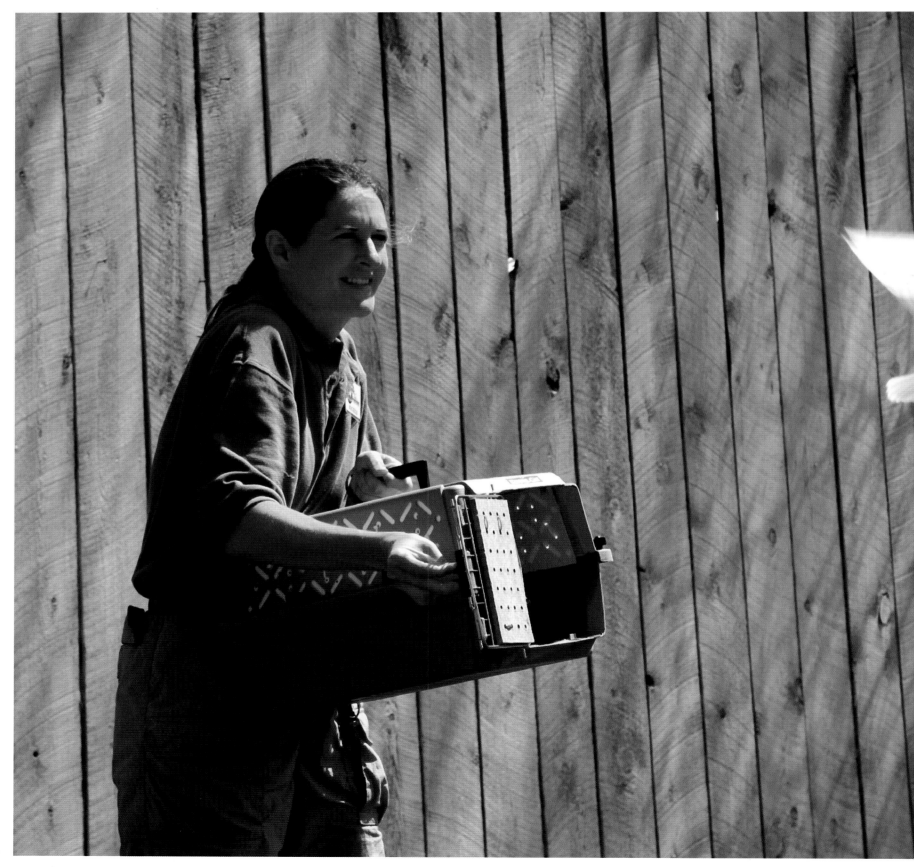

RAPID CITY

A badly broken wing landed a 5-year-old bald eagle at the bird rehab center. Too injured to be released, the bird, dubbed Wowicake, will live out its life at the center. Despite being federally protected, eagles are still shot, trapped, and poisoned, but 6,300 pairs now nest in the United States, up from 450 in 1960.

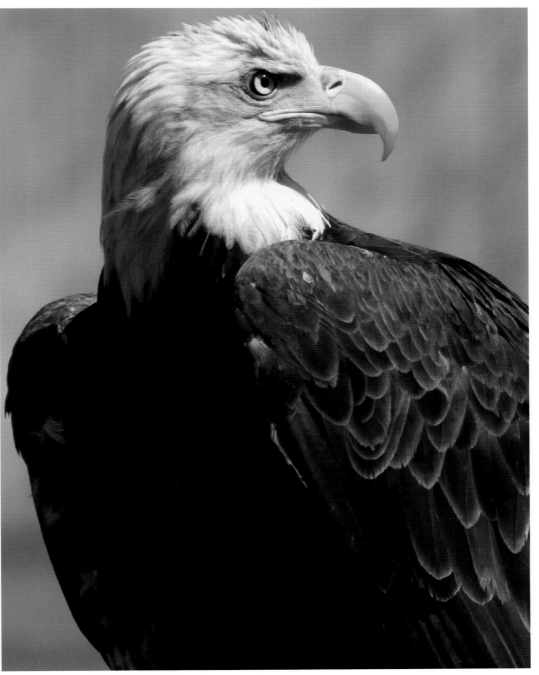

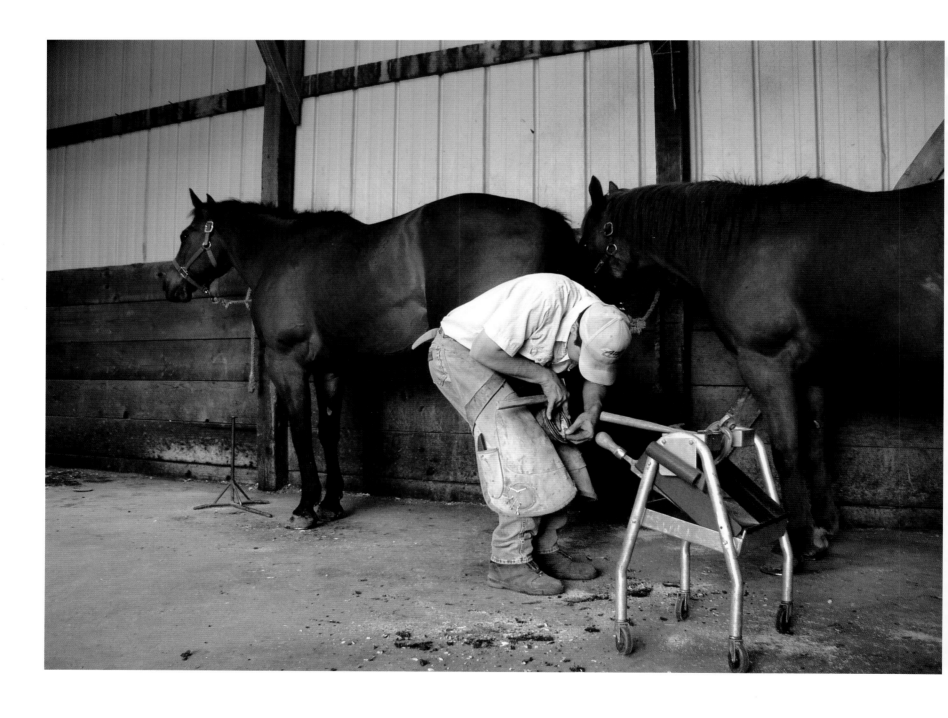

STURGIS

Farrier Trevor Ford's business is booming. He shoes six to eight horses a day—except during the annual Sturgis Motorcycle Rally in August, when 450,000 bikers descend on the city of 6,442. Then, it takes Ford two hours to drive three miles through crowd-packed streets to get to his shop. "I really hate that rally," he says.
Photos by Johnny Sundby,
Dakota Skies Photography

HERMOSA

Ninety percent of Ellen Ballard's customers, including Colleen Thompson (left), are women. "Horses get used to a female's touch, so they respond much better to a female farrier," says Ballard, who advertises her services strictly by word of mouth. Thompson lives in Rapid City but drives 20 miles to Hermosa for Ballard's services (price: $55 for four shoes).

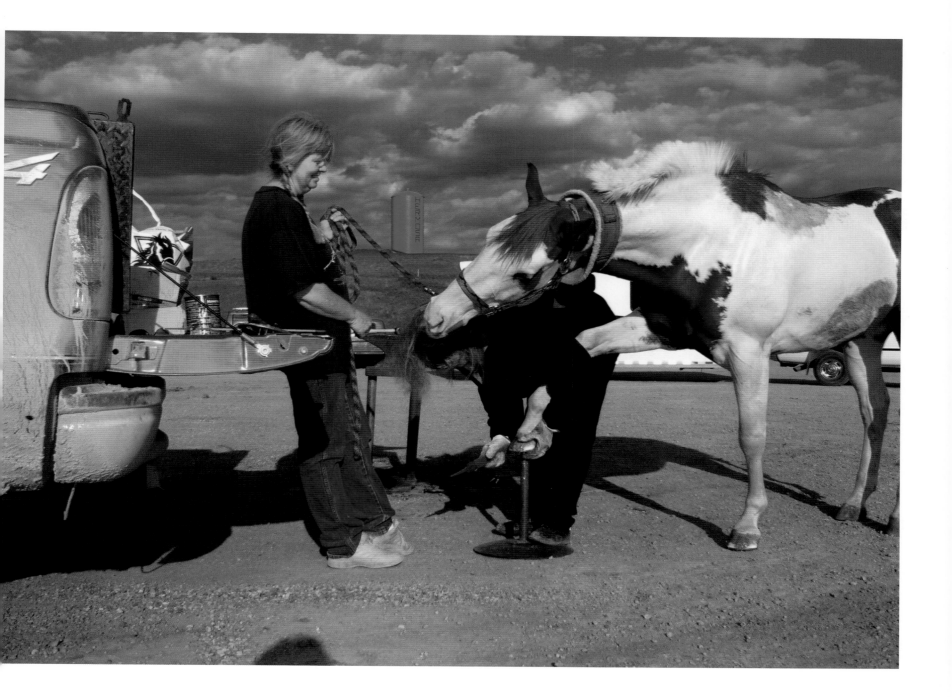

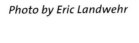

BROOKINGS
"There's no such thing as dog breath," says Stacy Husman. "It's just a sign of poor oral hygiene." The vet technician performs routine dog and cat teeth cleaning at the Gentle Doctor Animal Hospital where she polishes pet smiles with three toothpaste flavors: beef, poultry, and seafood.
Photo by Eric Landwehr

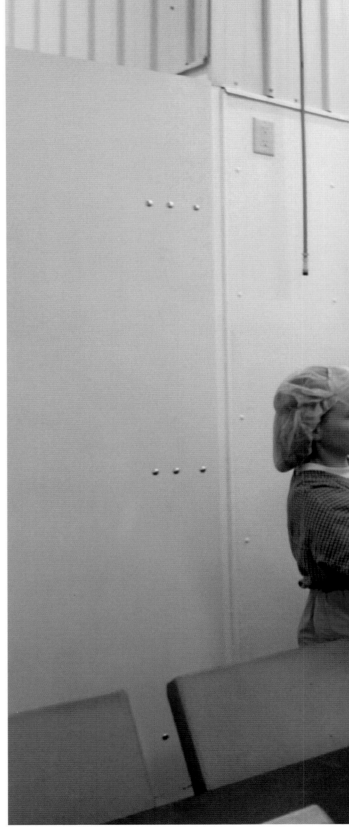

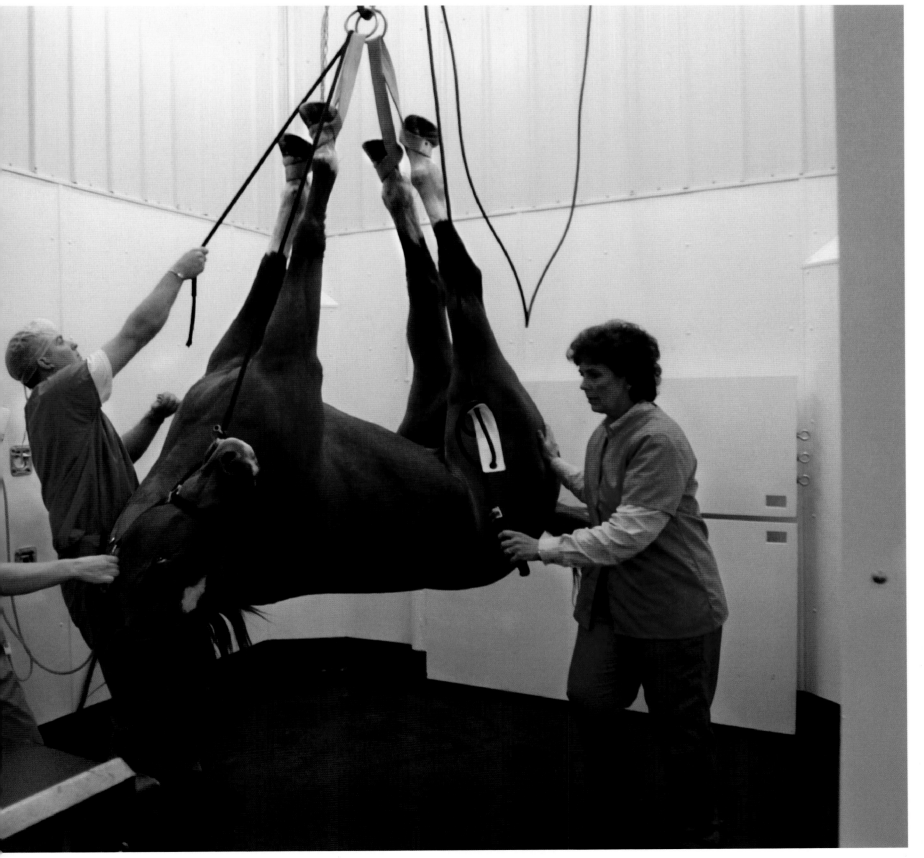

STURGIS

Vet techs Cindy Pleinis and Travis Clark and anesthesiologist Bonnie Ismay prepare a quarter horse for arthroscopic knee surgery at the Sturgis Veterinary Hospital and Equine Center. The procedure, performed by Bonnie's husband Dr. John Ismay, removes bone chips and requires a two-month recovery period. Bone chips are often caused by a horse hyperextending its knee during competitions.

Photo by Steven McEnroe

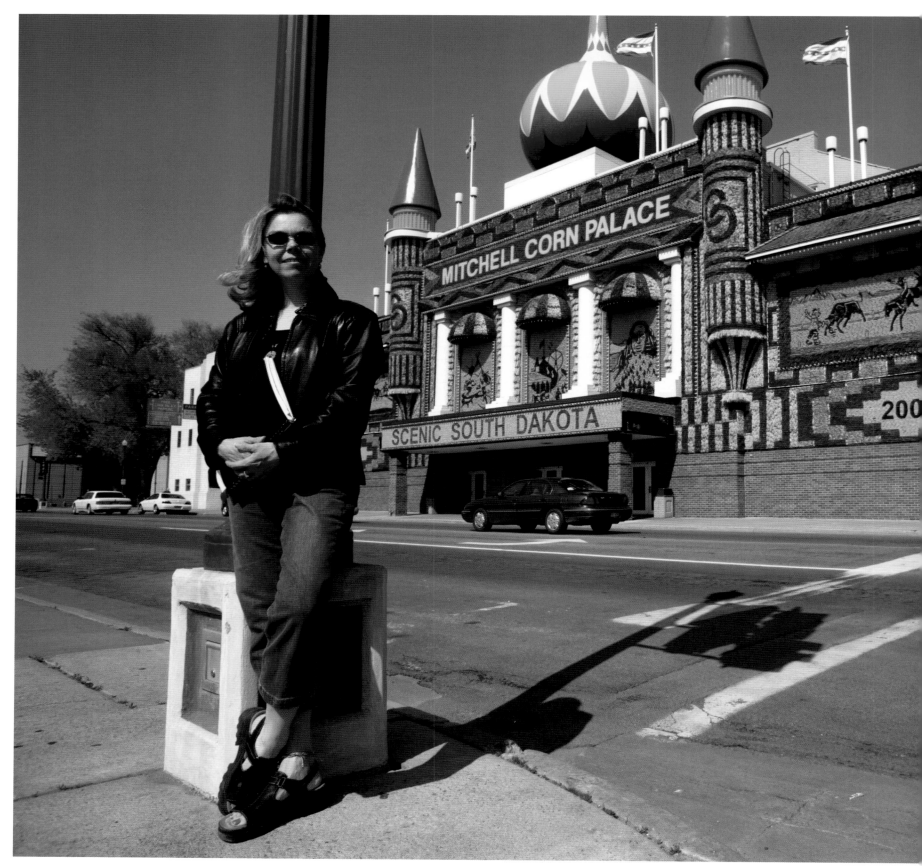

MITCHELL
The city spends $130,000 annually to decorate the exterior of the Corn Palace with murals made of—you guessed it—colored corn. In three months, the process will begin again. The current murals will be stripped off and replaced with a new motif from artist Cherie Ramsdell, the first woman hired to devise a design.
Photos by Dave Sietsema

MITCHELL

Since 1892, murals have adorned the Mitchell Corn Palace. Cherie Ramsdell's sketches will be brought to life with many colors of corn.

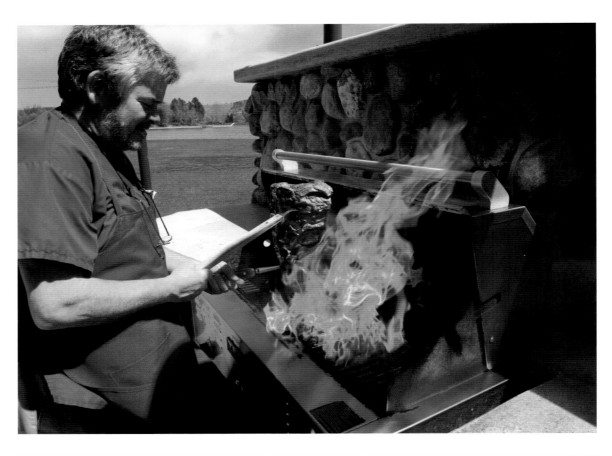

RAPID CITY

At an outdoor grill at the Chop House Restaurant, chef Steve Ramsdell fires one of the five ribeye loins he cooks every night; each serves about 15 people. Ramsdell, who's been a chef for 27 years and specializes in meats (although he boasts of his vegetarian kabobs) prepares everything from scratch, including béarnaise sauce. "I'm old fashioned," he says.
Photo by Mike Wolforth

BUSHNELL

Dave Huebner has lived in Florida, Hawaii, and California but chose to settle down in South Dakota. In 1972 he opened a pottery business in Bushnell (pop. 80), where he makes reproductions of historical pieces for festivals and gift shops. It all made sense when, years after moving here, he learned that his great-grandfather once ran Bushnell's general store just down the street.
Photo by Eric Landwehr

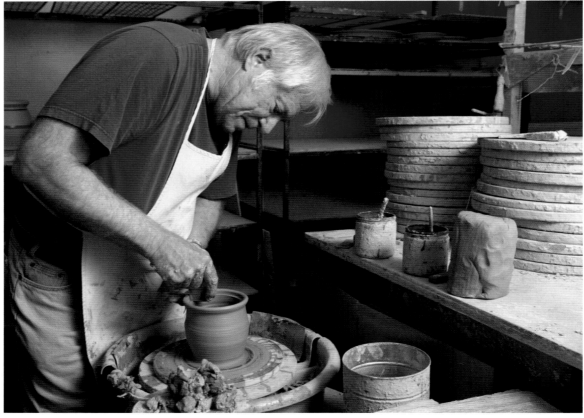

MITCHELL

Blacksmith Joel Westberg forges hot iron into wagon hooks for the antique wagons restored by Hansen Wheel & Wagon Shop and for those the company creates from scratch. The 25-year-old company also builds stagecoaches. One client is Wells Fargo Bank, which uses the coaches in commercials, parades, and promotions.
Photo by Dave Sietsema

FORT PIERRE

For nearly three decades, Dave Dahl has been making saddles for professional bronc riders. He's doing something right. Both the 2001 and 2002 world saddle bronc riding champions, Tom Reeves and Glen O'Neil, rode with Dahl's creations, which he makes with up to two cowhides.
Photo by Dave Sietsema

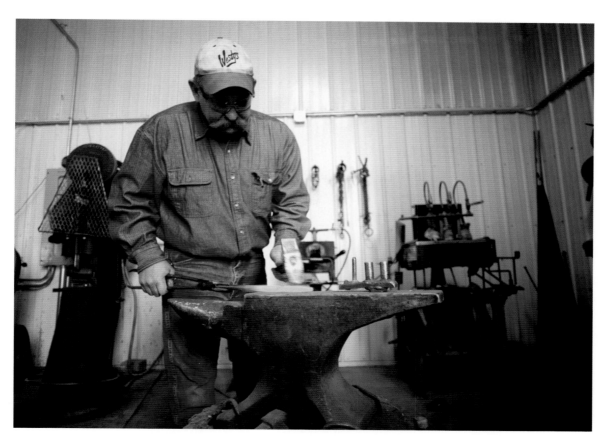

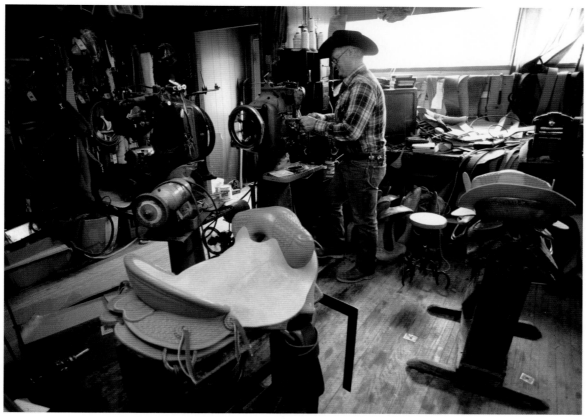

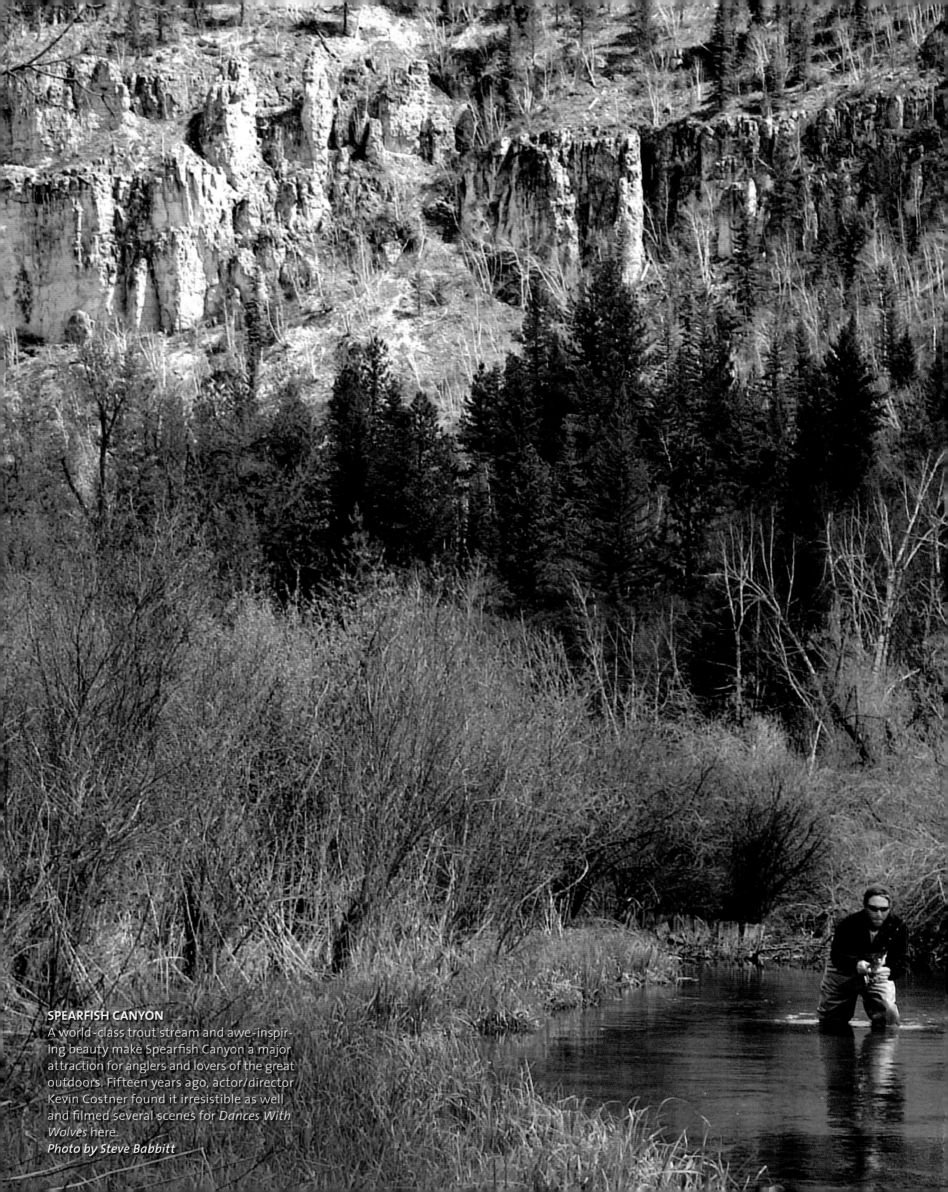

SPEARFISH CANYON
A world-class trout stream and awe-inspiring beauty make Spearfish Canyon a major attraction for anglers and lovers of the great outdoors. Fifteen years ago, actor/director Kevin Costner found it irresistible as well and filmed several scenes for *Dances With Wolves* here.
Photo by Steve Babbitt

South Dakota At Play

DUPREE

Maybe Kash Deal can capitalize on his name in the rodeo world. Sibling Kella came first, followed by Kaden and Kesse. It was only natural that the youngest Deal child would have a name that began with K. But Kash Deal? "The two just go together," says dad Sean.
Photo by Val Hoeppner

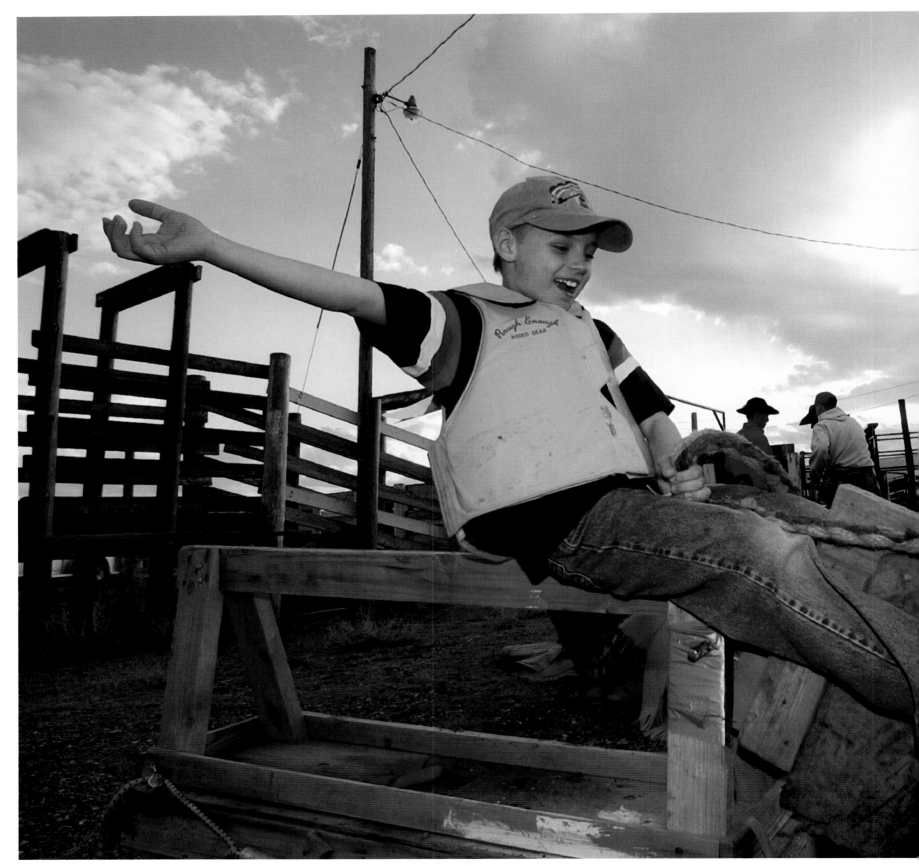

MARTIN

Cattle call: Layne Livermont and Cody Porch warm up before they start roping calves for branding at the ranch belonging to Layne's family.

Photo by Dave Sietsema

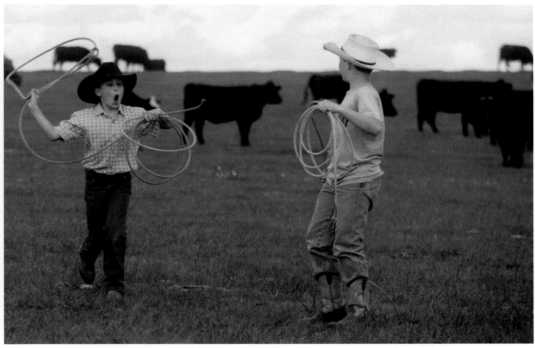

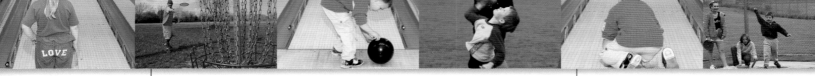

RAPID CITY

Disc golf, invented about 25 years ago by the man who reengineered the Frisbee, is catching on in South Dakota. The state now has 13 courses. Michael Brouillette putts on the first hole.
Photo by Mike Wolforth

BROOKINGS

Lanesplitter Tommy Kasper wills his ball toward the kingpin. The 4-year-old's bowl could have been disqualified because he crossed the foul line, but his Brookings Head Start Preschool classmates overlooked the transgression.
Photo by Eric Landwehr

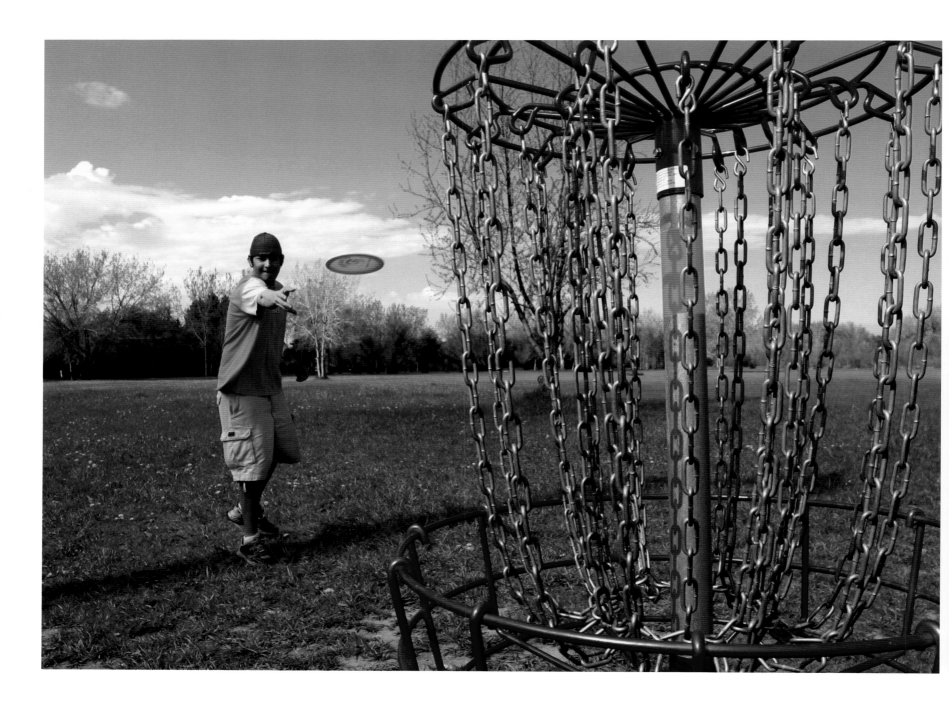

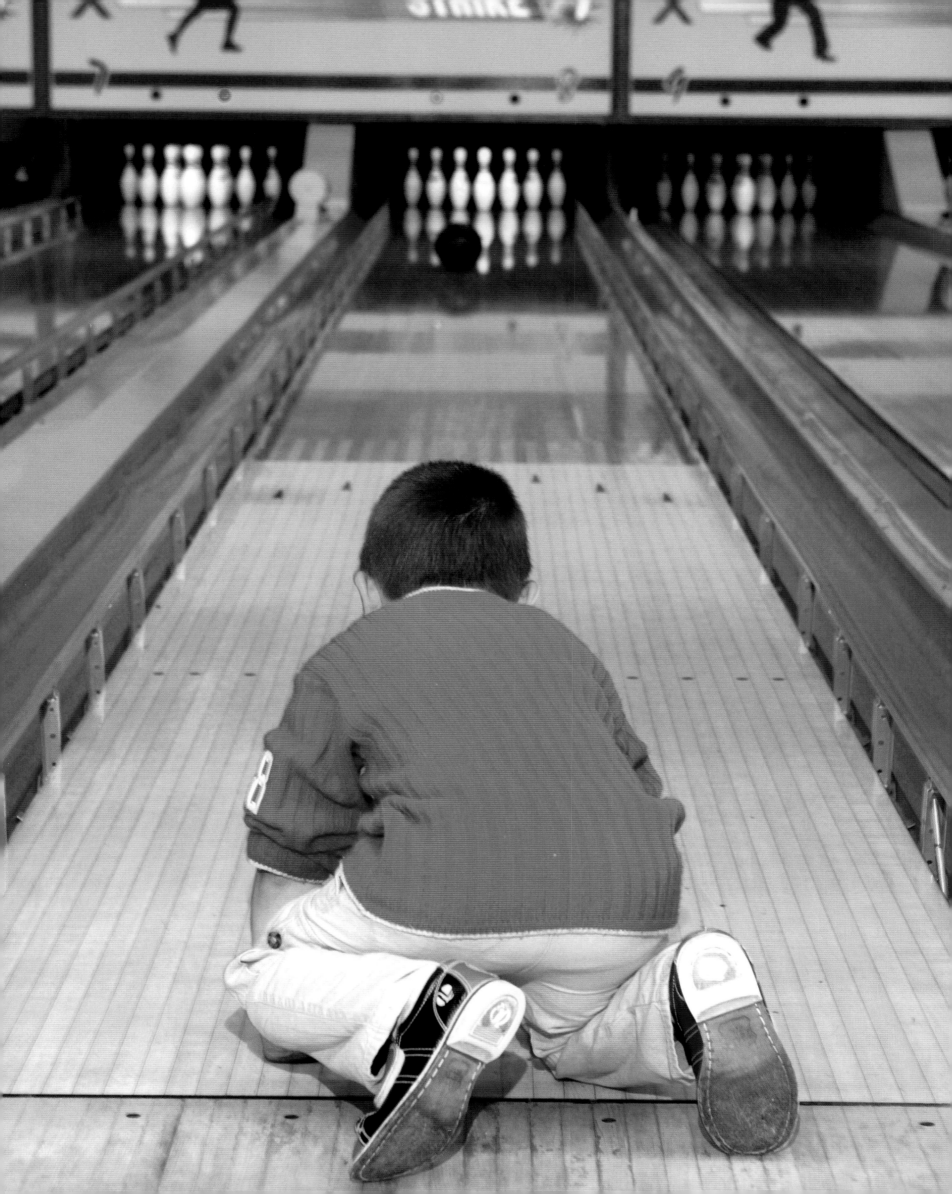

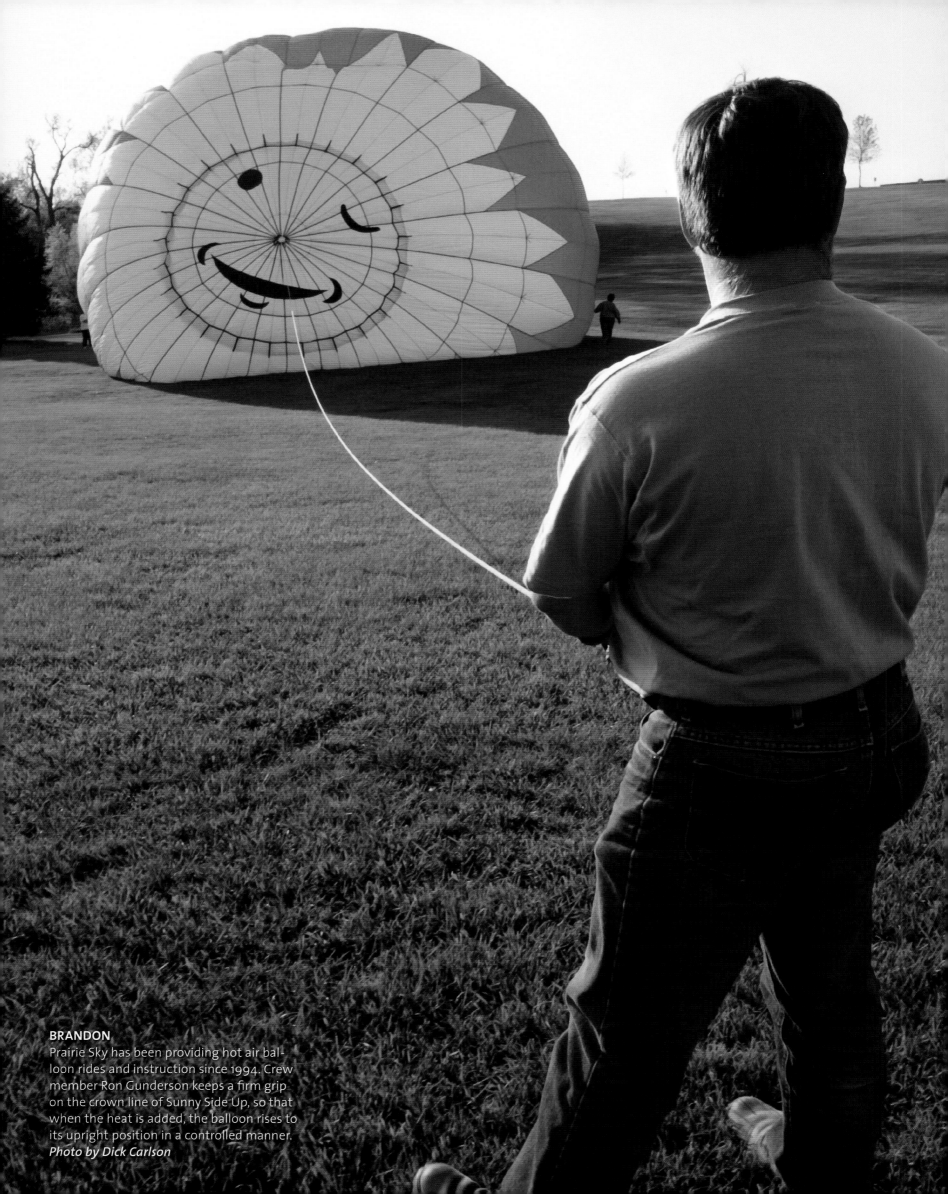

BRANDON
Prairie Sky has been providing hot air balloon rides and instruction since 1994. Crew member Ron Gunderson keeps a firm grip on the crown line of Sunny Side Up, so that when the heat is added, the balloon rises to its upright position in a controlled manner.
Photo by Dick Carlson

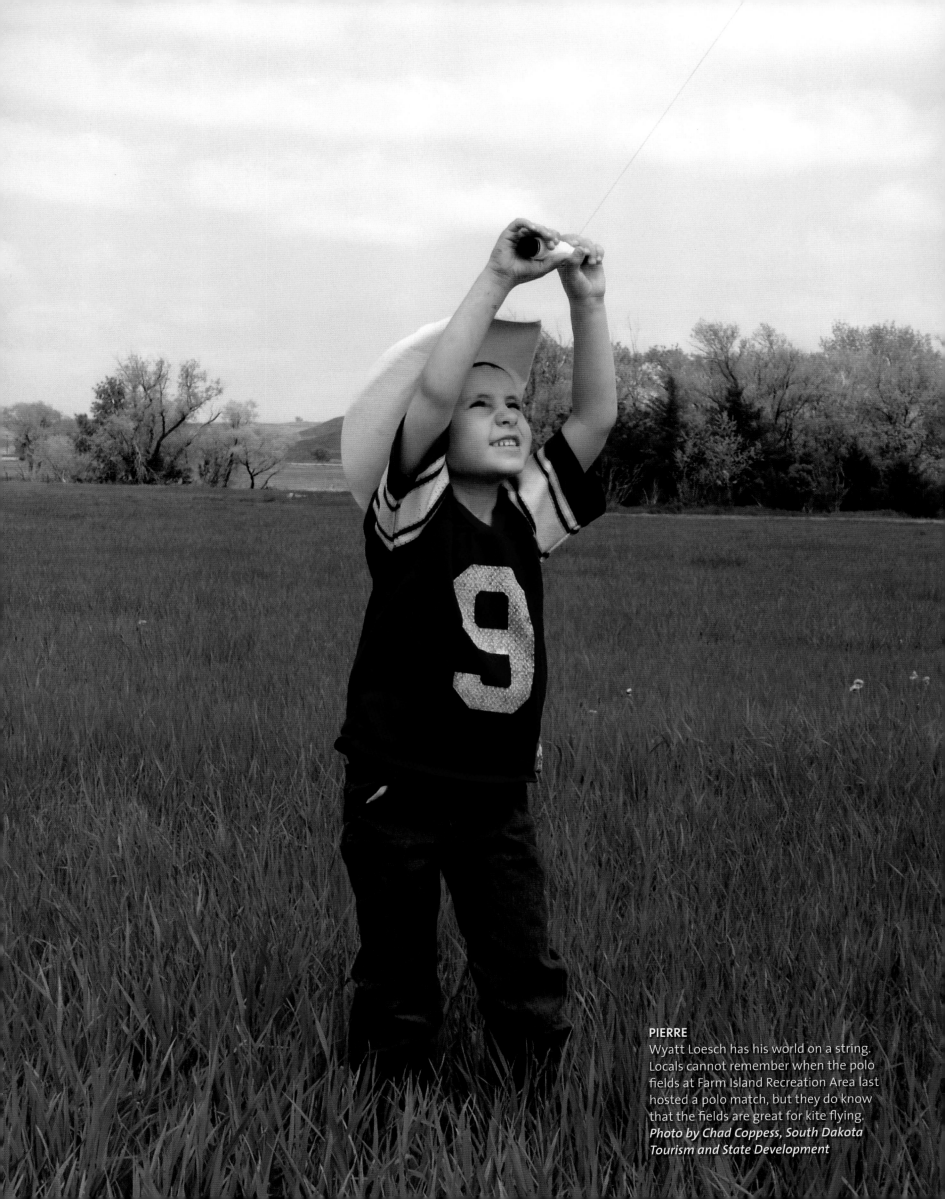

PIERRE
Wyatt Loesch has his world on a string.
Locals cannot remember when the polo
fields at Farm Island Recreation Area last
hosted a polo match, but they do know
that the fields are great for kite flying.
Photo by Chad Coppess, South Dakota
Tourism and State Development

BELLE FOURCHE
Flight instructor Ernie Clark soars above the Belle Fourche River in his Flightstar II ultralight. Making safe landings and handling emergencies are the heart of his teaching philosophy. "Ninety percent of all accidents occur because of poor judgment, not mechanical trouble," says the former Navy air crewman.
Photos by Steve Babbitt

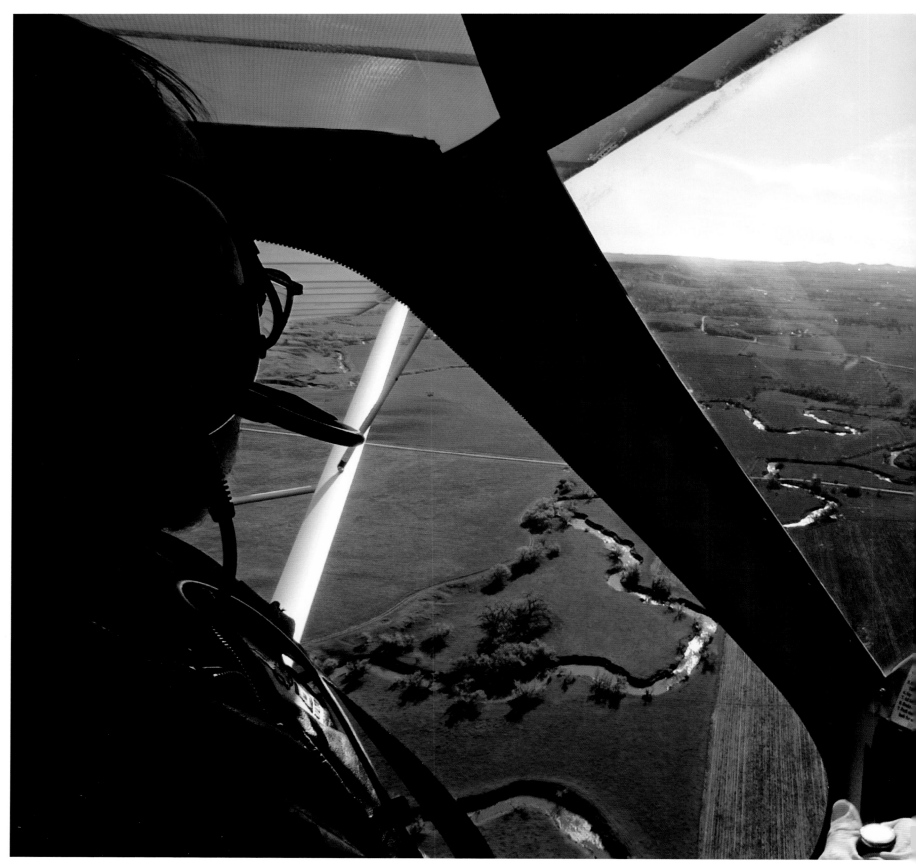

BELLE FOURCHE

Before he began giving flying lessons, Clark worked as a gold miner. He earned the nickname "Easy" for his uncanny ability to always find the easy way to do his work. His nickname lives on in his company's moniker: Ultralight and Easy.

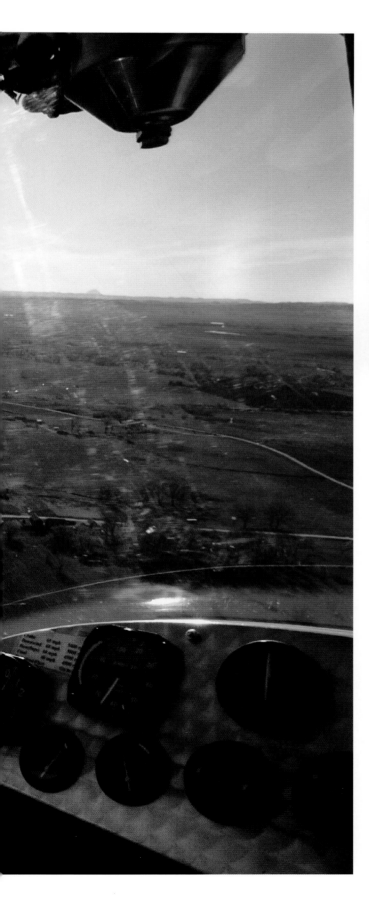

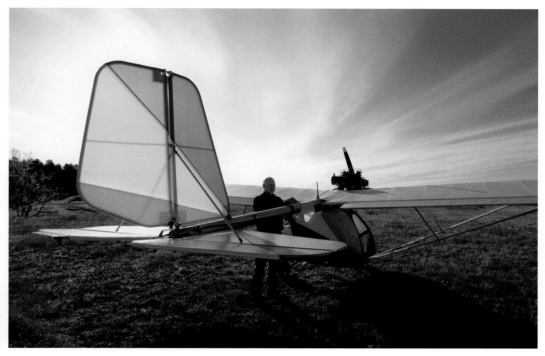

STONEVILLE
Second-grader Meagan Baker gets into the swing
of recess at Stoneville Country School, where
overcrowding is not an issue. Meagan is one of
eight students in the 91-year-old K–8 facility. The
trailer to the right of the school is available as
housing for any teacher who needs it.
Photo by Val Hoeppner

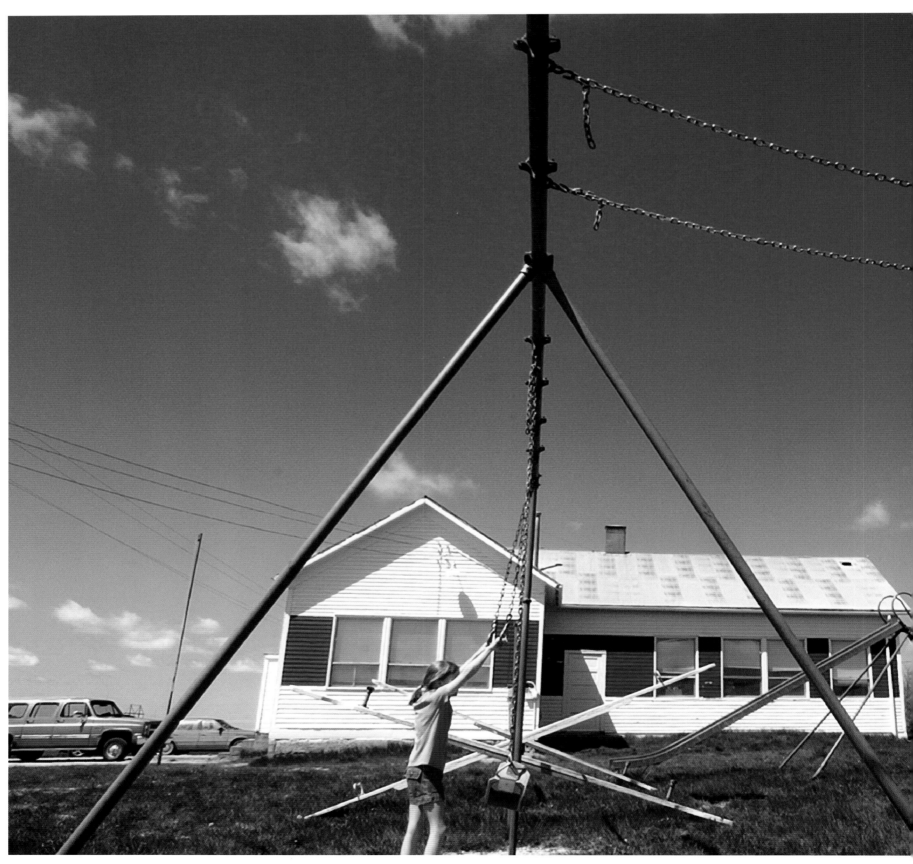

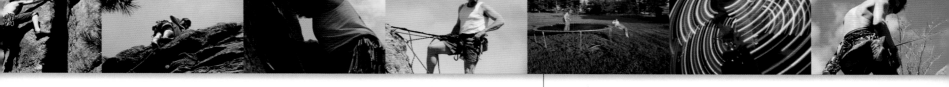

BLACK HAWK
In the backyard of the Wolforth home outside Rapid City, the Michelle and Webster show is about to begin. Webster, an Old English sheepdog, is known for his jump-and-slide routine.
Photo by Mike Wolforth

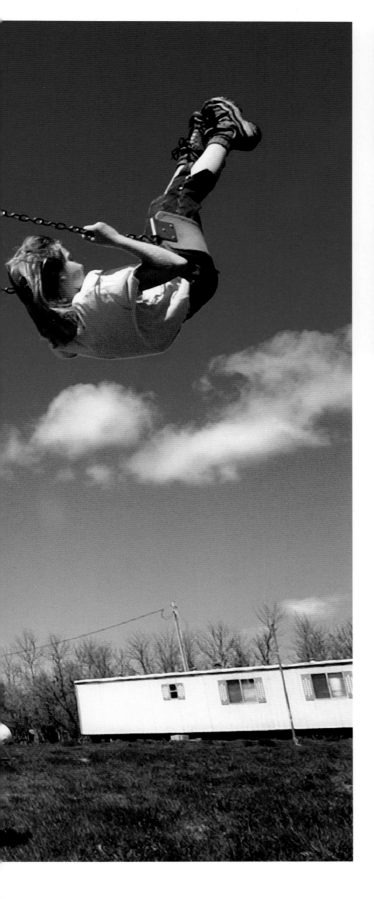

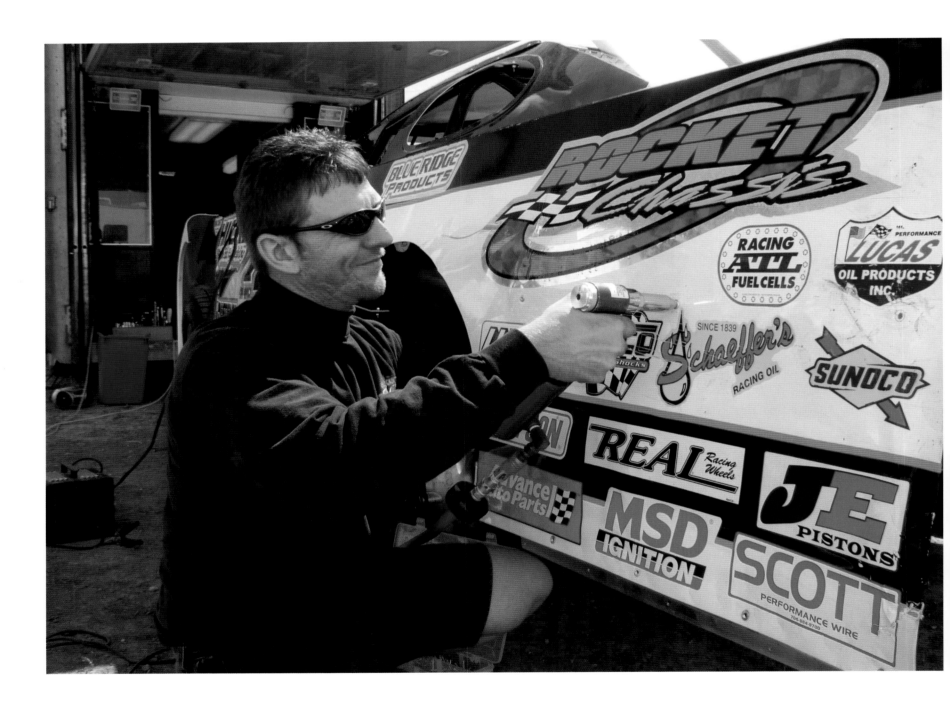

RAPID CITY
Rich Fouty makes some midrace adjustments to a late model race car at the Black Hills Speedway, which bills itself as the place "where the big boys make noise." Fouty came to Rapid City from Georgia to crew for the Extreme Dirt Series Race on the Speedway's semibanked dirt tracks.
Photo by Johnny Sundby,
Dakota Skies Photography

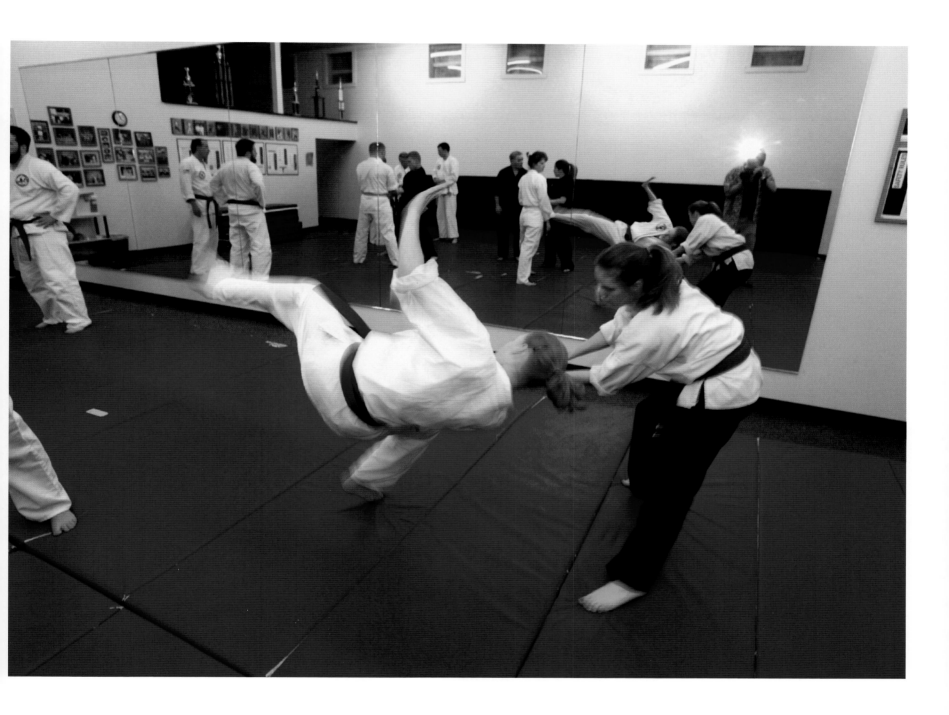

RAPID CITY

Mamie Beshara shows green belt Irene Conley the finer points of a jujitsu takedown at Dynamic Martial Arts studio. Jujitsu, a Japanese art of self-defense, was developed by samurai warriors in the 14th century. Its 21st-century incarnation is popular among women—40 percent of DMA's students are female.

Photo by Kevin Eilbeck

CHESTER

Photographer Eric Landwehr used a motor drive sequence and Photoshop software to render Lonnie Kocmick executing a barrel roll on his AirChair water ski. Landwehr was visiting a friend's cabin on Lake Brandt when he chanced upon Kocmick performing his high-speed acrobatics behind a Ski Centurion speedboat.
Photo by Eric Landwehr

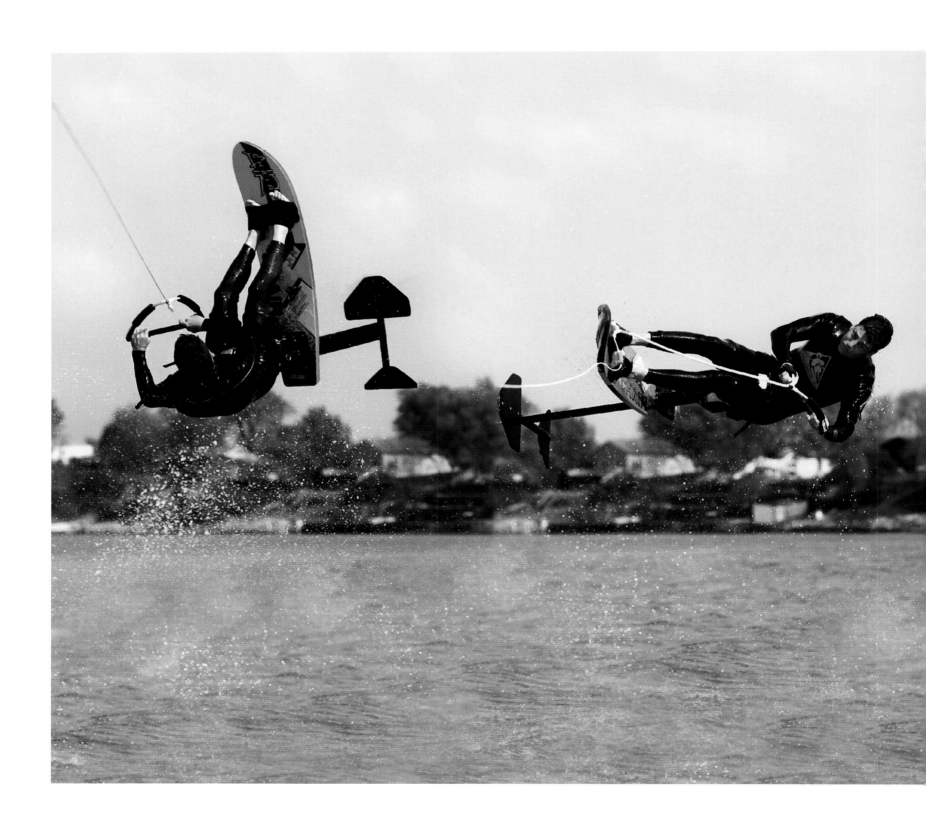

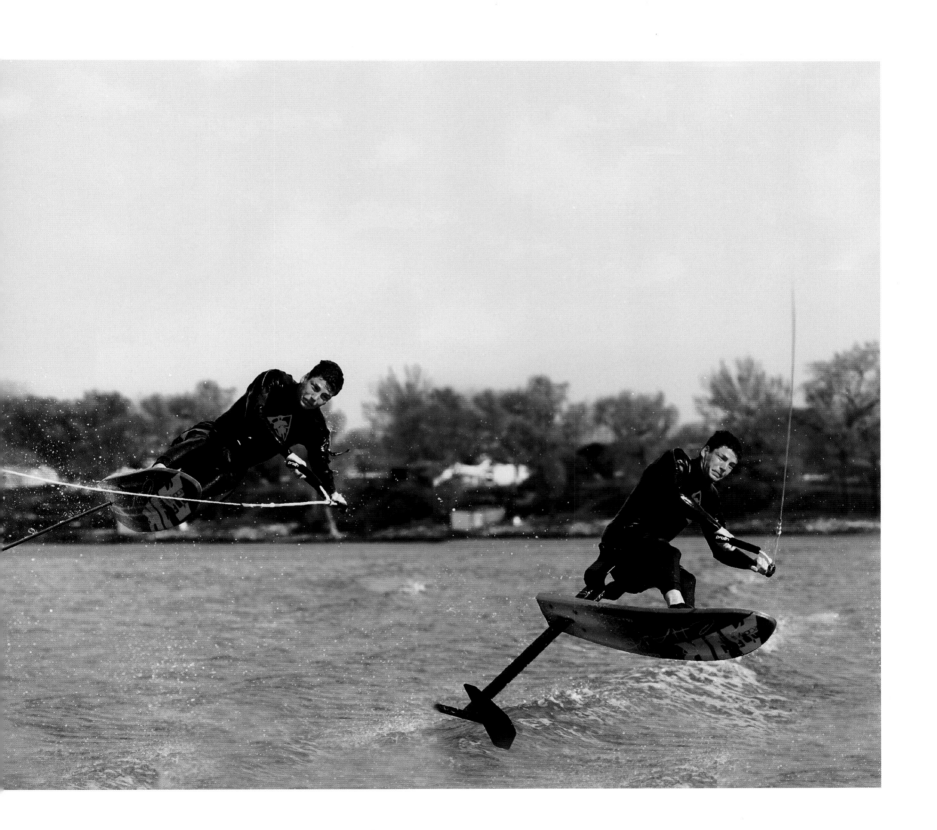

BROOKINGS

Nalladi waits all winter for the ice to melt on Interstate Lake. As soon as the freeze retreats, the black Lab spends afternoons with owner Kristine Madsen happily retrieving toys. Nalladi never seems to tire of the routine. After she dries off, she moves on to fetching balls and Frisbees.
Photos by Eric Landwehr

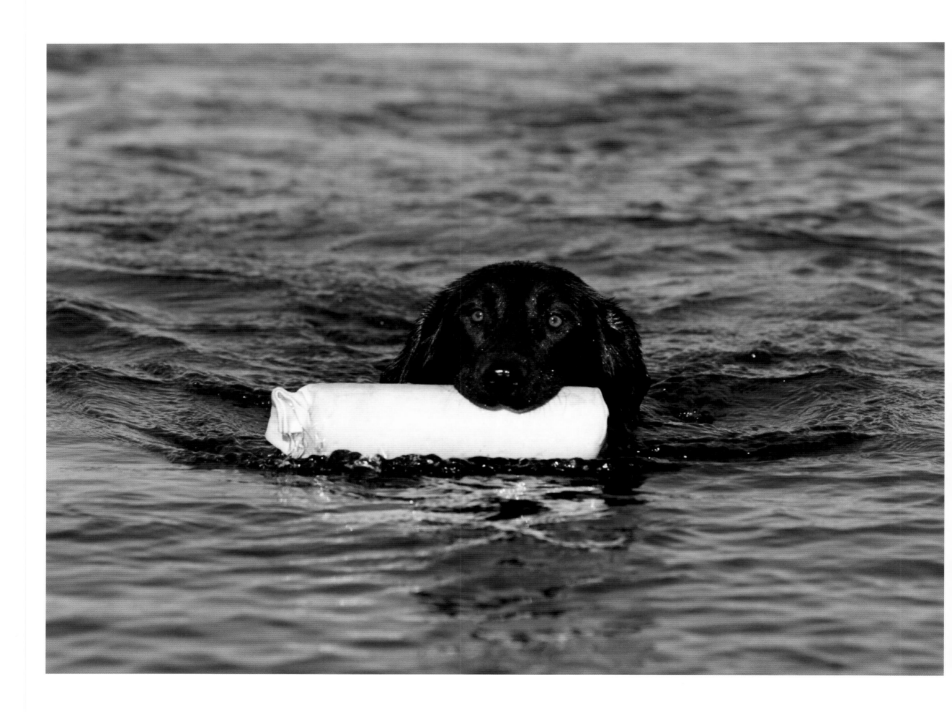

BROOKINGS

During the short South Dakota summer, Terry
Spitzenberger makes time on weekends to mean-
der on the lake with his granddaughter Carol Ann
Lyons. Grandpa Terry made Carol Ann, his only
grandchild, her own personalized paddle for her
second birthday.

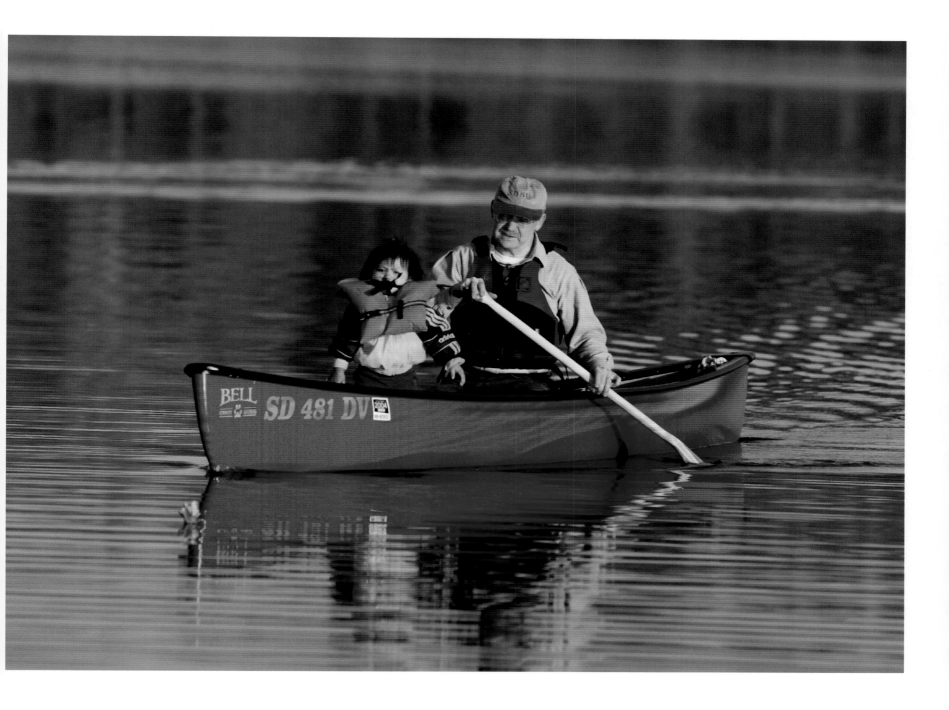

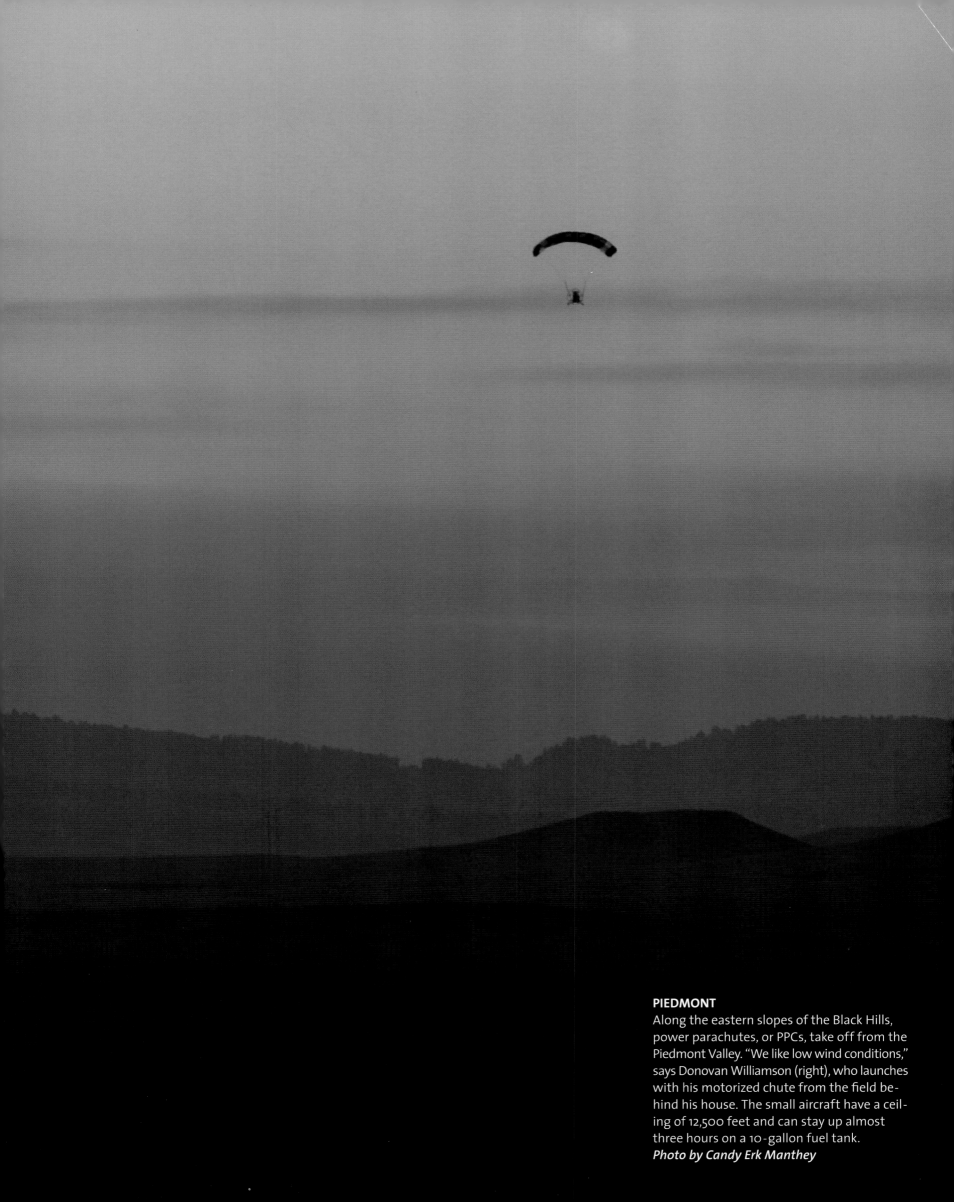

PIEDMONT
Along the eastern slopes of the Black Hills, power parachutes, or PPCs, take off from the Piedmont Valley. "We like low wind conditions," says Donovan Williamson (right), who launches with his motorized chute from the field behind his house. The small aircraft have a ceiling of 12,500 feet and can stay up almost three hours on a 10-gallon fuel tank.
Photo by Candy Erk Manthey

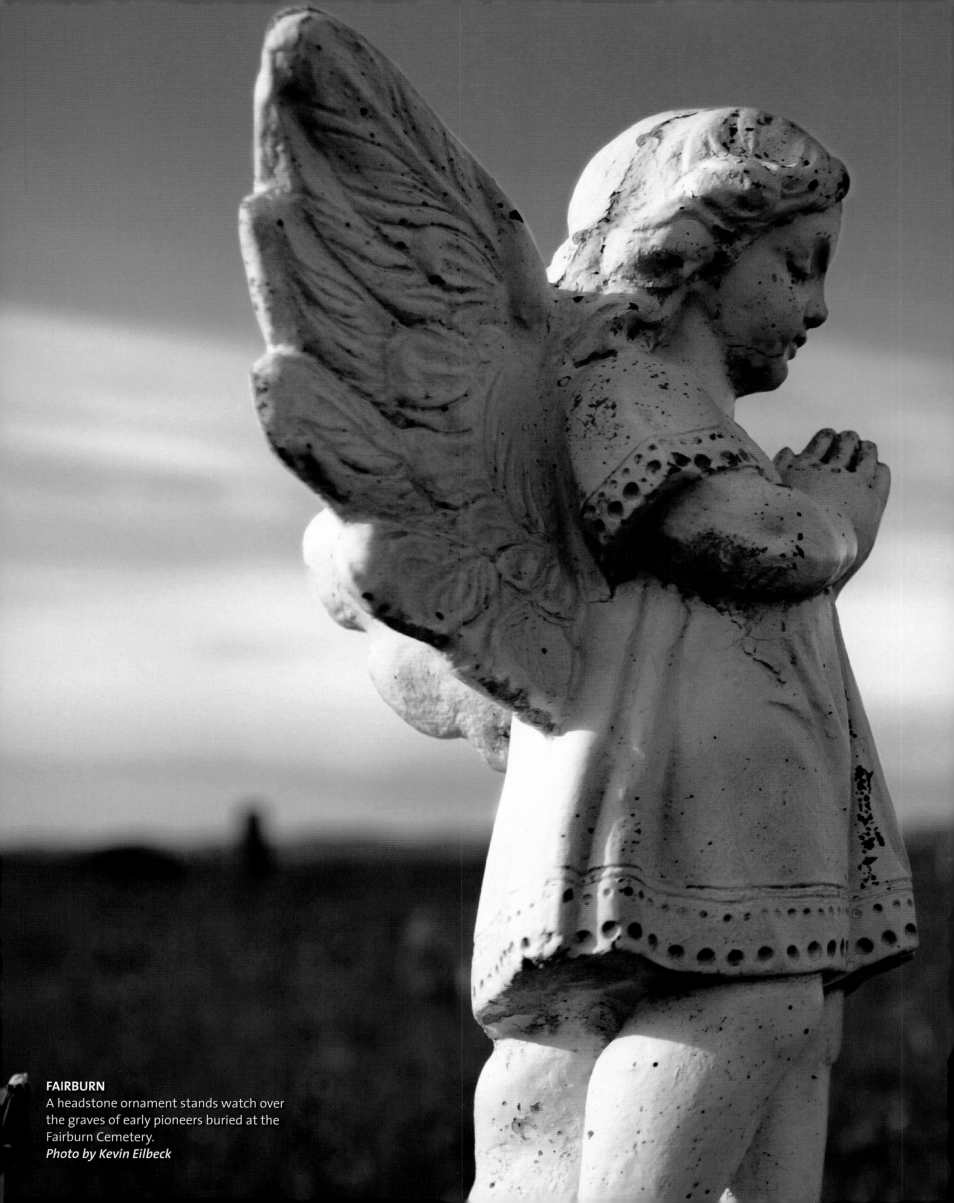

FAIRBURN
A headstone ornament stands watch over
the graves of early pioneers buried at the
Fairburn Cemetery.
Photo by Kevin Eilbeck

Reason To Believe

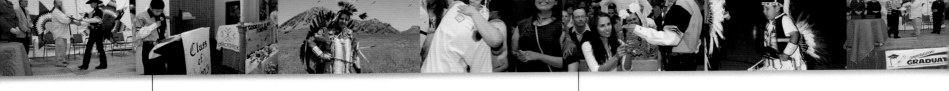

PINE RIDGE RESERVATION

During graduation at Our Lady of Lourdes School in Porcupine, eighth-grader Jeffery Whirlwind Horse gives the first reading at mass. He comes from a Lakota family known for its distinguished leadership on the reservation. His school, which incorporates Lakota studies into its curriculum, is run by Jesuits.

Photos by Don Doll, S.J., Creighton University

PINE RIDGE RESERVATION

As a show of appreciation, Jeffery presents family members, including his sister Tashina Jackson, with flowers dyed in the school colors of blue, white, and yellow.

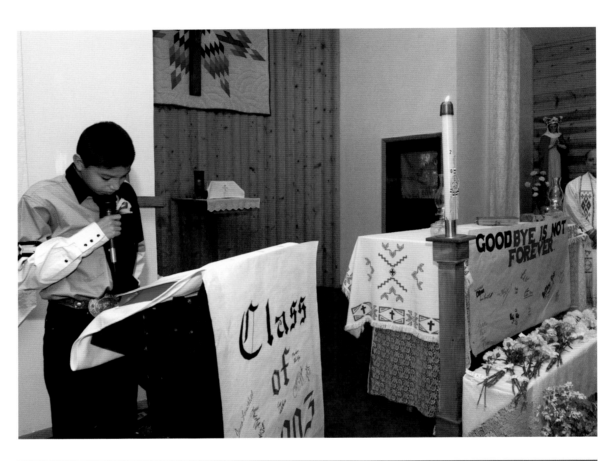

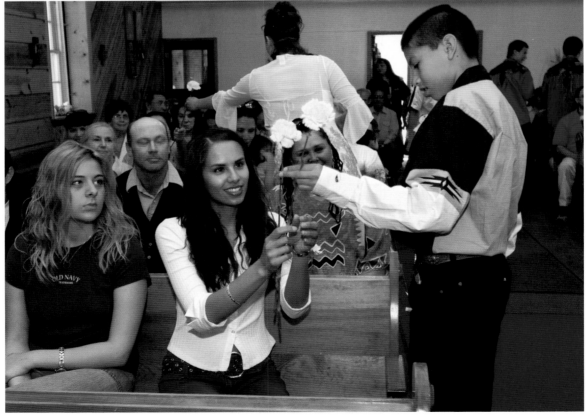

PINE RIDGE RESERVATION

Jeffery sits with classmate Lana Two Dogs during graduation. The eighth-grade ceremonies are joyous but unsettling, as students who've been together since kindergarten split up to attend one of the four high schools on the reservation.

PINE RIDGE RESERVATION

Jeffery embraces his mother, Devona Lone Wolf, a psychologist and college administrator. Having the youngest of her four children finish this stage of their schooling is a family milestone, she says. According to his proud mom, Jeffery is known for his sociability and prodigious memory—he knows the Harry Potter books by heart.

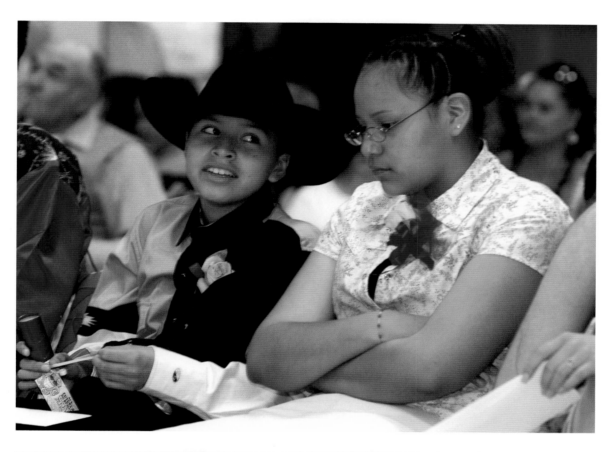

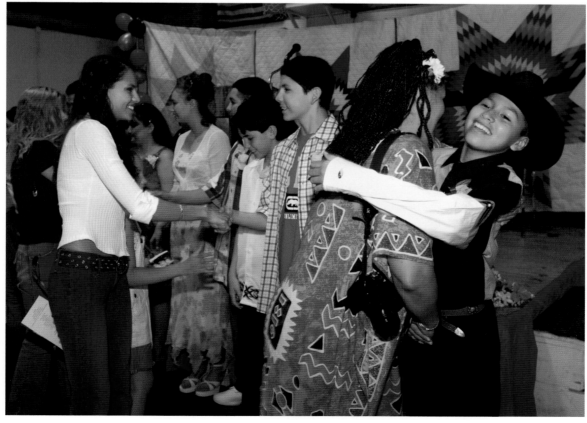

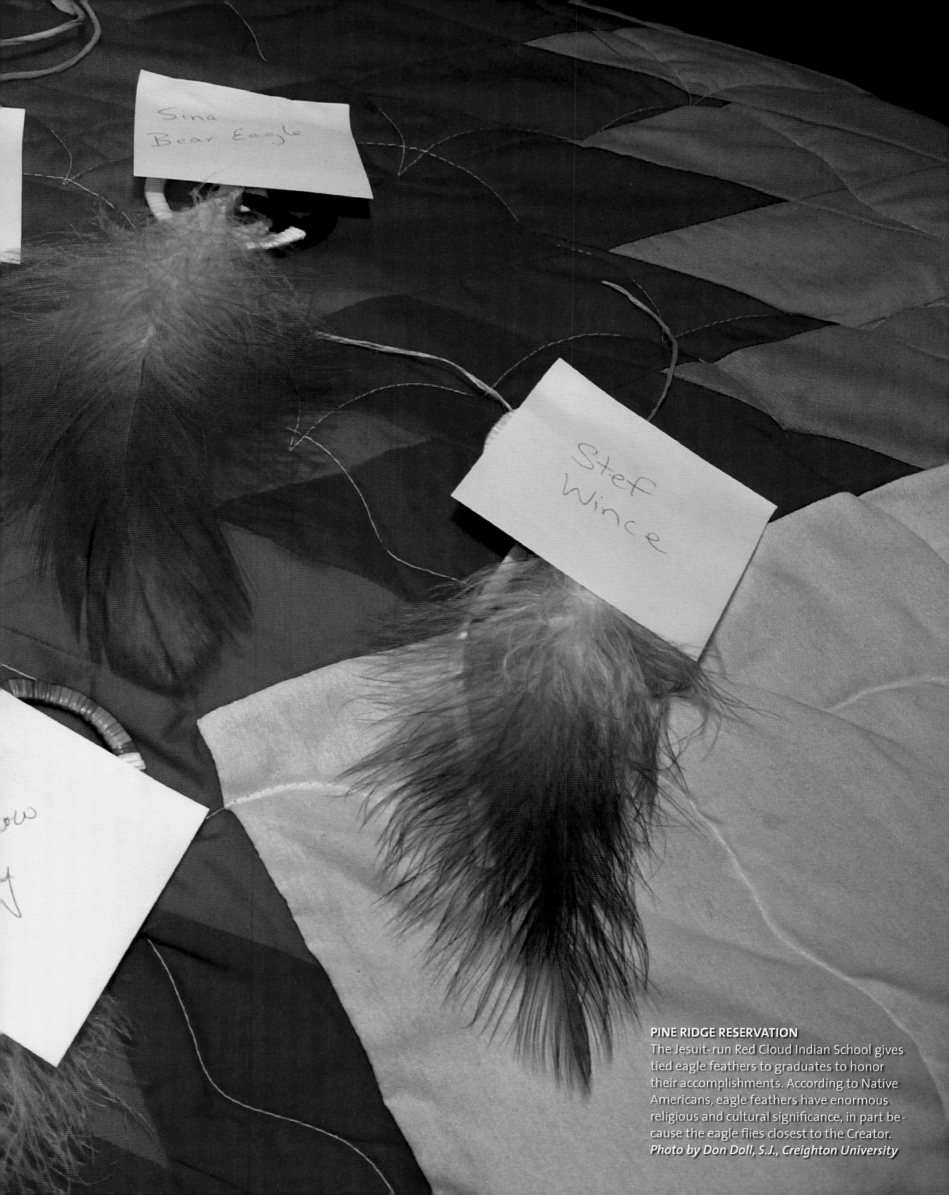

PINE RIDGE RESERVATION
The Jesuit-run Red Cloud Indian School gives tied eagle feathers to graduates to honor their accomplishments. According to Native Americans, eagle feathers have enormous religious and cultural significance, in part because the eagle flies closest to the Creator.
Photo by Don Doll, S.J., Creighton University

PINE RIDGE RESERVATION

At Red Cloud Indian School's graduation powwow, drummers perform a song to honor graduates. Twelve-year-old Todd Janis, in regalia his parents made for him, joins in. Pine Ridge offers three kinds of schools: public, tribal, and Catholic.
Photo by Don Doll, S.J., Creighton University

INTERIOR

With the Badlands National Park as a backdrop, Dallas Chief Eagle performs a rhythmic hoop dance. The world champion is director of the Hoop Dance Society on the Pine Ridge reservation and author of *Winter Count*, an historical novel about the battles of Wounded Knee and Little Bighorn.
Photo by Johnny Sundby,
Dakota Skies Photography

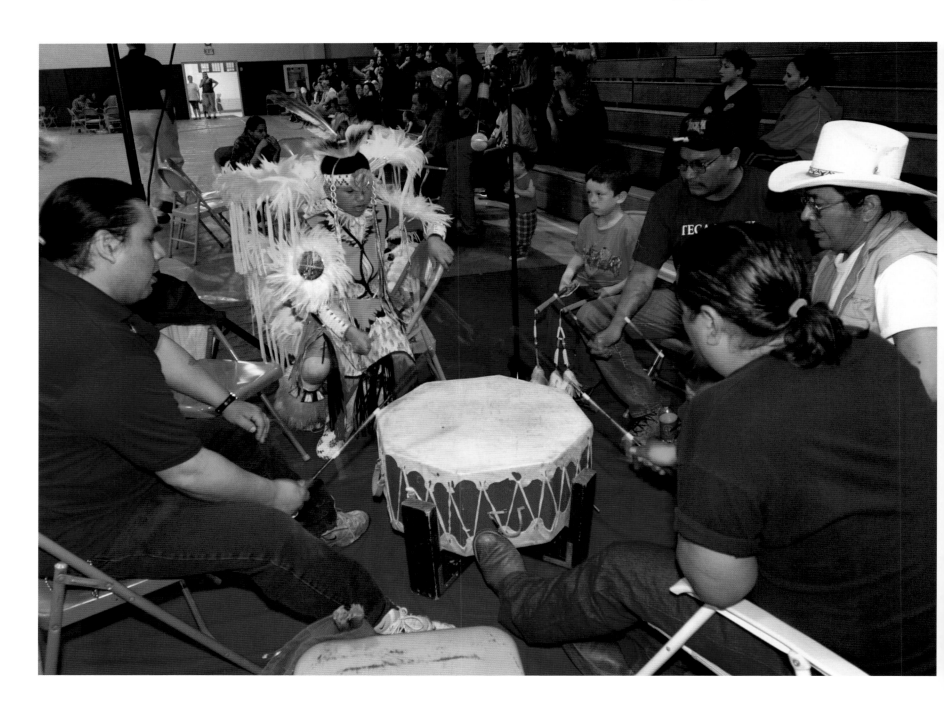

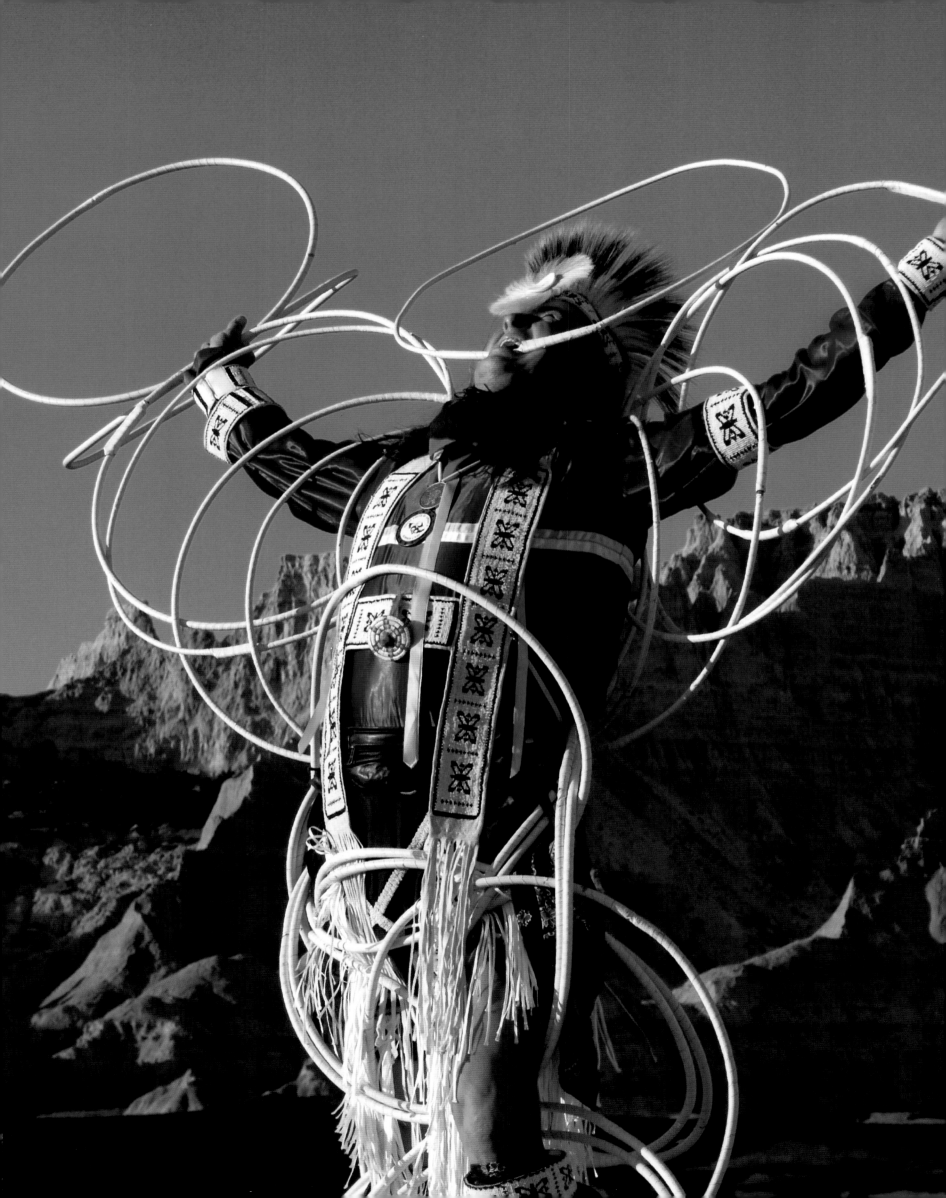

WHITE OWL
As Old Glory waves in the prairie wind along Highway 34, a sign proclaims the town's unwavering support for members of the armed forces.
Photo by Val Hoeppner

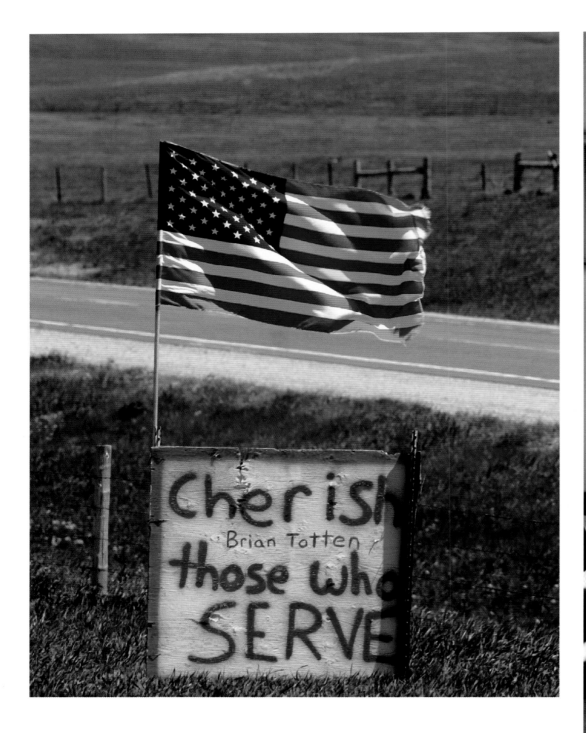

SILVER CITY

Lucille Curl catches up with Larry Fine at a pancake breakfast sponsored by the volunteer fire department. Silver City's 40 full-time residents gather for potluck dinners six to eight times per year. Occasionally, weekenders like Fine drive up from Rapid City to find out what's new in the tight-knit Black Hills community.

Photo by Kevin Eilbeck

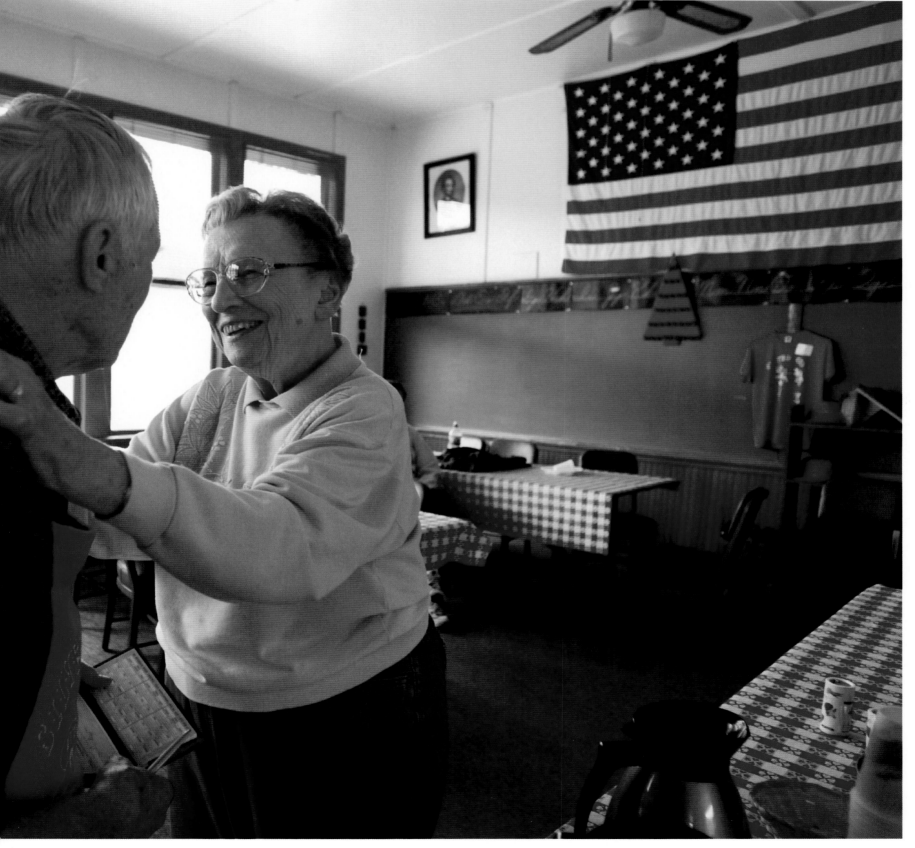

PINE RIDGE RESERVATION
Tennessean Bob Cargill visits Wounded Knee's mass grave, the burial site of the 300 Lakota men, women, and children massacred in 1890 by the 7th Cavalry. Cargill began reading about Native Americans while recovering from the amputation of his lower leg after a car accident. "The more I read, the madder I got about what we did to them." So, he says, "I brought my wounded knee to Wounded Knee."
Photo by Don Doll, S.J., Creighton University

PIERRE
A rally at the state capitol in support of South Dakota military personnel in Iraq brings out Lori Niehoff, Cindy Erikson, and Kila Vogel, who met through a family support group. Niehoff's son and Erikson and Vogel's husbands are stationed in Iraq with a National Guard engineering unit.
Photo by Chad Coppess,
South Dakota Tourism and State Development

PINE RIDGE RESERVATION

Red Cloud Indian School graduating seniors Paul
Twiss and Donnel Ecoffey, both Lakota, wrap out-
going school superintendent Tom Merkel, S.J., in a
star-patterned quilt. Star quilts made by Lakota
women are highly prized gifts at honoring cere-
monies. "It's a beautiful part of Lakota culture to
honor someone for their contribution," says
Merkel. "I was very touched."
Photo by Don Doll, S.J., Creighton University

RAPID CITY

Signing praises: First Christian Church welcomes
deaf congregants. After hiring an interpreter to
translate the sermon and songs during weekend
services, the church started sign language classes
for its hearing members, organized socials, and
helped members with hearing-equipment needs.
As a result, the church's 10 hearing-impaired pa-
rishioners are active in the fellowship.
Photo by Markus Erk

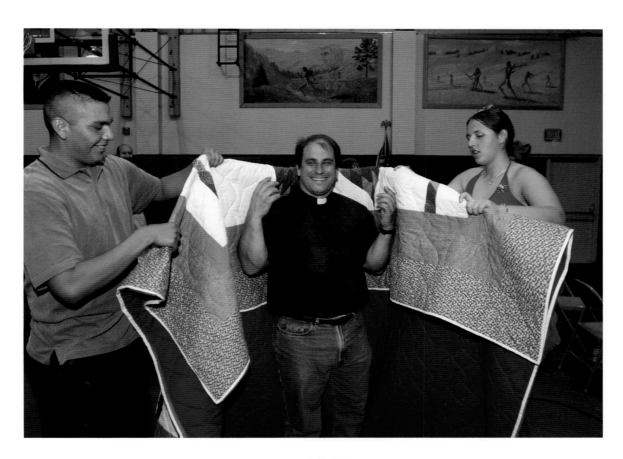

RAPID CITY

For three bucks, movie fans can watch second-run features downtown at the Elks Theatre on 6th Street (small popcorn, $2.50; Kiddie Coke, $1.00). The 1912 theater boasts the state's largest movie screen. The billing on the marquee is a shameless play for the camera.

Photo by Mike Wolforth

ALEX JOHNSON

KEYSTONE

In the 1930s, the state constructed three tunnels through the Black Hills' granite peaks to create framed views of Mount Rushmore. This one on Iron Mountain Road leads a minivan toward Custer State Park.
Photo by Johnny Sundby,
Dakota Skies Photography

DEADWOOD

At the Tatanka Interpretive Center (funded by Kevin Costner) in the Black Hills, a massive bronze sculpture by Peggy Detmers shows three Native American hunters about to drive buffalo over a cliff—a traditional method of killing. *Tatanka* means buffalo in Lakota.
Photo by Mike Wolforth

KEYSTONE

A ranger patrols the 25-foot part in Thomas Jefferson's hair. Between 1927 and 1939, unemployed miners carved Mount Rushmore's four presidential profiles using dynamite to carefully remove 450,000 tons of granite. Details such as the presidential pupils were sculpted by 400 workers armed with hammers and chisels.
Photo by Kevin Eilbeck

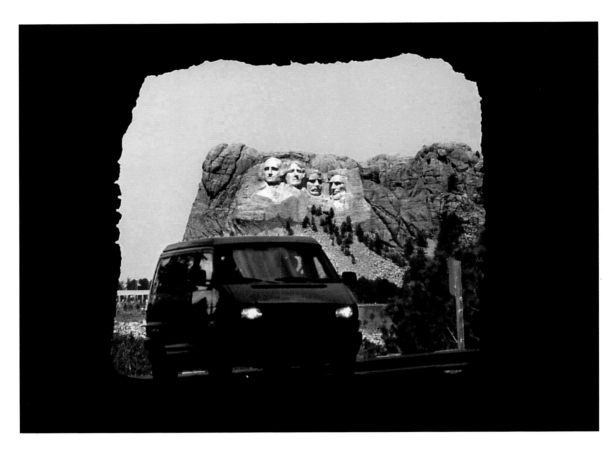

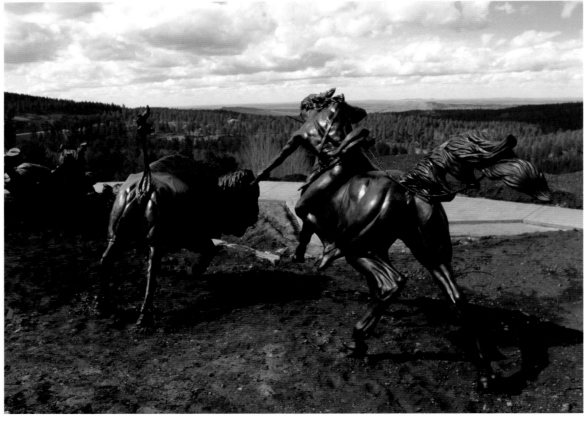

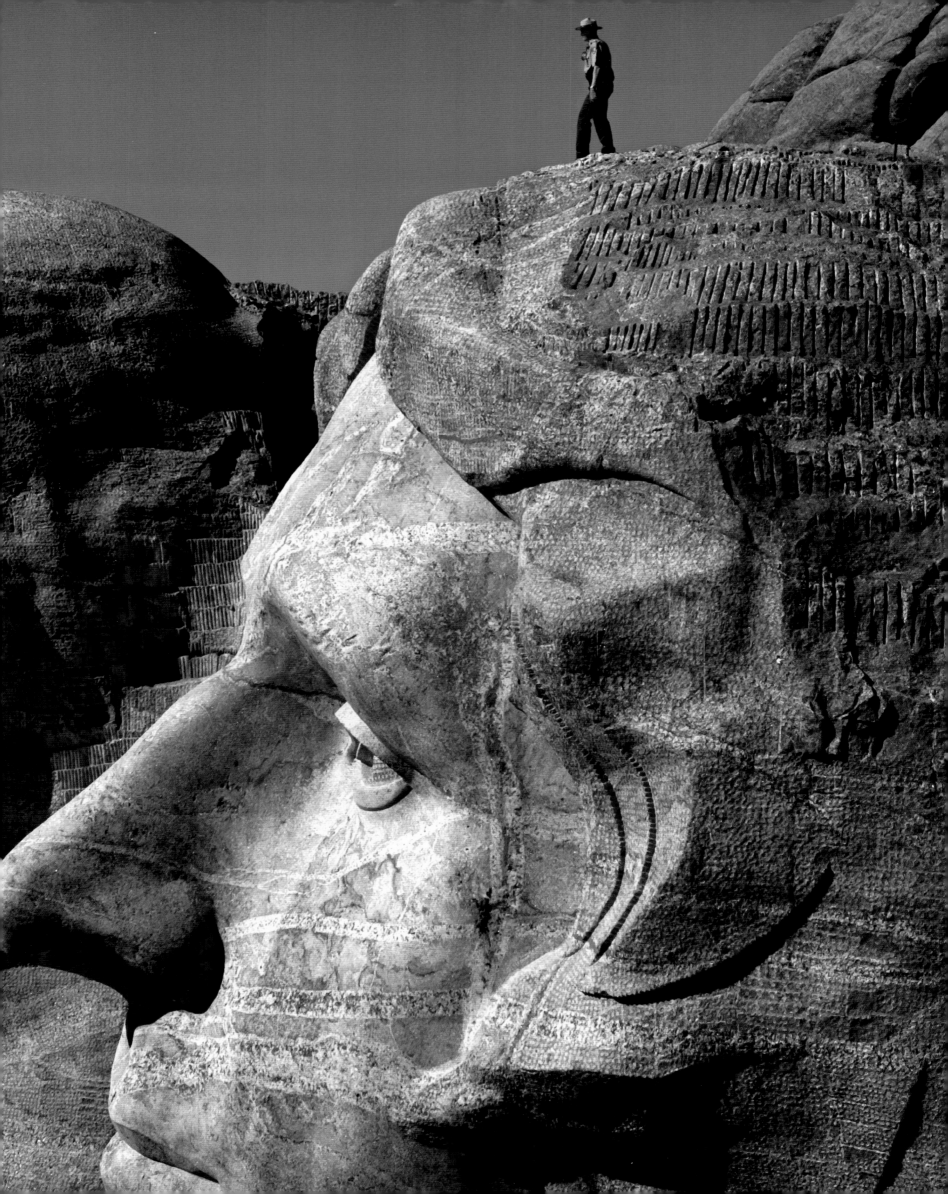

CUSTER COUNTY

The model of an enormous sculpture of Chief Crazy Horse indicates what the work will look like when finished. The project began in 1940 when Oglala Lakota Chief Henry Standing Bear asked sculptor Korczak Ziolkowski to show that Indians —not just the sponsors of nearby Mount Rushmore—have heroes, too. Ziolkowski died in 1982; his family continues his work.

Photos by Mike Wolforth

CUSTER COUNTY

The sculpture of Crazy Horse—a 17-mile drive from Mount Rushmore, is not yet complete. But the face of the famed warrior and tactical leader of the Lakota, who battled most of his short life against the incursions of the whites into the northern plains, is already a monumental presence.

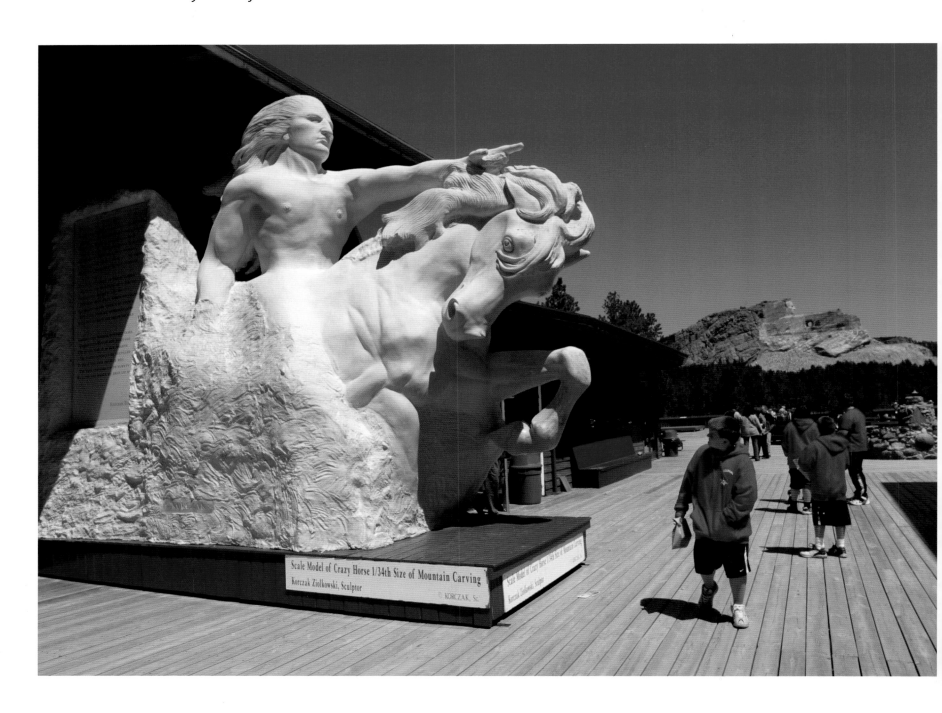

Scale Model of Crazy Horse 1/34th Size of Mountain Carving
Korczak Ziolkowski, Sculptor

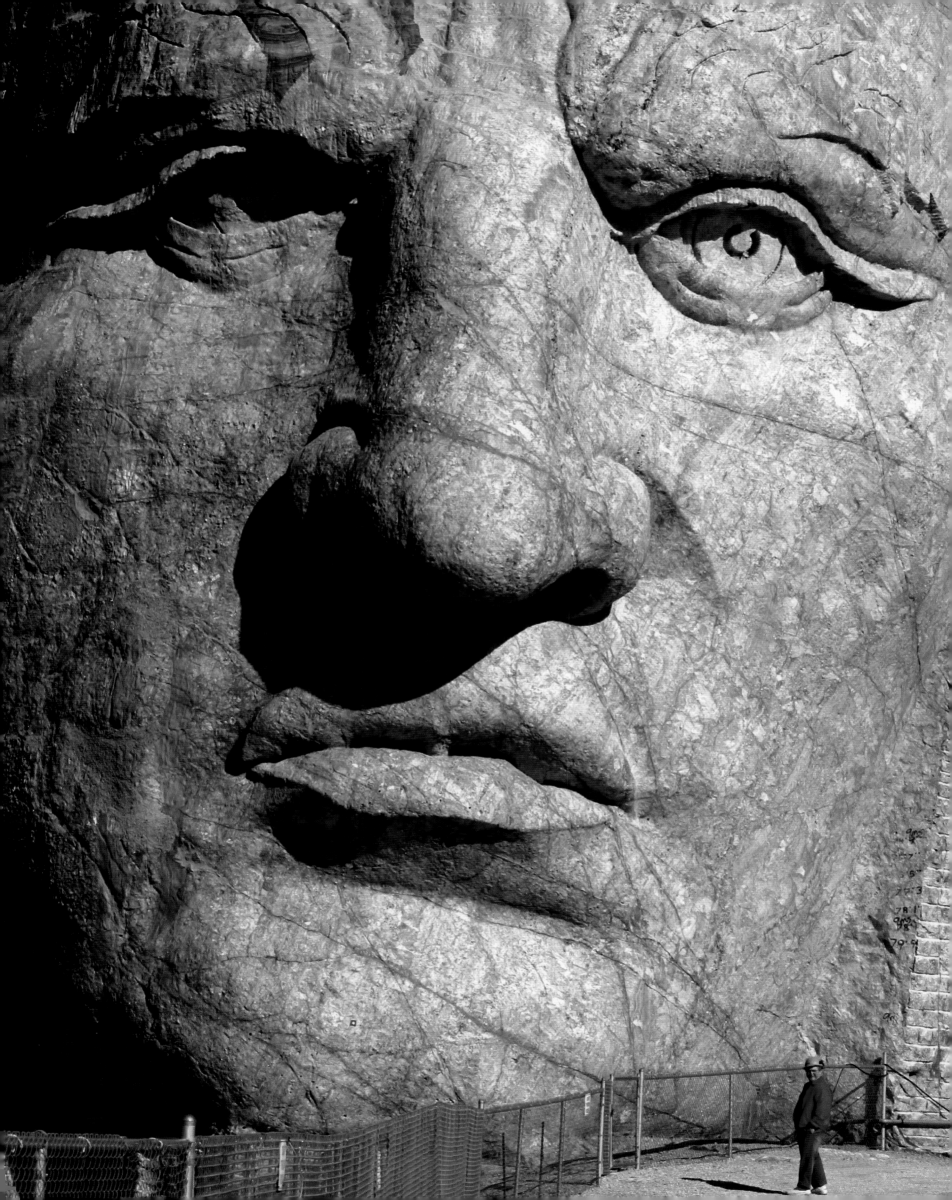

DEADWOOD

A former gold-mining town, Deadwood is known for its preservation of historic buildings and colorful history. In 1876, Wild Bill Hickok was shot in the back of the head during a poker game. Legend has it that he was holding aces and eights, which came to be known as the "dead man's hand."

Photos by Steve Babbitt

DEADWOOD

Lee Street is empty now but when Memorial Day rolls around it will overflow with tourists. Legalized gambling resuscitated Deadwood in 1989, and, since then, the town has drawn as many as 1.5 million visitors each year.

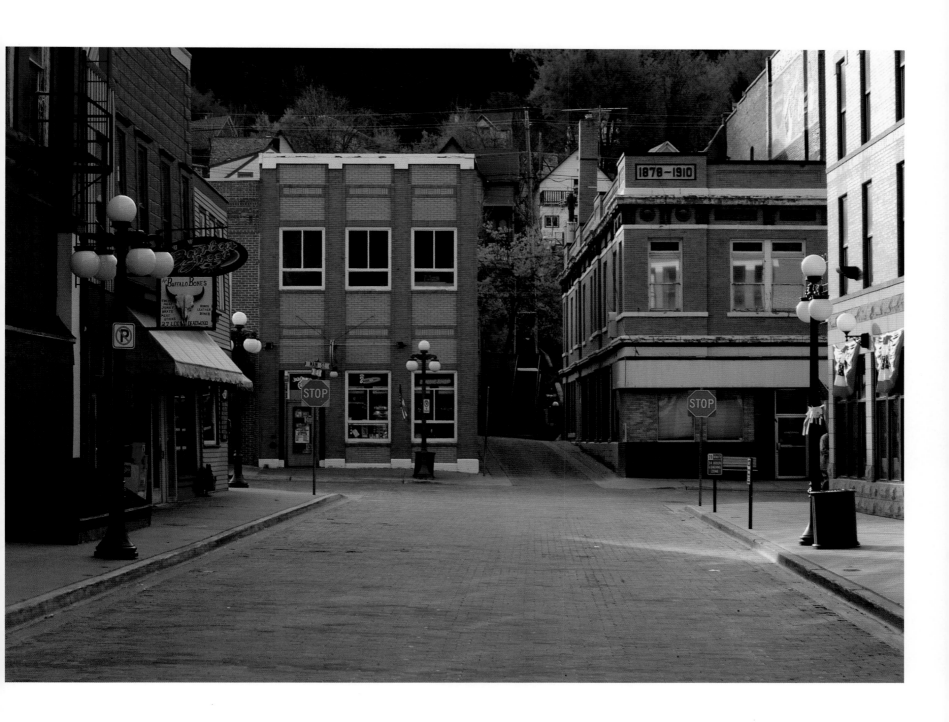

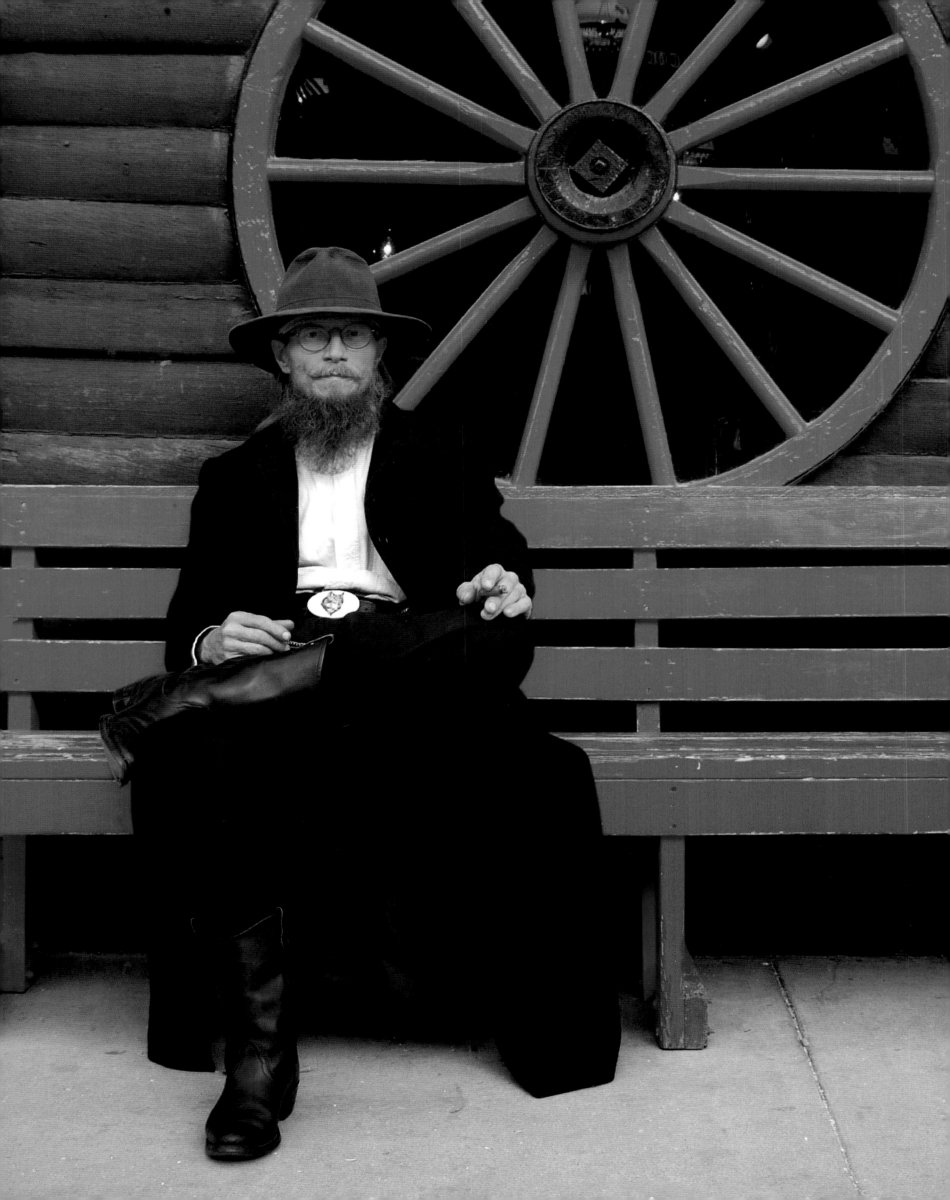

DEADWOOD

From the irony department: "Cactus Bob" Gardner was a prospector in Arizona for 14 years before being shot in the head by a gang a few years ago. He survived, changed careers, and now works in Deadwood with an acting troupe—that reenacts gunfights.

Photo by Steve Babbitt

CUSTER STATE PARK

Roadies: Lifelong friends Lee Linzay, J.C. Mahon, and Dores Griffin tooled up from Arkansas in Linzay's 1970 VW to check out South Dakota. Wowed by the view, the trio pulled in at the Needles Highway's Cathedral Spires overlook.

Photo by Steven A. Page

CLARK

Ken Bell, Sr., started *The Parade* 10 years ago when he left an old 1976 Ford LTD in his field. Another LTD died, so he painted it to match. He liked the look of it, so he kept adding cars.

Photo by Doug Dreyer, Dakota Images

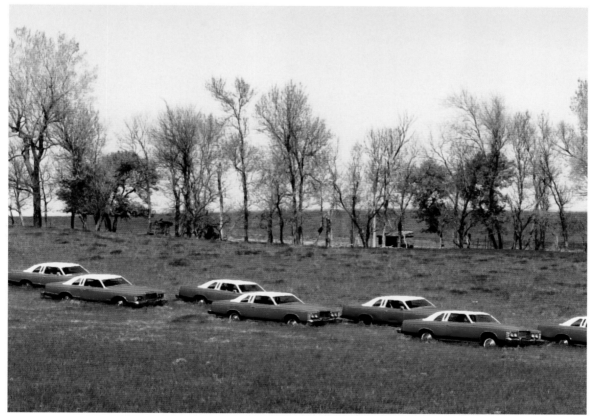

BETWEEN SIOUX FALLS AND PIERRE
Governor Mike Rounds got his pilot's license when he turned 17, and now it comes in handy on the job. Today, he's flying a state-owned King Air 200 home to Pierre after a deactivation ceremony for National Guard troops in Sioux Falls.
Photos by Chad Coppess,
South Dakota Tourism and State Development

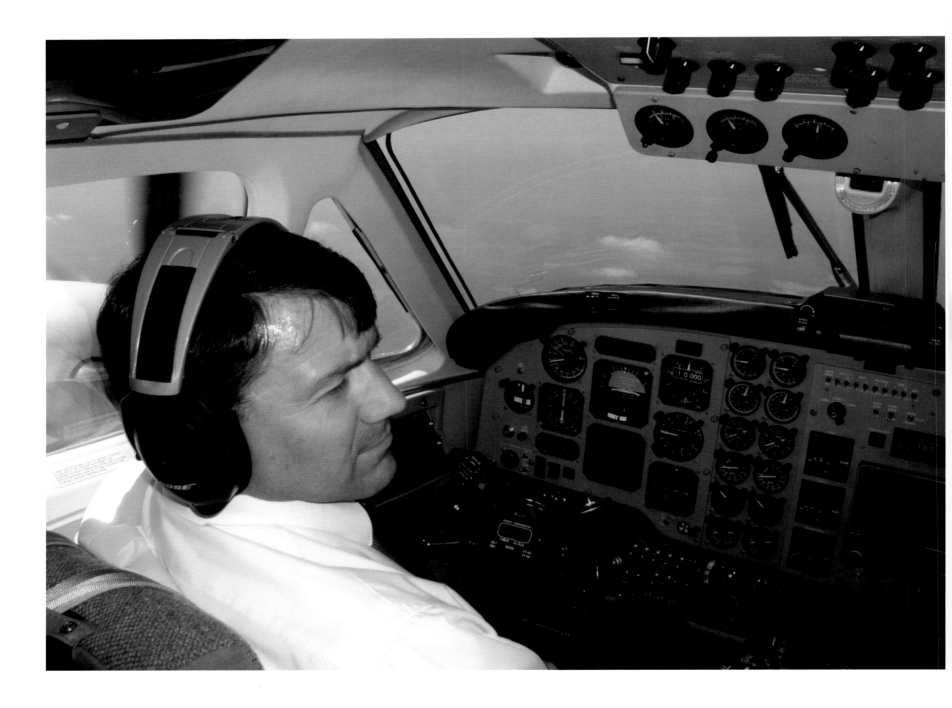

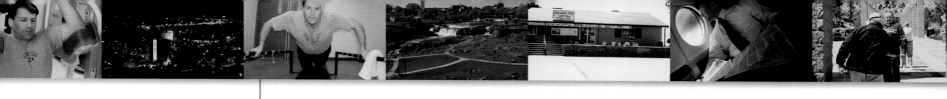

PIERRE

Governor Rounds stays in shape with an every-other-day workout at the YMCA.

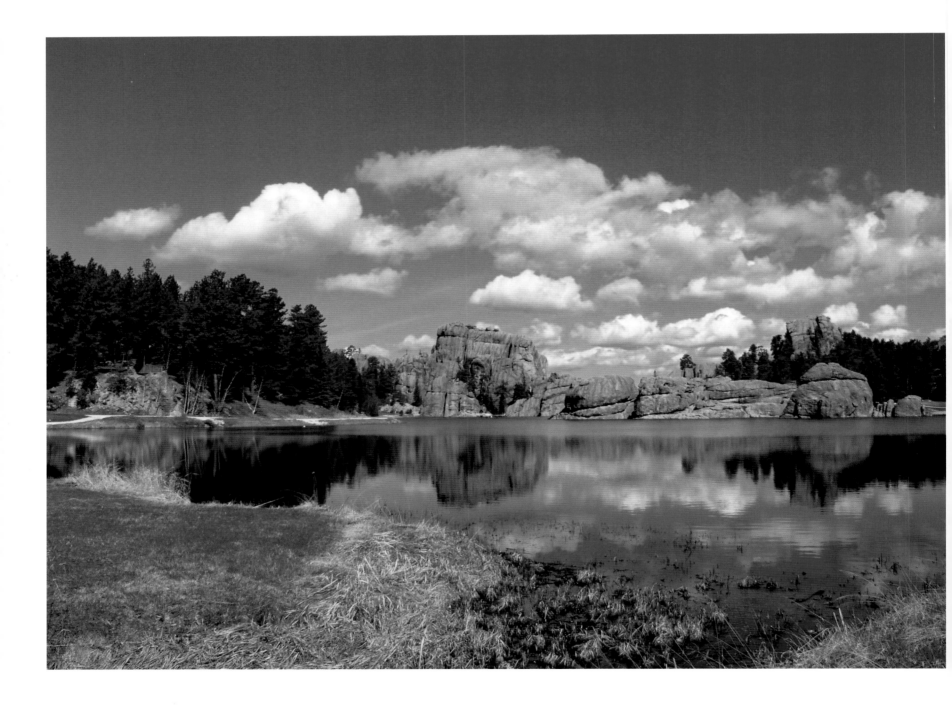

CUSTER STATE PARK

Early morning clouds over 71,000-acre Custer State Park reflect onto man-made Sylvan Lake. One of the largest state parks in the country, it is majestic, yet controversial: It lies within the Black Hills, on land long claimed by the Lakota Sioux. But it is named for a man whose actions were, and are, despised by Native people.
Photo by Steven A. Page

SISSETON

Marsh marigolds surround a waterfall at Sica Hollow. According to the Dakota people, this sacred place is protected by the *canotina*, or little people, and is a refuge that will sustain life when other places are depleted.
Photo by Greg Latza, peoplescapes.com

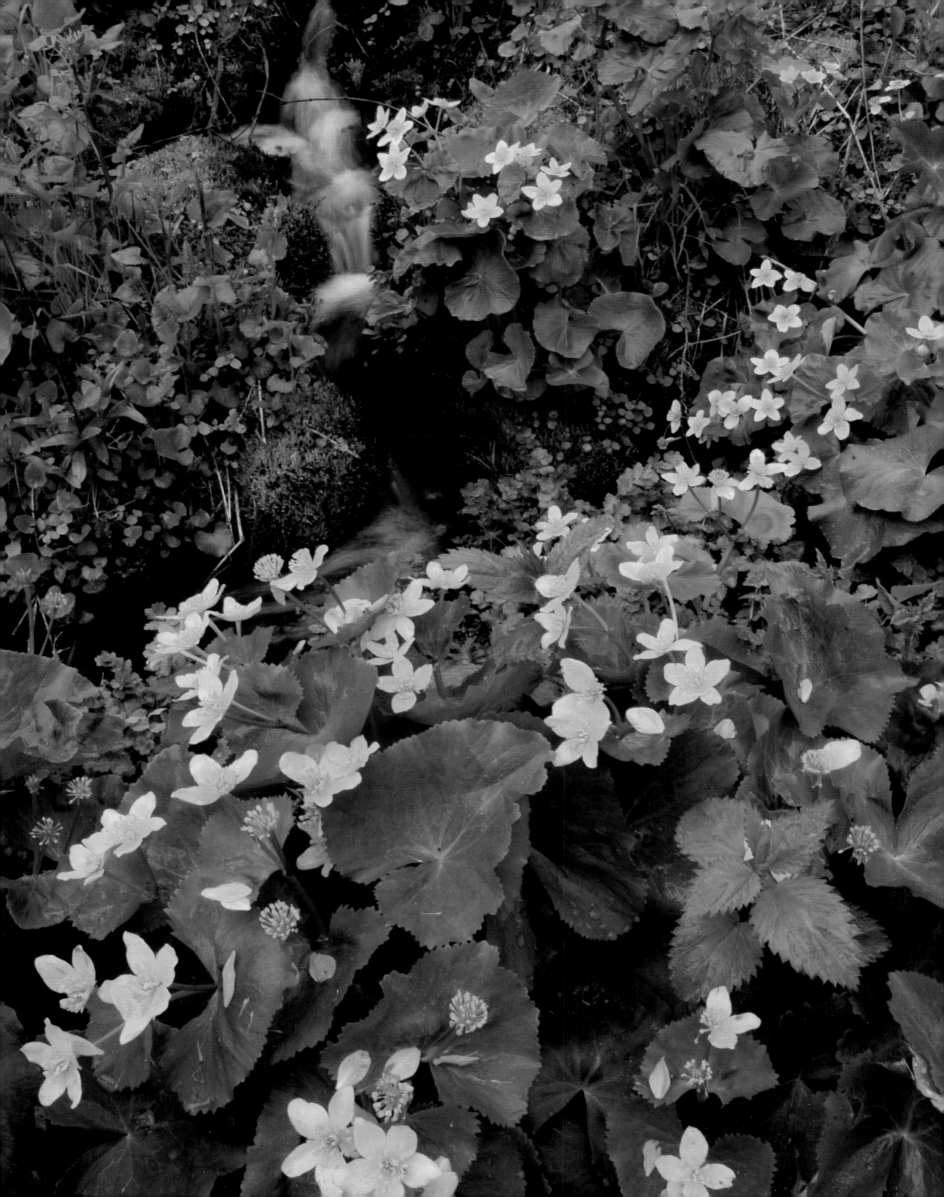

HILL CITY
Transporting gold and tin between Keystone and Hill City used to be the primary purpose of "the 1880 Train," which was built in 1906. These days, the steam engine train takes tourists on a two-hour ride through history.
Photo by Steven McEnroe

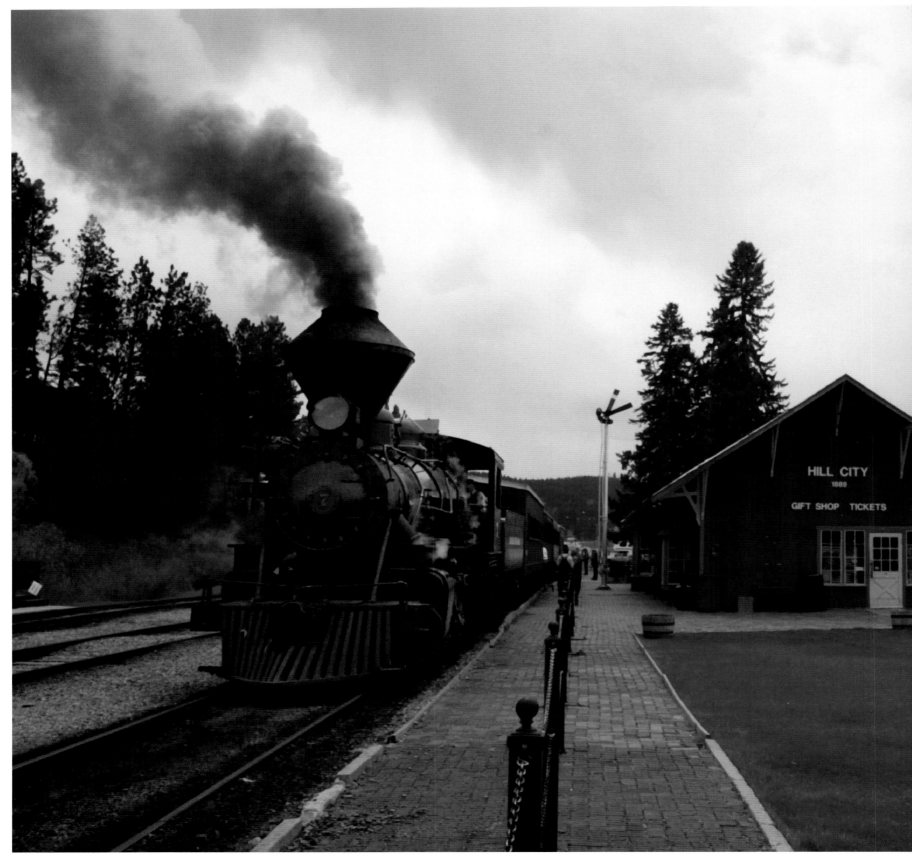

HILL CITY

"I've always loved steam engines," says conductor Dave Phillips, who worked on steam engine trains until he served in the Korean War. When he returned in 1954, steam engines had been replaced by diesel engines, so Phillips went to work for the South Dakota Department of Transportation. After retiring six years ago, Phillips finally realized his dream of being a steam engine conductor.
Photo by Doug Dreyer, Dakota Images

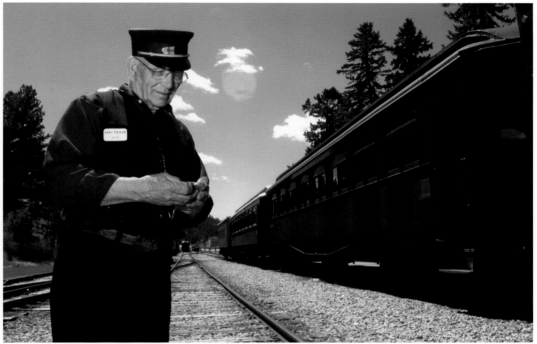

BADLANDS NATIONAL PARK
"I was totally unprepared for that revelation called the Badlands," wrote Frank Lloyd Wright of the inspiring natural architecture—spires, buttes, and cathedral peaks—he encountered in the 244,000-acre national park.
Photo by Johnny Sundby,
Dakota Skies Photography

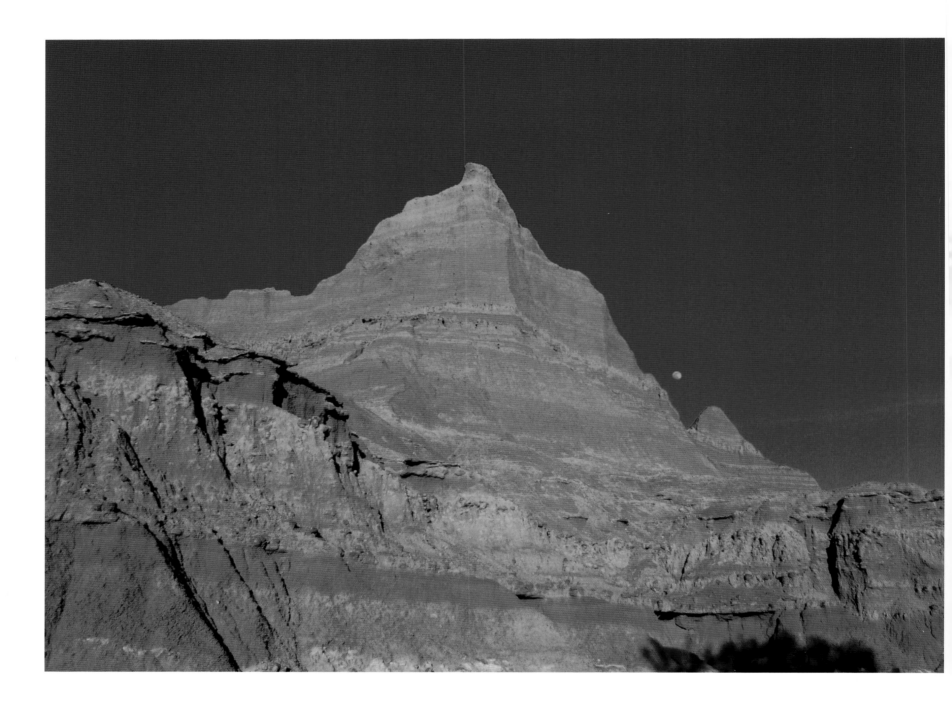

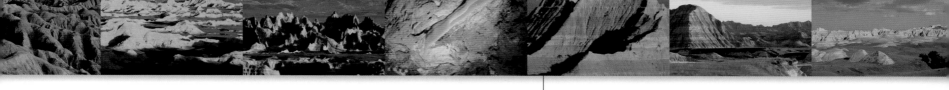

BADLANDS NATIONAL PARK

The bones of ancient mammals lie preserved in the layered sediment of the weathered spires and buttes at Badlands National Park. The area's dry peaks and ravines were once covered with lush rain forests, where early horse, sheep, rhinoceros, and pig species thrived 23 to 35 million years ago. Their fossilized remains are part of the world's richest Oligocene fossil beds.

Photo by Dick Kettlewell

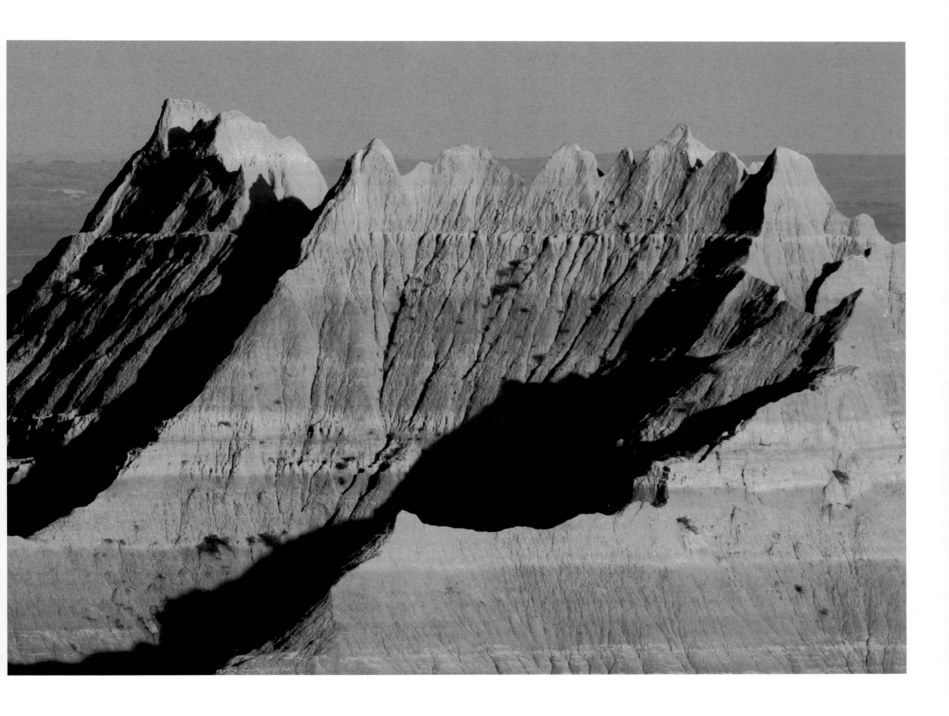

SIOUX FALLS

Fueled by water from a retreating glacier 14,000 years ago, Big Sioux River exposed the underlying quartzite bedrock and revealed the pinkish stone. The city of Sioux Falls is one of a handful of urban centers in America built around a system of rapids and falls.

Photo by Jason Rollison

BROOKINGS

Sunlight passing over Dean and Helen Christie's farm crosses paths with a sheet of rain, and a rainbow touches down next to the stable.

Photo by Eric Landwehr

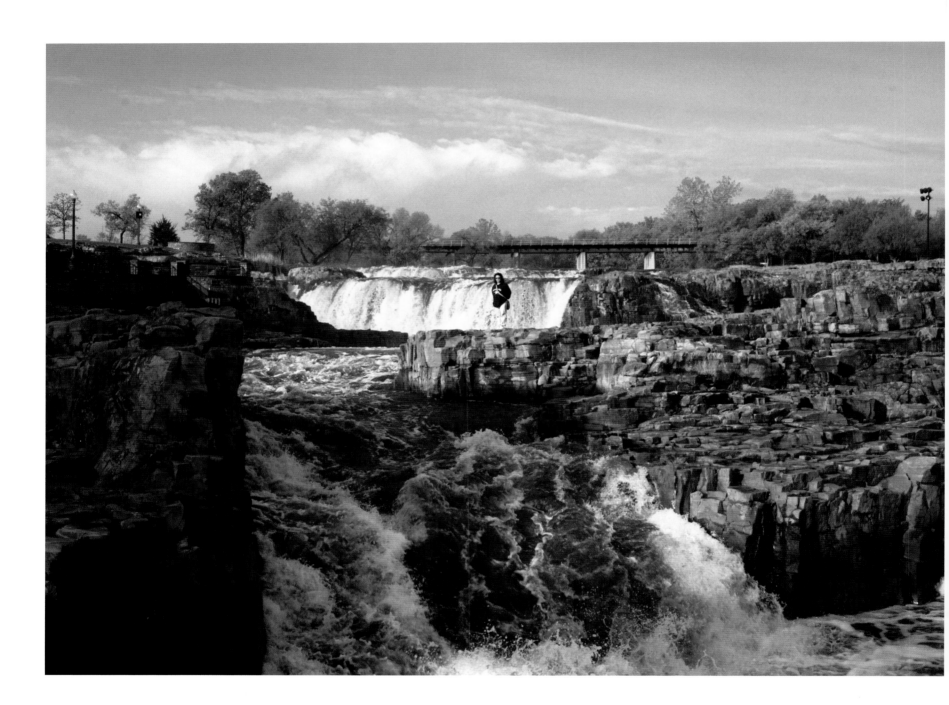

CUSTER

Visitors to Custer State Park are guaranteed to
see more than the nine bison advertised on the
license plate of the park's buffalo herdsman,
Chad Kremer. Custer's 73,000 acres of meadows
are home to 1,500 head, one of the world's largest
free-roaming bison herds.

Photo by Johnny Sundby,
Dakota Skies Photography

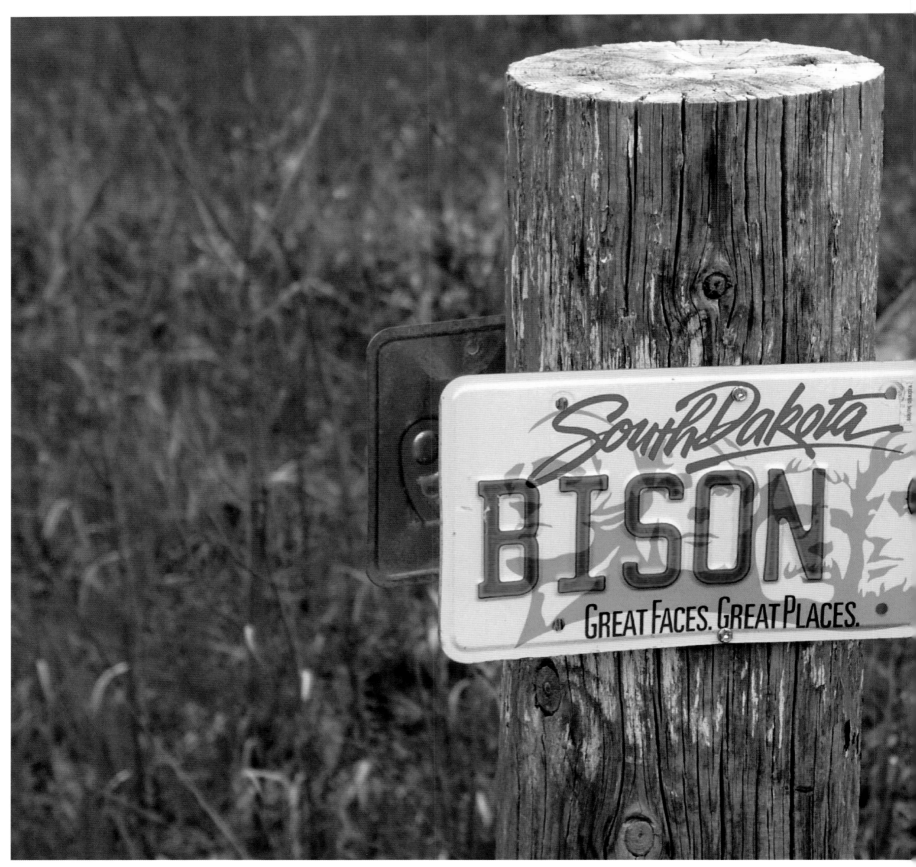

BADLANDS NATIONAL PARK

The pushing and shoving of two young bison bulls is playful now, but when mating season gets serious, the antics will become more aggressive. Bulls stand 6 feet tall at the shoulder, are 10 feet long, and can weigh more than a ton. In spite of their bulk, they are agile and fast —running up to 40 miles an hour.
Photo by Dick Kettlewell

BADLANDS NATIONAL PARK

American bison cows typically give birth to one calf in May after a nine-month gestation. Calves can stand within 30 minutes of birth, run within hours, and begin grazing within a week. Reintroduced to the park in 1963, after being absent from the prairies for about 100 years, a herd of 600 bison now populates the Sage Creek area of the Badlands.
Photo by Dick Kettlewell

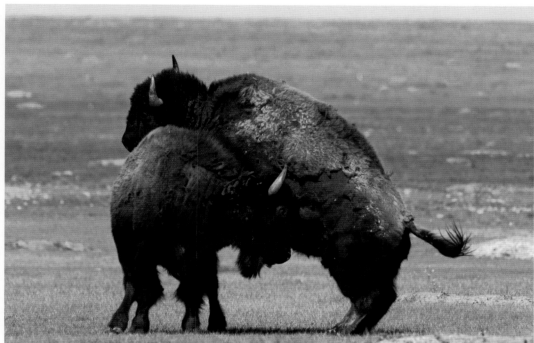

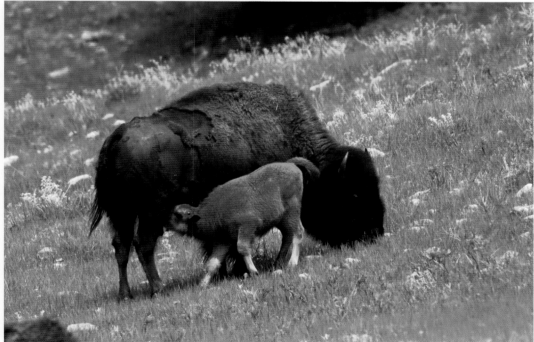

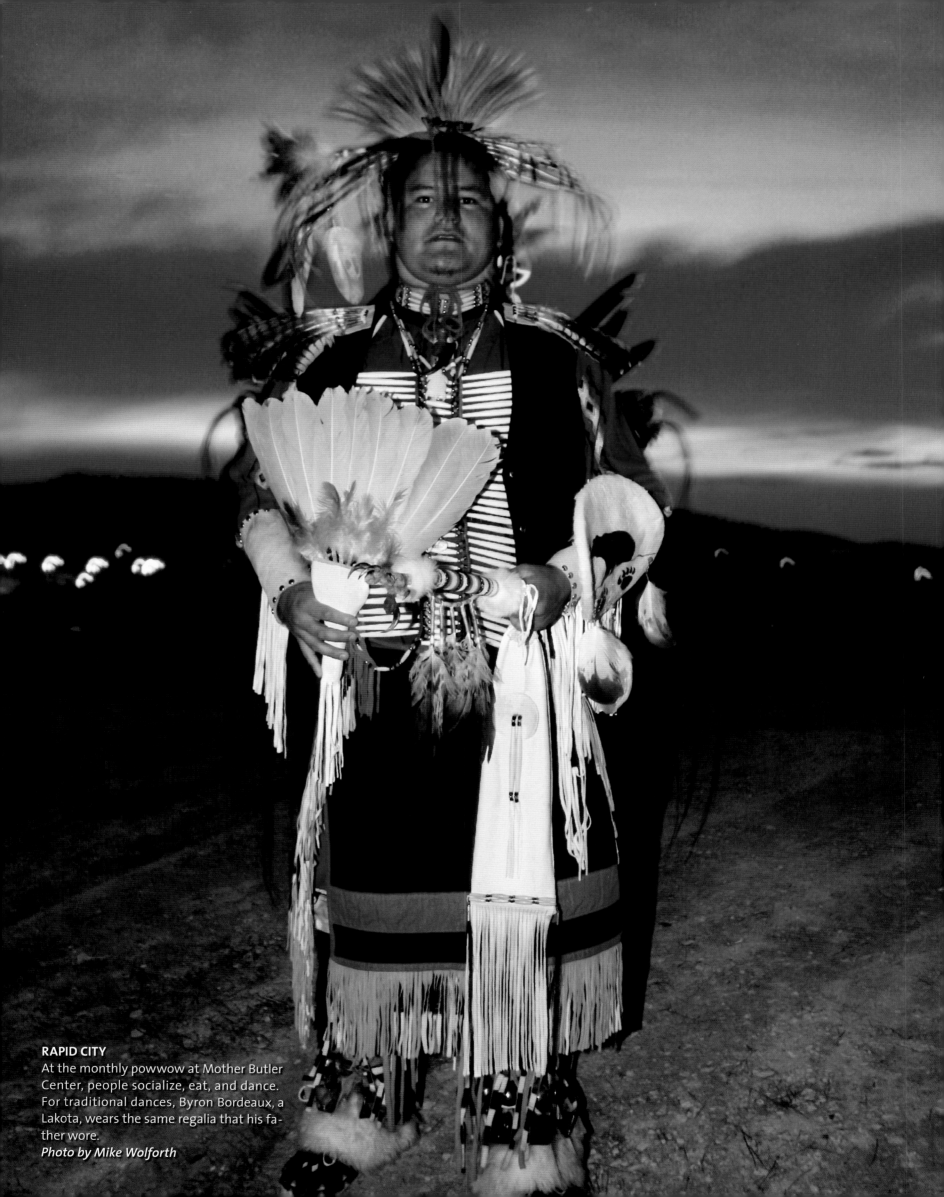

RAPID CITY
At the monthly powwow at Mother Butler Center, people socialize, eat, and dance. For traditional dances, Byron Bordeaux, a Lakota, wears the same regalia that his father wore.
Photo by Mike Wolforth

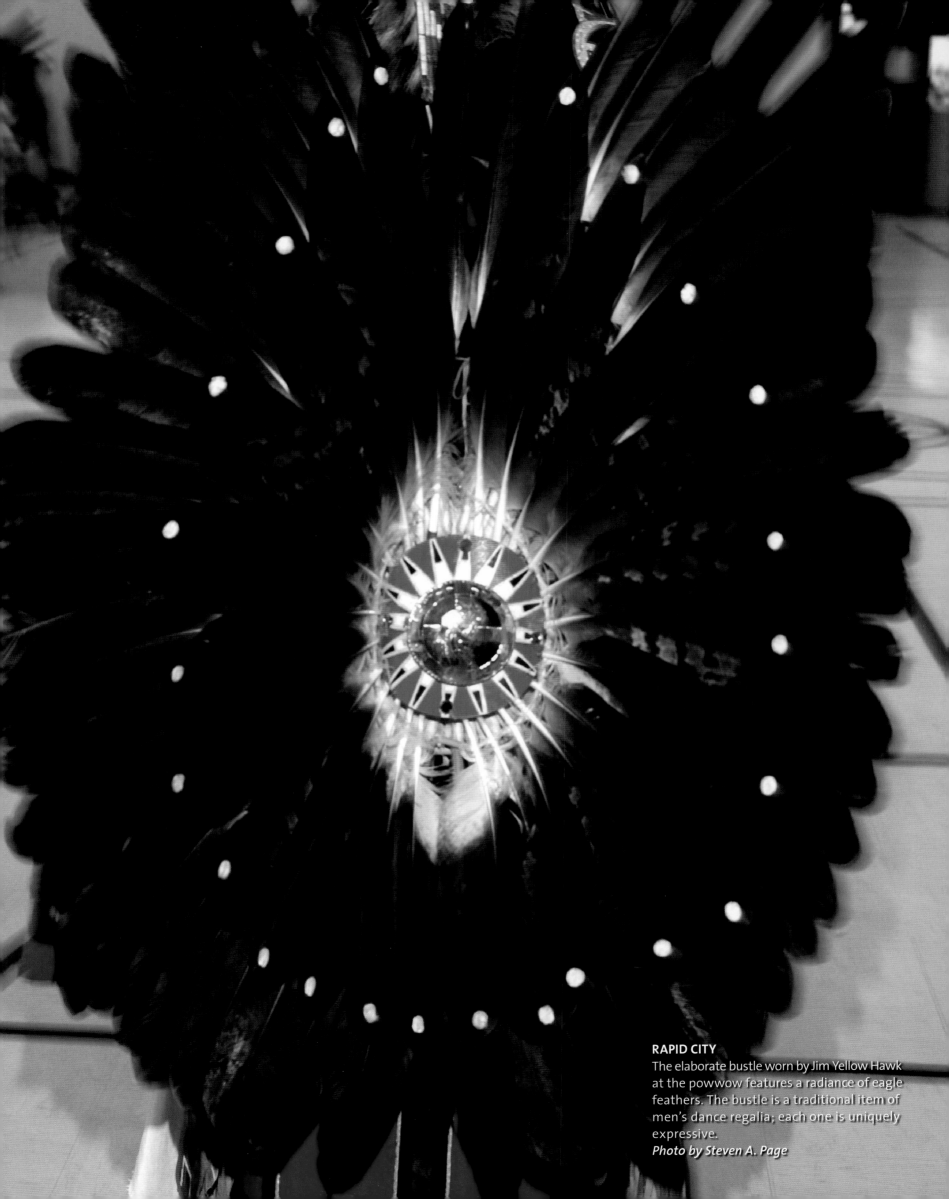

RAPID CITY
The elaborate bustle worn by Jim Yellow Hawk at the powwow features a radiance of eagle feathers. The bustle is a traditional item of men's dance regalia; each one is uniquely expressive.
Photo by Steven A. Page

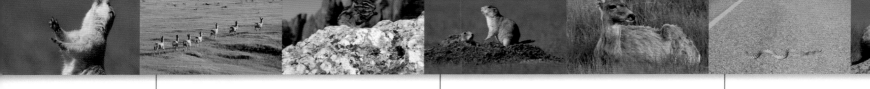

BADLANDS NATIONAL PARK
Mule deer share the prairie with pronghorn antelope, bison, prairie dogs, and black-footed ferrets. The lush grass is a welcome result of the spring rains that broke a two-year drought.
Photo by Dick Kettlewell

BADLANDS NATIONAL PARK
Sociable black-tailed prairie dogs live in a network of mounds and burrows, creating whole prairie dog towns beneath the soil. But the cute critters now have to contend with recent releases of endangered black-footed ferrets into their Badlands burrows. The ferrets eat only one thing—prairie dogs.
Photo by Dick Kettlewell

FAIRBURN
Why did the bull snake cross the road? To escape the vigilante mob. The non-poisonous reptiles have a bad rap in South Dakota—they're often mistaken for rattlesnakes and killed with the nearest garden implement. This one slithers away across Highway 44.
Photo by Johnny Sundby,
Dakota Skies Photography

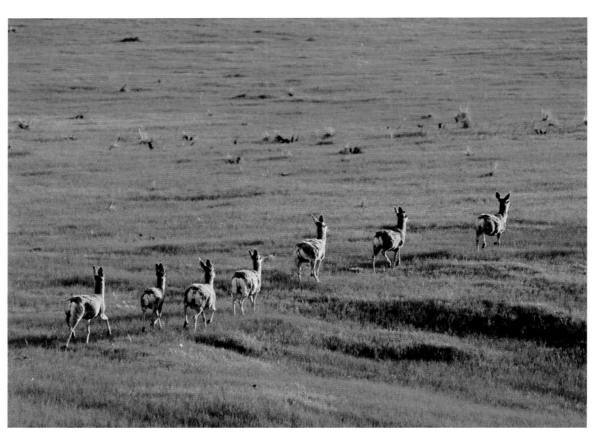

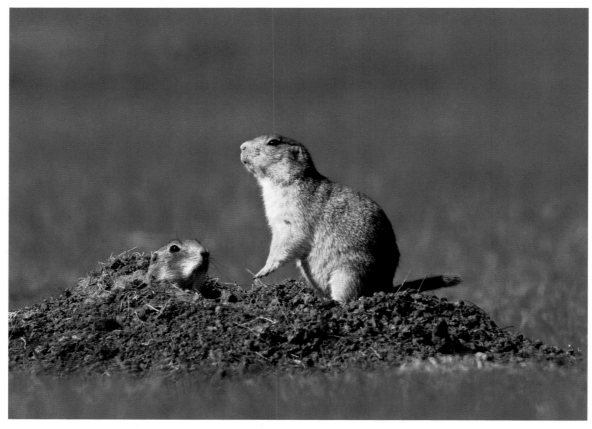

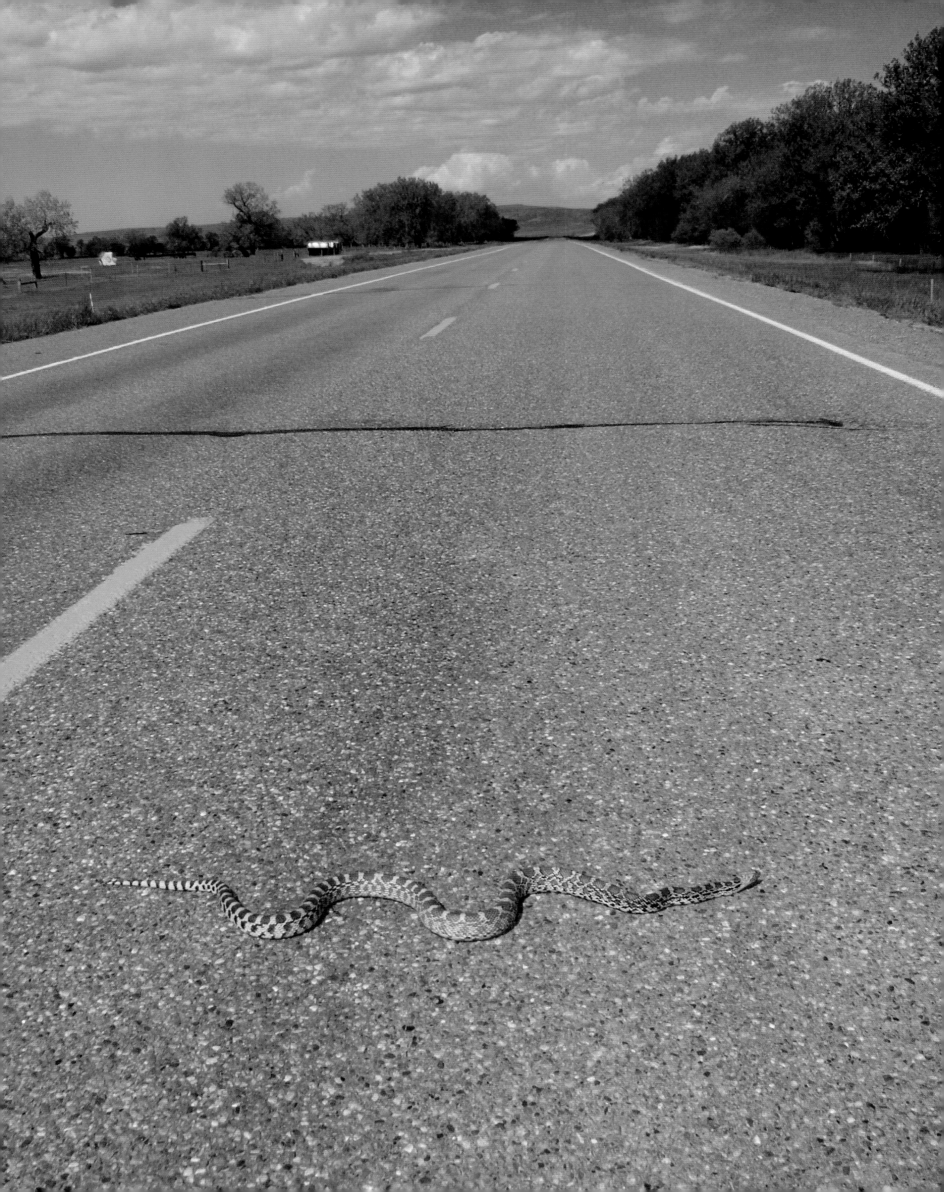

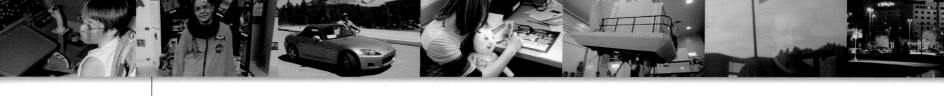

For a citywide middle-school assignment, students make displays about, and dress like, their personal heroes. Sixth-grader Emily Palmer chose astronaut Kalpana Chawla, who got her PhD in aerospace engineering in Colorado. Chawla worked in computational fluid dynamics at the NASA Ames Research Center, and died on the space shuttle *Columbia* in February 2003.
Photos by Mike Wolforth

ELLSWORTH AIR FORCE BASE

Kyleen Kinniburgh, happily camouflaged as if she were not a fourth-grader at Rapid Valley Elementary School, copilots a B-1B bomber at Ellsworth Air Force Base. Her visit is part of Starbase, a national program to give young people a hands-on introduction to science, math, aeronautics, and technology.

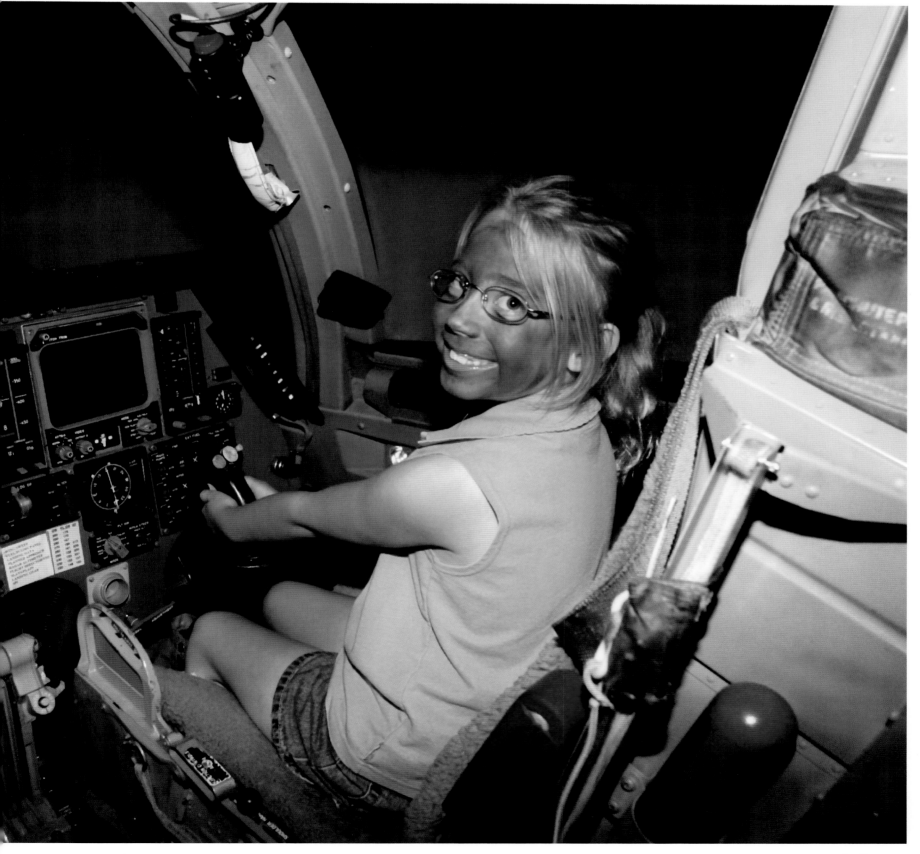

BROOKINGS

Upside-down engine oil pans serve as twin heads for Lyle Telkamp's towering highway monster. When he retired, about six years ago, Telkamp began tinkering around in his workshop and discovered that he had a knack for conjuring creatures out of scrap metal. "'Artist' is a kind way of putting it," says Telkamp. "I just weld together a bunch of junk."

Photo by Eric Landwehr

RAPID CITY

Dinosaur Park was created in 1936 with Works Progress Administration funding to capitalize on the success of nearby Mount Rushmore. The park was originally home to five prehistoric concrete creatures, including this 80-foot-long, 28-foot-tall brontosaurus. Two more giant reptile replicas were added in the 1960s.

Photo by Kathie Larson

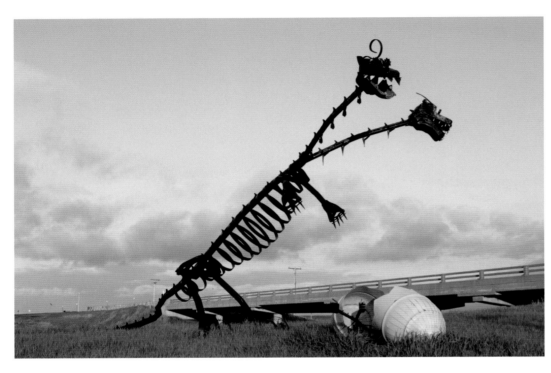

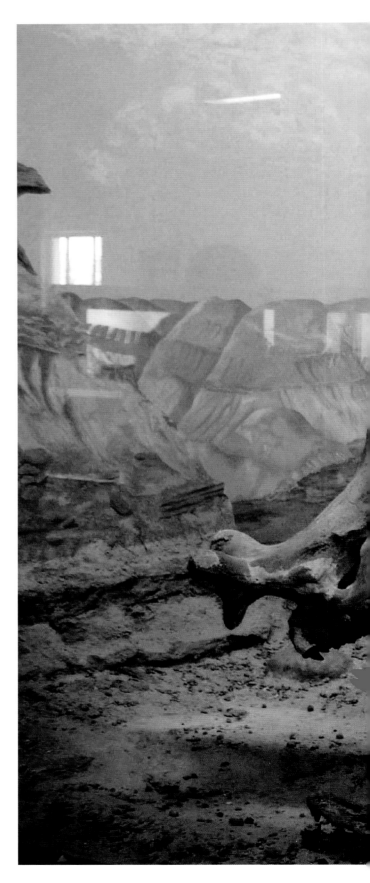

RAPID CITY

A life-size replica of a *Brontops robustus* captivates the imagination of dinosaur-obsessed Evan Sundby. The 4-year-old didn't mind that the Brontops is actually not a dinosaur but an extinct plant-eating relative of the horse that once flourished in the South Dakota Badlands.
Photo by Johnny Sundby,
Dakota Skies Photography

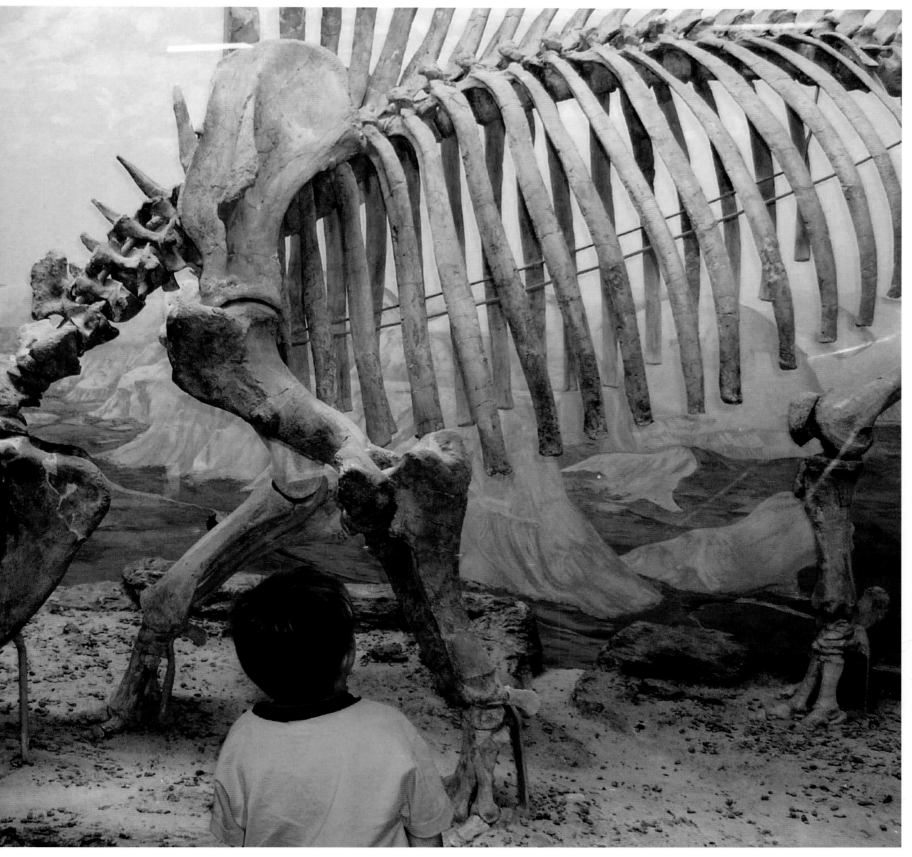

ENNING

There are nine K–8 schools left in the Meade County School District. Kelsey Baldwin is one of 42 students at Enning Country School, the largest, composed of two trailers. In South Dakota's far-flung rural areas, declining populations have forced schools to consolidate. Since 1970, the state's school-age population has dropped by nearly a third.

Photo by Val Hoeppner

BROOKINGS
Hillcrest Elementary first- and second-graders chime in with a refrain during the school's spring musical "How Does Your Garden Grow?" The concert highlights include a hoedown number performed by a vegetable ensemble and a rap song performed by a chorus of weeds.
Photo by Eric Landwehr

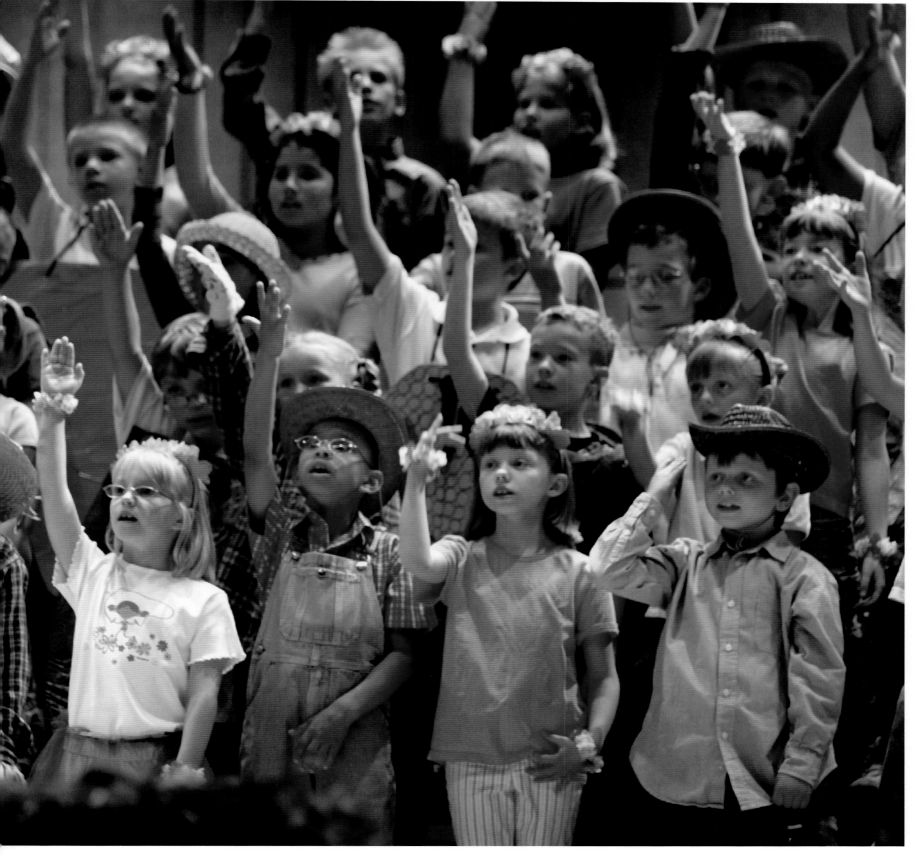

PIERRE
Smack in the middle of the state, on North Euclid, the Pierre Motel caters to construction workers, fishermen, hunters, maybe a lobbyist bound for the State Capitol, and just about anybody else who comes to town. A double room runs $38.95, plus tax.
Photo by Chad Coppess, South Dakota Tourism and State Development

ELKTON
I-29 runs north-south along the eastern border of the state, connecting Watertown, Brookings, and Sioux Falls to Sioux City, Iowa.
Photo by Greg Latza, peoplescapes.com

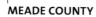

MEADE COUNTY

Siberian elm trees punctuate the amber glow in Meade County, five miles north of Rapid City. The Department of Game, Fish and Parks encourages landowners to maintain "shelter belts" with cost-share programs for planting native trees and shrubs.
Photo by Markus Erk

FORT THOMPSON

Power line towers rise over the Big Bend Dam on the Missouri River. The Big Bend plant harnesses enough energy from the river to light up 95,000 homes.
Photo by Doug Dreyer, Dakota Images

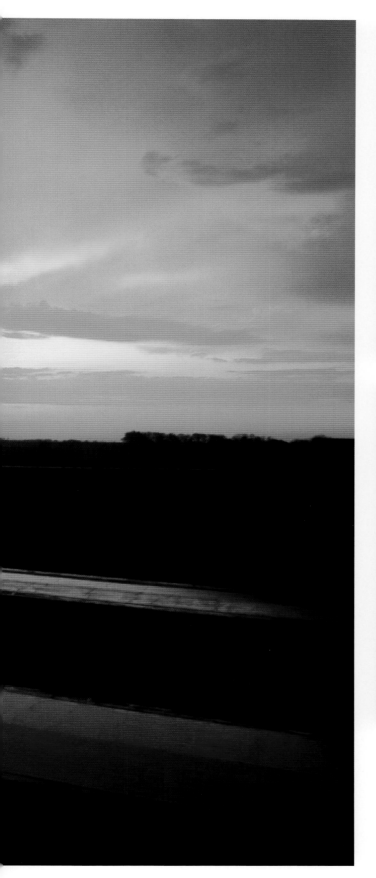

BADLANDS NATIONAL PARK
French-Canadian trappers described the arid lands of northwestern South Dakota as *les mauvaises terres à traverser* or "bad lands to cross."
Photo by Dick Kettlewell

How It Worked

The week of May 12-18, 2003, more than 25,000 professional and amateur photographers spread out across the nation to shoot over a million digital photographs with the goal of capturing the essence of daily life in America.

The professional photographers were equipped with Adobe Photoshop and Adobe Album software, Olympus C-5050 digital cameras, and Lexar Media's high-speed compact flash cards.

The 1,000 professional contract photographers plus another 5,000 stringers and students sent their images via FTP (file transfer protocol) directly to the *America 24/7* website. Meanwhile, thousands of amateur photographers uploaded their images to Snapfish's servers.

At *America 24/7*'s Mission Control headquarters, located at CNET in San Francisco, dozens of picture editors from the nation's most prestigious publications culled the images down to 25,000 of the very best, using Photo Mechanic by Camera Bits. These photos were transferred into Webware's ActiveMedia Digital Asset Management (DAM) system, which served as a central image library and enabled the designers to track, search, distribute, and reformat the images for the creation of the 51 books, foreign language editions, web and magazine syndication, posters, and exhibitions.

Once in the DAM, images were optimized (and in some cases resampled to increase image resolution) using Adobe Photoshop. Adobe InDesign and Adobe InCopy were used to design and produce the 51 books, which were edited and reviewed in multiple locations around the world in the form of Adobe Acrobat PDFs. Epson Stylus printers were used for photo proofing and to produce large-format images for exhibitions. The companies providing support for the *America 24/7* project offer many of the essential components for anyone building a digital darkroom. We encourage you to read more on the following pages about their respective roles in making *America 24/7* possible.

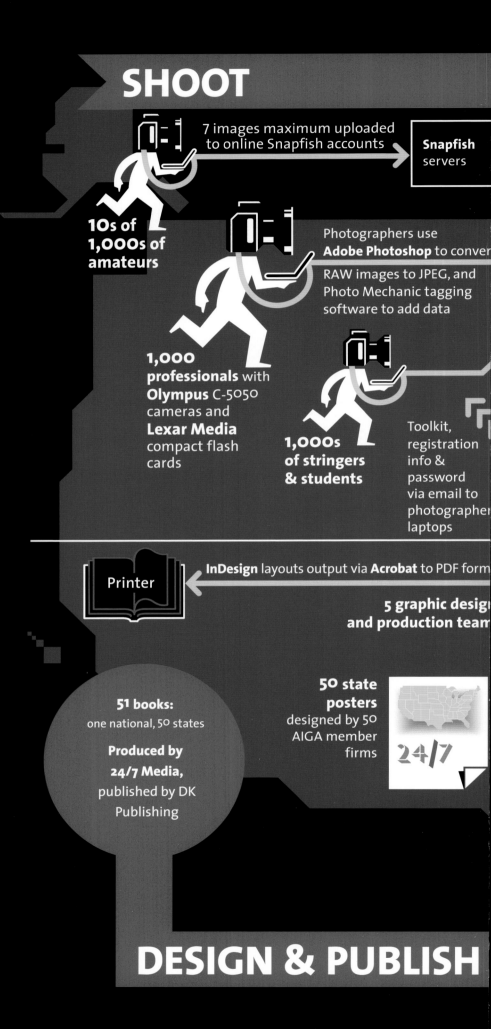

SHOOT

7 images maximum uploaded to online Snapfish accounts → **Snapfish** servers

10s of 1,000s of amateurs

Photographers use **Adobe Photoshop** to conver[t] RAW images to JPEG, and Photo Mechanic tagging software to add data

1,000 professionals with **Olympus** C-5050 cameras and **Lexar Media** compact flash cards

1,000s of stringers & students

Toolkit, registration info & password via email to photographer[s] laptops

InDesign layouts output via **Acrobat** to PDF form[at]

Printer

5 graphic desig[n] and production team[s]

51 books: one national, 50 states

Produced by 24/7 Media, published by DK Publishing

50 state posters designed by 50 AIGA member firms

24/7

DESIGN & PUBLISH

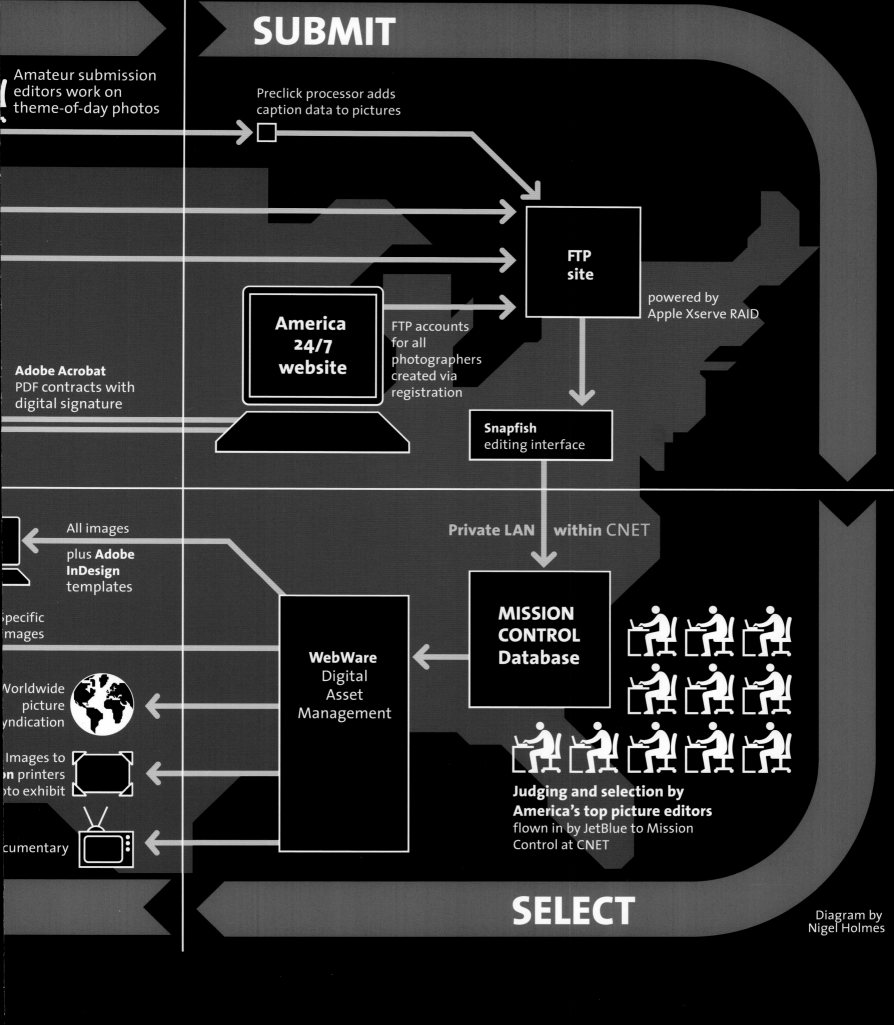

SUBMIT

Amateur submission editors work on theme-of-day photos

Preclick processor adds caption data to pictures

FTP site

powered by Apple Xserve RAID

America 24/7 website

FTP accounts for all photographers created via registration

Adobe Acrobat PDF contracts with digital signature

Snapfish editing interface

All images

plus **Adobe InDesign** templates

Private LAN within CNET

Specific images

MISSION CONTROL Database

WebWare Digital Asset Management

Worldwide picture syndication

Images to printers to exhibit

Judging and selection by America's top picture editors flown in by JetBlue to Mission Control at CNET

cumentary

SELECT

Diagram by Nigel Holmes

About Our Sponsors

America 24/7 gave digital photographers of all levels the opportunity to share their visions of what it means to live in the United States. This project was made possible by a digital photography revolution that is dramatically changing and improving picture-taking for professionals and amateurs alike. And an Adobe product, Photoshop®, has been at the center of this sea change.

Adobe's products reflect our customers' passion for the creative process, be it the photographer, graphic designer, layout artist, or printer. Adobe is the Publishing and Imaging Software Partner for *America 24/7* and products such as Adobe InDesign®, Photoshop, Acrobat®, and Illustrator® were used to produce this stunning book in a matter of weeks. We hope that our software has helped do justice to the mythic images, contributed by well-known photographers and the inspired hobbyist.

Adobe is proud to be a lead sponsor of *America 24/7*, a project that celebrates the vibrancy of the American spirit: the same spirit that helped found Adobe and inspires our employees and customers to deliver the very best.

Bruce Chizen
President and CEO
Adobe Systems Incorporated

OLYMPUS

Olympus, a global technology leader in designing precision healthcare solutions and innovative consumer electronics, is proud to be the official digital camera sponsor of *America 24/7*. The opportunity to introduce Americans from coast to coast to the thrill, excitement, and possibility of digital photography makes the vision behind this book a perfect fit for Olympus, a leader in digital cameras since 1996.

For most people, the essence of digital photography is best grasped through firsthand experience with the technology, which is precisely what *America 24/7* is about. We understand that direct experience is the pathway to inspiration, and welcome opportunities like this sponsorship to bring the power of the digital experience into the lives of people everywhere. To Olympus, *America 24/7* offers a platform to help realize a core mission: to deliver and make accessible the power of the digital experience to millions of American photographers, amateurs, and professionals alike.

The 1,000 professional photographers contracted to shoot on the America 24/7 project were all equipped with Olympus C-5050 digital cameras. Like all Olympus products, the C-5050 is offered by a company well known for designing, manufacturing, and servicing products used by professionals to perform their work, every day. Olympus is a customer-centric company committed to working one-to-one with a diverse group of professionals. From biomedical researchers who use our clinical microscopes, to doctors who perform life-saving procedures with our endo-scopes, to professional photographers who use cameras in their daily work, Olympus is a trusted brand.

The digital imaging technology involved with *America 24/7* has enabled the soul of America to be visually conveyed, not just by professional observers, but by the American public who participated in this project—the very people who collectively breath life into this country's existence each day.

We are proud to be enabling so many photographers to capture the pictures on these pages that tell the story of who we are as a nation. From sea to shining sea, digital imagery allows us to connect to one another in ways we never dreamed possible.

At Olympus, our ideas have proliferated as rapidly as technology has evolved. We have channeled these visions into breakthrough products and solutions to meet the demands of our changing world-products like microscopes, endoscopes, and digital voice recorders, supported by the highly regarded training, educational, and consulting services we offer our customers.

Today, 83 years after we introduced our first microscope, we remain as young, as curious, and as committed as ever.

Lexar Media has grown from the digital photography revolution, which is why we are proud to have supplied the digital memory cards used in the America 24/7 project. Lexar Media's high-performance memory cards utilize our unique and patented controller coupled with high-speed flash memory from Samsung, the world's largest flash memory supplier. This powerful combination brings out the ultimate performance of any digital camera.

Photographers who demand the most from their equipment choose our products for their advanced features like write speeds up to 40X, Write Acceleration technology for enabled cameras, and Image Rescue, which recovers previously deleted or lost images. Leading camera manu-facturers bundle Lexar Media digital memory cards with their cameras because they value its performance and reliability.

Lexar Media is at the forefront of digital photography as it transforms picture-taking worldwide, and we will continue to be a leader with new and innovative solutions for profes-sionals and amateurs alike.

Snapfish, which developed the technology behind the *America 24/7* amateur photo event, is a leading online photo service, with more than 5 million members and 100 million photos posted online. Snapfish enables both film and digital camera owners to share, print, and store their most important photo memories, at prices that cannot be equaled. Digital camera users upload photos into a password-protected online album for free. Users can also order film-quality prints on professional photographic paper for as low as 25¢. Film camera users get a full set of prints, plus online sharing and storage, for just $2.99 per roll.

Founded in 1995, eBay created a powerful platform for the sale of goods and services by a passionate community of individuals and businesses. On any given day, there are millions of items across thousands of categories for sale on eBay. eBay enables trade on a local, national and international basis with customized sites in markets around the world.

Through an array of services, such as its payment solution provider PayPal, eBay is enabling global e-commerce for an ever-growing online community.

JetBlue Airways is proud to be *America 24/7's* preferred carrier, flying photographers, photo editors, and organizers across the United States.

Winner of Condé Nast Traveler's Readers' Choice Awards for Best Domestic Airline 2002, JetBlue provides friendly service and low fares for travelers in 22 cities in nine states across America.

On behalf of JetBlue's 5,000 crew members, we're excited to be involved in this remarkable project, and for the opportunity to serve American travelers each and every day, coast to coast, 24/7.

DIGITAL POND

Digital Pond has been a leading creator of large graphic displays for museums, corporations, trade shows, retail environments and fine art since 1992.

We were proud to bring together our creative, print and display capabilities to produce signage and displays for mission control, critical retouching for numerous key images for the book, and art galleries for the New York Public Library and Bryant Park.

The Pond's team and SplashPic® Online service enabled us to nimbly design, produce and install over 200 large graphic panels in two NYC locations within the truly "24/7" production schedule of less than ten days.

⊚ WEBWARE™

WebWare Corporation is pleased to be a major sponsor of the America 24/7 project. We take pride in being part of a groundbreaking adventure that is stretching the boundaries—and the imagination—in digital photography, digital asset management, publishing, news, and global events.

Our ActiveMedia Enterprise™ digital asset management software is the "nerve center" of *America 24/7*, the central repository for managing, sharing, and collaborating on the project's photographs. From photo editors and book publishers to 24/7's media relations and marketing personnel, ActiveMedia provides the application support that links all facets of the project team to the content worldwide.

WebWare helps Global 2000 firms securely manage, reuse, and distribute media assets locally or globally. Its suite of ActiveMedia software products provide powerful media services platforms for integrating rich media into content management systems marketing and communication portals; web publishing systems; and e-commerce portals.

Google's mission is to organize the world's information and make it universally accessible and useful.

With our focus on plucking just the right answer from an ocean of data, we were naturally drawn to the America 24/7 project. The book you hold is a compendium of images of American life distilled from thousands of photographs and infinite possibilities. Are you looking for emotion? Narrative? Shadows? Light? It's all here, thanks to a multitude of photographers and writers creating links between you, the reader, and a sea of wonderful stories. We celebrate the connections that constitute the human experience and are pleased to help engender them. And we're pleased to have been a small part of this project, which captures the results of that interaction so vividly, so dynamically, and so dramatically.

Special thanks to additional contributors: FileMaker, Apple, Camera Bits, LaCie, Now Software, Preclick, Outpost Digital, Xerox, Microsoft, WoodWing Software, net-linx Publishing Solutions, and Radical Media. The Savoy Hotel, San Francisco; The Pan Pacific, San Francisco; Four Seasons Hotel, San Francisco; and The Queen Anne Hotel. Photography editing facilities were generously hosted by CNET Networks, Inc.

Participating Photographers

South Dakota Coordinator: Lloyd B. Cunningham, Senior Photographer, *The Argus Leader*

Steve Babbitt
Dennes Barrett
Dick Carlson
Chad Coppess, South Dakota Tourism and State Development
Cody Coppess
Lloyd B. Cunningham, *The Argus Leader*
Don Doll, S.J., Creighton University
Doug Dreyer, Dakota Images
Kevin Eilbeck
Markus Erk
Val Hoeppner
Dick Kettlewell
Eric Landwehr
Kathie Larson

Greg Latza, peoplescapes.com
Candy Erk Manthey
Steven McEnroe
Mike Normile
Rob O'Keefe
Steven A. Page
Jason Rollison
Tom Russell
Dave Sietsema
Chad Spicer
Johnny Sundby, Dakota Skies Photography
Ted Williams
Mike Wolforth

Thumbnail Picture Credits

Credits for thumbnail photographs are listed by the page number and are in order from left to right.

20 Dave Sietsema
Greg Latza, peoplescapes.com
Greg Latza, peoplescapes.com
Dave Sietsema
Greg Latza, peoplescapes.com
Markus Erk
Greg Latza, peoplescapes.com

22 Kevin Eilbeck
Doug Dreyer, Dakota Images
Kevin Eilbeck
Kevin Eilbeck
Johnny Sundby, Dakota Skies Photography
Kevin Eilbeck
Kevin Eilbeck

23 Johnny Sundby, Dakota Skies Photography
Kevin Eilbeck
Kevin Eilbeck
Kevin Eilbeck
Kevin Eilbeck
Dick Kettlewell
Kevin Eilbeck

25 Lloyd B. Cunningham, *The Argus Leader*
Johnny Sundby, Dakota Skies Photography
Lloyd B. Cunningham, *The Argus Leader*
Lloyd B. Cunningham, *The Argus Leader*
Markus Erk
Lloyd B. Cunningham, *The Argus Leader*
Lloyd B. Cunningham, *The Argus Leader*

26 Doug Dreyer, Dakota Images
Mike Wolforth
Mike Wolforth
Mike Wolforth
Mike Wolforth
Mike Wolforth
Mike Wolforth

27 Mike Wolforth
Mike Wolforth
Mike Wolforth
Mike Wolforth
Mike Wolforth
Mike Wolforth
Mike Wolforth

28 Dave Sietsema
Markus Erk
Dave Sietsema
Markus Erk
Markus Erk
Markus Erk
Dave Sietsema

29 Dave Sietsema
Markus Erk
Dave Sietsema
Dave Sietsema
Dave Sietsema
Kevin Eilbeck
Markus Erk

30 Markus Erk
Eric Landwehr
Doug Dreyer, Dakota Images
Mike Wolforth
Kevin Eilbeck
Eric Landwehr
Jason Rollison

31 Eric Landwehr
Kevin Eilbeck
Kevin Eilbeck
Kevin Eilbeck
Eric Landwehr
Steven McEnroe
Johnny Sundby, Dakota Skies Photography

32 Johnny Sundby, Dakota Skies Photography
Johnny Sundby, Dakota Skies Photography
Kevin Eilbeck
Eric Landwehr
Markus Erk
Markus Erk
Dick Kettlewell

33 Johnny Sundby, Dakota Skies Photography
Johnny Sundby, Dakota Skies Photography
Markus Erk
Johnny Sundby, Dakota Skies Photography
Eric Landwehr
Mike Wolforth
Steven A. Page

40 Markus Erk
Dave Sietsema
Doug Dreyer, Dakota Images
Lloyd B. Cunningham, *The Argus Leader*
Dave Sietsema
Markus Erk
Markus Erk

41 Markus Erk
Candy Erk Manthey
Doug Dreyer, Dakota Images
Dave Sietsema
Dave Sietsema
Markus Erk
Lloyd B. Cunningham, *The Argus Leader*

42 Markus Erk
Markus Erk
Don Doll, S.J., Creighton University
Markus Erk
Doug Dreyer, Dakota Images
Chad Coppess,
South Dakota Tourism and State Development
Don Doll, S.J., Creighton University

43 Chad Coppess,
South Dakota Tourism and State Development
Don Doll, S.J., Creighton University
Johnny Sundby, Dakota Skies Photography
Dave Sietsema
Johnny Sundby, Dakota Skies Photography
Val Hoeppner

44 Markus Erk
Chad Coppess,
South Dakota Tourism and State Development
Don Doll, S.J., Creighton University
Markus Erk
Dick Kettlewell
Steven McEnroe
Dick Kettlewell

45 Chad Coppess,
South Dakota Tourism and State Development
Steven McEnroe
Markus Erk
Steven McEnroe
Markus Erk
Johnny Sundby, Dakota Skies Photography
Markus Erk

46 Kathie Larson
Kevin Eilbeck
Kevin Eilbeck
Kevin Eilbeck
Kevin Eilbeck
Kevin Eilbeck

47 Kevin Eilbeck
Kevin Eilbeck
Kevin Eilbeck
Kevin Eilbeck
Kevin Eilbeck
Kathie Larson
Kevin Eilbeck

49 Lloyd B. Cunningham, *The Argus Leader*
Lloyd B. Cunningham, *The Argus Leader*
Jason Rollison
Lloyd B. Cunningham, *The Argus Leader*
Lloyd B. Cunningham, *The Argus Leader*
Steven A. Page
Lloyd B. Cunningham, *The Argus Leader*

50 Kevin Eilbeck
Kevin Eilbeck
Jason Rollison
Kevin Eilbeck
Michael T. Northrup, University of South Dakota
Michael T. Northrup, University of South Dakota
Michael T. Northrup, University of South Dakota

51 Michael T. Northrup, University of South Dakota
Steve Babbitt
Michael T. Northrup, University of South Dakota
Michael T. Northrup, University of South Dakota
Kevin Eilbeck
Michael T. Northrup, University of South Dakota
Michael T. Northrup, University of South Dakota

52 Steve Babbitt
Steve Babbitt
Steve Babbitt
Steve Babbitt
Steve Babbitt
Steve Babbitt
Steve Babbitt

53 Steve Babbitt
Steve Babbitt
Steve Babbitt
Steve Babbitt
Steve Babbitt
Steve Babbitt
Steve Babbitt

54 Dave Sietsema
Dave Sietsema
Dave Sietsema
Greg Latza, peoplescapes.com
Greg Latza, peoplescapes.com
Dave Sietsema
Dave Sietsema

55 Mike Wolforth
Greg Latza, peoplescapes.com
Greg Latza, peoplescapes.com
Greg Latza, peoplescapes.com
Mike Wolforth
Greg Latza, peoplescapes.com
Greg Latza, peoplescapes.com

56 Steven A. Page
Doug Dreyer, Dakota Images
Steven A. Page
Steve Babbitt

57 Mike Wolforth
Steve Babbitt
Doug Dreyer, Dakota Images
Steve Babbitt
Steven A. Page
Steven A. Page

58 Val Hoeppner
Markus Erk
Val Hoeppner
Val Hoeppner
Markus Erk
Val Hoeppner
Val Hoeppner

59 Val Hoeppner
Val Hoeppner
Markus Erk
Val Hoeppner
Val Hoeppner
Val Hoeppner
Val Hoeppner

60 Dick Kettlewell
Eric Landwehr
Johnny Sundby, Dakota Skies Photography
Janez A. Sever
Dick Kettlewell
Mike Wolforth
Dick Kettlewell

61 Mike Wolforth
Johnny Sundby, Dakota Skies Photography
Johnny Sundby, Dakota Skies Photography
Don Doll, S.J., Creighton University
Janez A. Sever
Johnny Sundby, Dakota Skies Photography
Janez A. Sever

62 Eric Landwehr
Johnny Sundby, Dakota Skies Photography
Steven McEnroe
Eric Landwehr
Steven McEnroe
Steven McEnroe
Mike Wolforth

63 Steven McEnroe
Eric Landwehr
Steven McEnroe
Johnny Sundby, Dakota Skies Photography
Steven McEnroe
Steven McEnroe
Eric Landwehr

64 Doug Dreyer, Dakota Images
Dave Sietsema
Eric Landwehr
Eric Landwehr
Mike Wolforth
Dick Kettlewell
Steven A. Page

65 Mike Wolforth
Mike Wolforth
Mike Wolforth
Steven A. Page
Dave Sietsema
Mike Wolforth
Johnny Sundby, Dakota Skies Photography

66 Eric Landwehr
Mike Wolforth
Mike Wolforth
Eric Landwehr
Eric Landwehr
Markus Erk
Mike Wolforth

67 Dave Sietsema
Dave Sietsema
Markus Erk
Doug Dreyer, Dakota Images
Dave Sietsema
Eric Landwehr
Mike Wolforth

70 Val Hoeppner
Chad Coppess,
South Dakota Tourism and State Development
Dave Sietsema
Val Hoeppner
Val Hoeppner
Val Hoeppner
Val Hoeppner

71 Val Hoeppner
Val Hoeppner
Dave Sietsema
Val Hoeppner
Val Hoeppner
Val Hoeppner
Val Hoeppner

72 Eric Landwehr
Mike Wolforth
Eric Landwehr
Jason Rollison
Eric Landwehr
Jason Rollison
Johnny Sundby, Dakota Skies Photography

76 Dick Carlson
Steve Babbitt
Dick Carlson
Steve Babbitt
Steve Babbitt
Dick Carlson
Dick Carlson

77 Dick Carlson
Steve Babbitt
Dick Carlson
Dick Carlson
Dick Carlson
Steve Babbitt
Dick Carlson

78 Mike Wolforth
Chad Coppess,
South Dakota Tourism and State Development
Val Hoeppner
Chad Coppess,
South Dakota Tourism and State Development
Mike Wolforth
Mike Wolforth
Mike Wolforth

79 Mike Wolforth
Mike Wolforth
Mike Wolforth
Mike Wolforth
Mike Wolforth
Janez A. Sever
Mike Wolforth

80 Kevin Eilbeck
Eric Landwehr
Dave Sietsema
Kevin Eilbeck
Johnny Sundby, Dakota Skies Photography
Kevin Eilbeck
Chad Coppess,
South Dakota Tourism and State Development

81 Eric Landwehr
Kevin Eilbeck
Jason Rollison
Kevin Eilbeck
Steven A. Page
Mike Wolforth
Johnny Sundby, Dakota Skies Photography

82 Eric Landwehr
Eric Landwehr
Jason Rollison
Eric Landwehr
Michael T. Northrup, University of South Dakota
Eric Landwehr

83 Michael T. Northrup, University of South Dakota
Eric Landwehr
Steve Babbitt
Eric Landwehr
Steve Babbitt
Eric Landwehr
Eric Landwehr

84 Eric Landwehr
Val Hoeppner
Eric Landwehr
Steven A. Page
Eric Landwehr
Steven A. Page
Eric Landwehr

85 Steven McEnroe
Val Hoeppner
Eric Landwehr
Steve Babbitt
Steven A. Page
Steve Babbitt
Eric Landwehr

90 Don Doll, S.J., Creighton University
Don Doll, S.J., Creighton University
Steven A. Page
Don Doll, S.J., Creighton University
Don Doll, S.J., Creighton University
Mike Wolforth
Don Doll, S.J., Creighton University

91 Don Doll, S.J., Creighton University
Don Doll, S.J., Creighton University
Steven A. Page
Don Doll, S.J., Creighton University
Don Doll, S.J., Creighton University
Don Doll, S.J., Creighton University
Don Doll, S.J., Creighton University

94 Mike Wolforth
Don Doll, S.J., Creighton University
Don Doll, S.J., Creighton University
Don Doll, S.J., Creighton University
Johnny Sundby, Dakota Skies Photography
Don Doll, S.J., Creighton University
Mike Wolforth

96 Markus Erk
Kevin Eilbeck
Doug Dreyer, Dakota Images
Val Hoeppner
Steven McEnroe
Janez A. Sever
Dick Kettlewell

97 Kevin Eilbeck
Kevin Eilbeck
Steven A. Page
Kevin Eilbeck
Val Hoeppner
Kevin Eilbeck
Lloyd B. Cunningham, *The Argus Leader*

98 Markus Erk
Don Doll, S.J., Creighton University
Eric Landwehr
Chad Coppess,
South Dakota Tourism and State Development
Chad Coppess,
South Dakota Tourism and State Development
Don Doll, S.J., Creighton University
Jason Rollison

99 Don Doll, S.J., Creighton University
Don Doll, S.J., Creighton University
Jason Rollison
Jason Rollison
Markus Erk
Don Doll, S.J., Creighton University
Jason Rollison

102 Steven A. Page
Johnny Sundby, Dakota Skies Photography
Mike Wolforth
Mike Wolforth
Kathie Larson
Kevin Eilbeck
Mike Wolforth

104 Mike Wolforth
Mike Wolforth
Mike Wolforth
Mike Wolforth
Mike Wolforth
Mike Wolforth
Mike Wolforth

107 Steve Babbitt
Steve Babbitt
Doug Dreyer, Dakota Images
Johnny Sundby, Dakota Skies Photography
Steve Babbitt
Doug Dreyer, Dakota Images
Johnny Sundby, Dakota Skies Photography

109 Chad Coppess,
South Dakota Tourism and State Development
Steve Babbitt
Don Doll, S.J., Creighton University
Steven A. Page
Steven McEnroe
Doug Dreyer, Dakota Images
Steven A. Page

110 Chad Coppess,
South Dakota Tourism and State Development
Steven A. Page
Chad Coppess,
South Dakota Tourism and State Development
Chad Coppess,
South Dakota Tourism and State Development
Kathie Larson
Chad Coppess,
South Dakota Tourism and State Development
Mike Wolforth

111 Chad Coppess,
South Dakota Tourism and State Development
Doug Dreyer, Dakota Images
Chad Coppess,
South Dakota Tourism and State Development
Jason Rollison
Kathie Larson
Chad Coppess,
South Dakota Tourism and State Development
Steven A. Page

112 Greg Latza, peoplescapes.com
Steven A. Page
Greg Latza, peoplescapes.com
Greg Latza, peoplescapes.com
Greg Latza, peoplescapes.com
Dick Kettlewell
Greg Latza, peoplescapes.com

114 Chad Coppess,
South Dakota Tourism and State Development
Dick Kettlewell
Doug Dreyer, Dakota Images
Steven McEnroe
Chad Coppess,
South Dakota Tourism and State Development
Dick Kettlewell
Steven A. Page

115 Kevin Eilbeck
Steven McEnroe
Dick Kettlewell
Doug Dreyer, Dakota Images
Steven McEnroe
Chad Coppess,
South Dakota Tourism and State Development
Steven McEnroe

116 Dick Kettlewell
Johnny Sundby, Dakota Skies Photography
Dick Kettlewell
Dick Kettlewell
Johnny Sundby, Dakota Skies Photography
Steven A. Page

117 Dick Kettlewell
Johnny Sundby, Dakota Skies Photography
Dick Kettlewell
Johnny Sundby, Dakota Skies Photography
Dick Kettlewell
Dick Kettlewell
Dick Kettlewell

118 Dick Kettlewell
Jason Rollison
Dick Kettlewell
Candy Erk Manthey
Eric Landwehr
Greg Latza, peoplescapes.com
Steve Babbitt

120 Dick Kettlewell
Dick Kettlewell
Johnny Sundby, Dakota Skies Photography
Dick Kettlewell
Dick Kettlewell
Dick Kettlewell
Dick Kettlewell

121 Dick Kettlewell
Dick Kettlewell
Jason Rollison
Steven McEnroe
Dick Kettlewell
Johnny Sundby, Dakota Skies Photography
Johnny Sundby, Dakota Skies Photography

124 Dick Kettlewell
Dick Kettlewell
Chad Coppess,
South Dakota Tourism and State Development
Dick Kettlewell
Dick Kettlewell
Johnny Sundby, Dakota Skies Photography
Dick Kettlewell

126 Mike Wolforth
Mike Wolforth
Mike Wolforth
Mike Wolforth
Mike Wolforth
Kevin Eilbeck
Mike Wolforth

127 Mike Wolforth
Johnny Sundby, Dakota Skies Photography
Mike Wolforth
Steven McEnroe
Mike Wolforth
Mike Wolforth
Mike Wolforth

128 Chad Coppess,
South Dakota Tourism and State Development
Eric Landwehr
Doug Dreyer, Dakota Images
Kathie Larson
Doug Dreyer, Dakota Images
Dick Kettlewell
Dick Kettlewell

129 Dick Kettlewell
Dick Kettlewell
Dick Kettlewell
Steven A. Page
Johnny Sundby, Dakota Skies Photography
Dick Kettlewell
Mike Wolforth

130 Eric Landwehr
Eric Landwehr
Kathie Larson
Val Hoeppner
Mike Wolforth
Dick Kettlewell
Steven A. Page

131 Steven A. Page
Steven McEnroe
Val Hoeppner
Eric Landwehr
Steven A. Page
Steven McEnroe
Val Hoeppner

134 Markus Erk
Steven A. Page
Greg Latza, peoplescapes.com
Steven A. Page
Dick Kettlewell
Steven McEnroe
Dick Kettlewell

135 Dick Kettlewell
Dick Kettlewell
Markus Erk
Dick Kettlewell
Doug Dreyer, Dakota Images
Steven A. Page
Dick Kettlewell

Staff

The *America 24/7* series was imagined years ago by our friend Oscar Dystel, a publishing legend whose vision and enthusiasm have been a source of great inspiration.

We also wish to express our gratitude to our truly visionary publisher, DK.

Rick Smolan, Project Director
David Elliot Cohen, Project Director

Administrative
Katya Able, Operations Director
Gina Privitere, Communications Director
Chuck Gathard, Technology Director
Kim Shannon, Photographer Relations Director
Erin O'Connor, Photographer Relations Intern
Leslie Hunter, Partnership Director
Annie Polk, Publicity Manager
John McAlester, Website Manager
Alex Notides, Office Manager
C. Thomas Hardin, State Photography Coordinator

Design
Brad Zucroff, Creative Director
Karen Mullarkey, Photography Director
Judy Zimola, Production Manager
David Simoni, Production Designer
Mary Dias, Production Designer
Heidi Madison, Associate Picture Editor
Don McCartney, Production Designer
Diane Dempsey Murray, Production Designer
Jan Rogers, Associate Picture Editor
Bill Shore, Production Designer and Image Artist
Larry Nighswander, Senior Picture Editor
Bill Marr, Sarah Leen, Senior Picture Editors
Peter Truskier, Workflow Consultant
Jim Birkenseer, Workflow Consultant

Editorial
Maggie Canon, Managing Editor
Curt Sanburn, Senior Editor
Teresa L. Trego, Production Editor
Lea Aschkenas, Writer
Olivia Boler, Writer
Korey Capozza, Writer
Beverly Hanly, Writer
Bridgett Novak, Writer
Alison Owings, Writer
Fred Raker, Writer
Joe Wolff, Writer
Elise O'Keefe, Copy Chief
Daisy Hernández, Copy Editor
Jennifer Wolfe, Copy Editor

Infographic Design
Nigel Holmes

Literary Agent
Carol Mann, The Carol Mann Agency

Legal Counsel
Barry Reder, Coblentz, Patch, Duffy & Bass, LLP
Phil Feldman, Coblentz, Patch, Duffy & Bass, LLP
Gabe Perle, Ohlandt, Greeley, Ruggiero & Perle, LLP
Jon Hart, Dow, Lohnes & Albertson, PLLC
Mike Hays, Dow, Lohnes & Albertson, PLLC
Stephen Pollen, Warshaw Burstein, Cohen, Schlesinger & Kuh, LLP
Rick Pappas

Accounting and Finance
Rita Dulebohn, Accountant
Robert Powers, Calegari, Morris & Co. Accountants
Eugene Blumberg, Blumberg & Associates
Arthur Langhaus, KLS Professional Advisors Group, Inc.

Picture Editors
J. David Ake, Associated Press
Caren Alpert, formerly *Health* magazine
Simon Barnett, *Newsweek*
Caroline Couig, *San Jose Mercury News*
Mike Davis, formerly *National Geographic*
Michel duCille, *Washington Post*
Deborah Dragon, *Rolling Stone*
Victor Fisher, formerly Associated Press
Frank Folwell, *USA Today*
MaryAnne Golon, *Time*
Liz Grady, formerly *National Geographic*
Randall Greenwell, *San Francisco Chronicle*
C. Thomas Hardin, formerly *Louisville Courier-Journal*
Kathleen Hennessy, *San Francisco Chronicle*
Scot Jahn, *U.S. News & World Report*
Steve Jessmore, *Flint Journal*
John Kaplan, University of Florida
Kim Komenich, *San Francisco Chronicle*
Eliane Laffont, Hachette Filipacchi Media
Jean-Pierre Laffont, Hachette Filipacchi Media
Andrew Locke, MSNBC
Jose Lopez, *The New York Times*
Maria Mann, formerly AFP
Bill Marr, formerly *National Geographic*
Michele McNally, *Fortune*
James Merithew, *San Francisco Chronicle*
Eric Meskauskas, *New York Daily News*
Maddy Miller, *People* magazine
Michelle Molloy, *Newsweek*
Dolores Morrison, *New York Daily News*
Karen Mullarkey, formerly *Newsweek, Rolling Stone, Sports Illustrated*
Larry Nighswander, Ohio University School of Visual Communication
Jim Preston, *Baltimore Sun*
Sarah Rozen, formerly *Entertainment Weekly*
Mike Smith, *The New York Times*
Neal Ulevich, formerly Associated Press

Website and Digital Systems
Jeff Burchell, Applications Engineer

Television Documentary
Sandy Smolan, Producer/Director
Rick King, Producer/Director
Bill Medsker, Producer

Video News Release
Mike Cerre, Producer/Director

Digital Pond
Peter Hogg
Kris Knight
Roger Graham
Philip Bond
Frank De Pace
Lisa Li

Senior Advisors
Jennifer Erwitt, Strategic Advisor
Tom Walker, Creative Advisor
Megan Smith, Technology Advisor
Jon Kamen, Media and Partnership Advisor
Mark Greenberg, Partnership Advisor
Patti Richards, Publicity Advisor
Cotton Coulson, Mission Control Advisor

Executive Advisors
Sonia Land
George Craig
Carole Bidnick

Advisors
Chris Anderson
Samir Arora
Russell Brown
Craig Cline
Gayle Cline
Harlan Felt
George Fisher
Phillip Moffitt
Clement Mok
Laureen Seeger
Richard Saul Wurman

DK Publishing
Bill Barry
Joanna Bull
Therese Burke
Sarah Coltman
Christopher Davis
Todd Fries
Dick Heffernan
Jay Henry
Stuart Jackman
Stephanie Jackson
Chuck Lang
Sharon Lucas
Cathy Melnicki
Nicola Munro
Eunice Paterson
Andrew Welham

Colourscan
Jimmy Tsao
Eddie Chia
Richard Law
Josephine Yam
Paul Koh
Chee Cheng Yeong
Dan Kang

Chief Morale Officer
Goose, the dog